Crucifixions and Resurrections of the Image

Crucifixions and Resurrections of the Image

Christian Reflections on
Art and Modernity

George Pattison

scm press

© George Pattison 2009

The Author has asserted his right under the Copyright, Designs and Patents Act, 1988, to be identified as the Author of this Work

British Library Cataloguing in Publication data

A catalogue record for this book is available from the British Library

978-0-334-04341-6

First published in 2009 by SCM Press
13–17 Long Lane,
London EC1A 9PN

www.scm-canterburypress.co.uk

SCM Press is an imprint of Hymns Ancient and Modern Ltd
(a registered charity) St Mary's Works, St Mary's Plain,
Norwich, NR3 3BH, UK

Typeset by Regent Typesetting, London
Printed and bound in Great Britain by
CPI Antony Rowe, Chippenham SN14 6LH

Contents

Acknowledgements

Many of the chapters included in this volume arose out of lectures and seminars, including several hosted by the Art and Christianity Enquiry (ACE), and I am especially grateful to ACE for the opportunity to develop my thinking about art through participating in these events. Through them I have learned much from other speakers and from the typically well-informed and creative-minded audiences. In this connection I would like to record special thanks to Tom Devonshire-Jones and Charles Pickstone for their role in inviting me and their part in the conversations to which the invitations led. Other hosts have included the North East Chaplaincy to the Arts and Recreation, New College, Edinburgh, and Wimbledon Parish Church. Most of the chapters have been published in earlier versions, though in every case there have been significant changes in the versions presented here. I am grateful for the following permissions for reproducing work already published: to the Sea of Faith Network for the article 'From Creation to Recreation', published in *Sofia*, No. 89, September 2008; to the Society for the Propagation of Christian Knowledge for the article 'George Frederick Watts and "Hope"', published in *Theology*, November/December 1994; to the University of Sunderland Press for the article 'Theological Response to Antony Gormley's "Still Moving"', published in Bill Hall and David Jasper, eds, *Art and the Spiritual*, University of Sunderland Press, 2003; to the Religion and Arts Program of the United

Theological Seminary of the Twin Cities for the article 'Letters from America: Robert Natkin and Friends', published in *Arts: The Arts in Religious and Theological Studies*, Vol. 6: 2, Spring 1994–5; to the Peter Fuller Foundation for the articles 'Joseph Beuys: A Leaf from the book of Jeremiah' (*Blunt Edge* 5, September 2005) and to Roy Oxlade for the article 'Anselm Kiefer's "Palm Sunday"', published in *Blunter Edge* 1, June 2008; 'Art, Modernity and the Death of God' is developed from an article with the same title published in the now defunct journal *The Month*, October 1997, Second New Series, Vol. 30, No. 10. The extract from T. S. Eliot's *Four Quartets* is reproduced by permission of Faber and Faber Ltd.

I should like to thank Charles Pickstone (again) and Roy Oxlade, both of whom looked through a first draft of this collection and made helpfully critical comments. I'm not sure that the final version will entirely satisfy either of them, but I'm happier with it as a result of being able to respond to their thoughts.

Introduction

This book is not a theology of art. The sub-title of my first book, *Art, Modernity and Faith* (Pattison 1991), suggested that it was intended to work 'towards a theology of art' and perhaps it did manage to indicate what I regard as essential in any serviceable theological approach to the visual arts. There I especially emphasized the philosopher Maurice Merleau-Ponty's account of 'flesh' and 'embodiment' as highlighting a fundamental element in any possible theology of art, and argued that this would apply both to those theologies that based themselves on the revelatory possibilities of creation and to those that preferred to see art in the perspective of redemption. Visual art is produced by, and is only meaningful to, beings who are what and as they are as embodied inhabitants of a material world. That being said, this same material world will *look* very different according to whether we see it as a meaningless play of chaotic forces, as a divine creation shot through with a 'structural grace' or as the sign of a new and better creation to come. And perhaps, theologically, that is about all that needs to be said. However, *Art, Modernity and Faith* also acknowledged that our visual and verbal resources for interpreting what we see are shaped, refined and, in some cases, rendered more difficult by the intellectual, cultural and social history in which we all participate. In my earlier book the historical factor was developed with particular regard to competing narratives about the break-up of what some have called the medieval

1

synthesis and the advent of modernity. This raised questions as to whether art could only be theologically meaningful if it was rooted and grounded in the kind of harmonious world-view that some, especially Romantic and Catholic writers, attribute to the Middle Ages, or whether – as in the case of Paul Tillich – it was precisely with regard to the terrifying abysses of the twentieth century that art came closest to revelation. *Art, Modernity and Faith* itself chose not to resolve such issues. As I wrote there, 'the theology of art is open both to the dark vision of Rothko's final works and to the Neo-Romantic quest for a new unitary vision' (Pattison 1998, p. 154) – a view I still maintain and that, I think, corresponds to most people's ability to respond to a wide range of artistic styles, schools and works.

Many theologians have, of course, wanted a theology of art to be far more prescriptive. Although his examples are mostly literary rather than visual, Hans Urs von Balthasar has provided a remarkable stimulus to theological engagement with the arts. In some respects von Balthasar continues the Catholic tradition of seeing the Middle Ages as a high-point of Christian culture, a time when art, religion, knowledge and society were united in a mutually enhancing synthesis that provided an unsurpassable context for the production of art that was both truly great and truly popular. Yet von Balthasar is also marked by the twentieth-century experience – one of his first books, written in the interwar years, was entitled *The Apocalypse of the German Soul*. History has an ineluctable tragic dimension, as the original revelation of divine glory is dimmed and obscured. Yet even in such dark modern works as those of Dostoevsky and Bernanos a distant glimmer of this glory shines on. Indeed, without it, there would be only darkness. Ambitiously, von Balthasar embeds his historical narrative in a 'theological aesthetics', seeing the Beautiful as a basic theological category of theological reflection, long neglected in favour of other transcendentals, such as Being, the Good and the True. I

have discussed elsewhere why I regard this in many ways admirable ambition as over-ambitious, not least because 'aesthetics' is itself a problematic term and a problematic discipline (Pattison 2008).

Perhaps at the other extreme are those, such as Mark C. Taylor and Don Cupitt, who have insisted that the modern and postmodern experience is not to be seen exclusively in terms of dimming the original light of revelation but simply as the way in which we live now. In this perspective visual art can never communicate otherwise than as 'disfiguring' its subject matter (Taylor 1992) or must accept – and even celebrate – the fact that it now operates 'on the level', refraining from all attempts at signifying a transcendent reality and being content to play on the rippling surface of the flow of life (Cupitt 1990). However, albeit for different reasons, the normative, not to say prescriptive tone of Taylor's and Cupitt's contributions needs, I think, to be resisted.* Like von Balthasar, both say much that excites, illuminates and extends the possibilities of theological engagement with the visual arts, but as we now move into the post-postmodern world it is ever clearer that many artists, believers and seekers do continue to look to art for visions of height and depth, meaning, truth and light – even if we are now collectively aware of the myriad forces that obstruct or distort any claim to have found a definitive answer or to have created any unambiguously significant form.

Yet the kind of territory covered by Taylor especially – territory that this book will also spend much time in – also makes clear that the prospect of an imminent 're-enchantment' of the world must be indefinitely postponed or, at least, that such re-enchantment is likely to occur only fitfully, occasionally, and in fragmentary and ambiguous ways.** The loss of a spontaneous and shared sense

* In Chapter 7 we shall see something of the limitations of Taylor's approach in relation to his interpretation of the work of Anselm Kiefer.

** On the idea of re-enchantment, see Gablik (1991) and Elkins and Morgan (2009).

of the sacred and the dimming of our capacity for a child-like wonder in the face of the world's manifold mysteries seems irreversible – whether we are thinking in terms of cultural history or of our individual journeys. The realities of the historical traumas of the twentieth century, the complexities of our technological society and the continuing power of the military–industrial lobby that bared its teeth in the 2003 invasion of Iraq are too great to be charmed away by the spell of art. Whether such a re-enchantment is conceived in terms of art coming to the aid of religion or of religion providing the soil for art's regeneration or of some kind of collaborative venture – and whether the religious basis is Christian (Graham 2007) or more diffusely 'spiritual' (Huyghe and Ikeda 2007) – possibilities of tragedy cannot be conjured away and the tragedies of the past and present must find their place in any spirituality that wants to be taken seriously.

This collection of essays and talks – and it is important to point out that the majority of the following chapters derive from invited lecturing opportunities – does not set out to be prescriptive, either with regard to theology or with regard to how we might best theorize our experience of art. It is, to repeat, not a theology of art. Yet, as my sub-title is intended to suggest, it is not without a certain commitment or set of commitments. These are 'Christian reflections' and they seek to explore a selection – and it is, of course, only a minute selection – of modern, mostly twentieth-century, artists and art-works in a perspective derived from the Christian dialectic of crucifixion and resurrection. I think I am on fairly safe theological ground in saying that this dialectic is properly central to any genuinely Christian theology, although I shall not be exploring in any detail how it relates to other elements in the larger construct of Christian doctrine. In Chapter 3 in particular I do venture some comments on the relationship between the theological topics of creation and redemption and how these might illuminate our approach to creativity.

There I argue that, ultimately, it is the doctrine of redemption that provides the criterion by which to measure and interpret the doctrine of redemption. But this does not mean that the doctrine of creation is therefore rendered superfluous, merely that it does not tell us all that it is capable of telling us unless or until we see it in the perspective of redemption. Our hope for the last day is the best guide we have to our memory of the first. That being said, the doctrine of creation gathers together and offers resources for Christian thinking and living and, not least, for experiencing our visual environment, that are perhaps easily obscured in the perspective of crucifixion–resurrection. And perhaps a different doctrinal starting-point and a different selection of artists would have produced a collection with a very different shape and feel – without in any way being incompatible with what is said here. 'Incompatibility' registers a relationship between propositions, not a measure of our differing responses to art. It is entirely possible to experience rapture before a Constable or a Monet and also to be shaken to the foundations of one's being by Grünewald or Picasso.

Even if the collective experience of the twentieth century makes the choice of the axis crucifixion–resurrection almost compulsory, artists, no less than believers, continue to bear their own witness to the goodness of creation 'deep down things'. Indeed, without the persuasiveness of such testimony, our hope for a better world becomes a kind of Gnosticism. Christian hope is not for a different world or another world but for the redemption and re-creation of this world, the only world, and the world that is both God's good creation and the fallen world of human history and suffering. As I briefly mention in Chapter 2, modern art has, in its own way, kept our memory and imagination of this good creation alive. From the luminous colours of the impressionists and post-impressionists to the symbiosis of human artistry and nature in works by Andy Goldsworthy and Richard Long, and in

innumerable works by modern masters and humble amateurs, modern art gives many reminders that this is also a good place and it is good to be here.

Were this book to be attempting to offer a full-scale 'theology of art' it would have to complete the following tasks. In the first place, it would have to demonstrate and justify the selection of its doctrinal perspective. That is to say, it would have to show why art was best viewed theologically from, for example, the perspective of creation (e.g. Begbie 1991), sacramentality (e.g. Brown and Loades 1995), or Christology (Tillich – in many works). It would then also need to show how what was said under that rubric affected or was affected by what is said from the viewpoint of other theological topics, for example, how sacramentality is related to creation and to Christology. And – if it wished to do what most theologies feel obligated to do – it would also need to indicate how it generated norms to be applied in the actual production and reception of art. As it is, this book does none of these things, nor does it intend to. In fact, I am not persuaded that such a theology of art is even worth trying. Precisely because the conditions under which we experience art today are so plural, and because modern theology itself has learned that its manifold topics are not self-enclosed units but dynamic elements that are only meaningful by virtue of their constant and open-ended interaction, it is very unlikely that we will ever have a theology of art capable of generating norms for the Christian response to art. In reality – and even if this is only making a virtue of necessity – our encounters with art cannot but have a certain personal or even arbitrary quality. Furthermore, the way in which these encounters occur at particular points in our individual life-journeys and at particular cultural moments enforces this irreducibly personal element in the way we live with art. Had it been some other day and had it been somewhere else, I might never have seen that painting by van Gogh that gave me a never-to-be-forgotten insight into the potential terror of exist-

ence, or glimpsed the rhythm of the dance-like encounter between Jesus and Mary Magdalene in Fra Angelico's fresco of the resurrection that so exquisitely and uniquely communicates the movement of grace itself.

At a very practical level, if there is one thing needful for revitalizing the Christian engagement with art, it is, after all, simply the courage to be honest in our response to what we see and not to be intimidated by theological or art-historical experts into approving what we don't actually approve, or disapproving of what actually moves us more than we dare admit, or pretending to knowledge when the work produces only perplexity – which, of course, can also be fruitful! Rather than constructing a theology of art, we would do better to spend one hour with a single, simple painting attuning ourselves to how and why it does with us what it does. And, as in the old adage about the biblical scholar who immerses himself in the dictionary to rise up in the presence of God, absorption in even a quite modest work of a great master – Corot, let us say – can yield a similar outcome.

Yet those who have internalized the teachings of the Christian Church and who have been formed at many levels of their being by the Christian tradition cannot help bringing this knowledge – more or less implicit, more or less explicit – to their experiences with art. Mostly spontaneously, we select and apply those elements of the tradition that are most relevant to getting the best out of a given experience. Clearly, in the case of explicitly religious art, the work itself prefigures that choice: theologically speaking, we evaluate a Nativity or a Resurrection in terms of our understanding of the doctrinal meaning of those events – and it is not hard to call to mind works on either subject that often seem to a contemporary eye to be a travesty of their subject matter. At the same time, the work itself can also awaken us to new possibilities in the doctrine itself that we had not previously known, as in the example of the Fra Angelico fresco just mentioned.

When we come specifically to the world of modern art and especially to that part of modern art that explicitly engages the historical traumas of the twentieth century, crucifixion and resurrection offer compelling points of theological reference for interpreting what is going on before our eyes. Some – Tillich and Mark C. Taylor perhaps – might seem to choose crucifixion alone, and there are dreadful moments in modern times and in many personal histories when it seems almost obscene to speak of anything but crucifixion. The horror of what is truly horrific is mocked, not mitigated, when theology is too quick with its words of comfort and its promise of a happy ending. But, theologically, crucifixion is never without a relation to resurrection and, in the mirror of resurrection, to creation. Last things and first things deepen and extend what we see in the hour on Golgotha. How this works out in our response to a particular work is always going to be particular, singular and, often, complex. Art has often been hailed as offering a kind of immediacy that the theological word-child both needs and (typically) flees. Yet if we are to learn anything important about ourselves from art the process is unlikely to be easier than the kind of learning that occurs in language and, specifically, in the language of theology. It is different, that's all – and learning to see that difference and learning to see where it leads us does not mean having to abandon our verbal theology but, rather, expanding our sense for what is being said in the words and silences that make up our language.

Christian reflections on art and modernity, then, are not intended to tell us how Christians ought to look at art, nor are they intended to suggest we should abandon thinking about God in words and look at pictures instead. Rather, they are the working-out of a process – still ongoing – in which words and images – and silences – might help renew, sustain and encourage us in the faith that the crucifixions we know may bring us to the resurrections for which we hope.

1

The Context and the Inheritance

Since the Romantic era, art and religion have lived in a conflicted yet symbiotic relationship. On the one hand, art has shared the modern world's striving for autonomy and has refused to be constrained in its choice or treatment of subject matter by the declarations of ecclesiastical authorities. From Byron to *Jerry Springer – the Opera* the arts have separated out from and often found themselves in conflict with the Church. At the same time, art has repeatedly manifested a certain fascination with the religious. Sometimes this has taken an ecclesiastical turn (as in the Gothic revival), while at others it has been a less specific aspiration to evoke a 'spiritual dimension'. In the first case this can lead to the artist becoming a kind of servant of the Church (as in Eric Gill's ideal of the Christian craftsman), whereas in the second it can either envisage art as a kind of substitute for religion, that is as modernity's repository of 'eternal values' (as in aspects of Soviet culture) or as the conjuration of a new religion (as in New Age aesthetics). There is therefore evidence for interpreting the association of art and religion either as a sign of secularization or as a reminder of continuing possibilities of re-enchantment. And perhaps both are legitimate, depending on the particular case at issue. For when we come down to particulars it will often be difficult to see where exactly the balance lies – do we interpret Chagall's copious use of religious symbolism as 'religious' or as a secular artist's appropriation of more or less arbitrarily selected

fragments of diverse (both Jewish and Christian) traditions? And how and by whom might such questions rightly be decided? To which we might merely add that, for its part, religion has had a similarly ambivalent attitude to art. On the one hand, it has long suspected art of being a vehicle of sensuality and uncontrolled imagining (as in the predictable Christian protests about Scorsese's film *The Last Temptation of Christ* for example). Yet it has also often sought art, both as a source for its own renewal and as an instrument of apologetic or evangelistic outreach (as in such diverse figures as Walter Hussey and Mel Gibson).

In this book I do not want to resolve any of these probably irresolvable tensions and questions. Neither the secularization thesis, nor the recurrent hope of a new synthesis of art and religion that might do for our time what the medieval Cathedral builders did for theirs, is adequate to account for the complex and diverse situation in which we actually find ourselves today. Even in the work of a single artist it is often difficult – as in the example of Chagall, just cited – to neatly separate out the 'spiritual' and the 'secular' elements or to come to a final decision as to where the overall thrust of the work is tending. Such decisions are even harder when it comes to whole schools or cultural movements. Similarly, it is entirely open to debate – it is in fact constantly debated! – which form of religion or, more specifically, of Christianity is the most authentic representative of the tradition. The stresses and strains of such a situation tempt us to simplification, as in the tendency among some theologians to divide the world up between nihilists and true believers. Even the once-popular apologetic strategy of identifying secular questions and Christian answers is insufficiently nuanced to deal with contemporary pluralism. Perhaps, then, I am merely making a virtue of necessity, but it is probably more interesting and more creative to accept the complexity and to make the most of the myriad possibilities that our times offer for

exploring the many-faceted combinations of sacred and secular, religious and worldly, Christian and non-Christian, orthodoxy and heresy. In fact these same fault-lines run through each of us singly: in some measure each of us is sacred and secular, religious and worldly, and even the best Christians are rarely Christian and nothing but Christian. And although, as a matter of fact, the artists and works I have chosen to focus on here are not primarily Church artists, working in or for the Church, a similar pattern of tensions would doubtless emerge had I concentrated instead on the art that has been commissioned for or integrated into Church contexts.

What this book offers, then, is an exploration of how some of these polarities play themselves out in our contemporary experience of art, especially the arts of the image. My guiding assumption is that modern and what has been called postmodern art is not simply a manifestation of a progressive secularization and still less a consistent crucifixion of the divine image that humanity is and is called to be. Rather, in looking at such works we see a shifting pattern of smaller or greater crucifixions and resurrections of this image, often reflecting the ebb and flow of larger societal events in which that image finds itself at risk. It is not coincidental in this regard that the central figures and works to be discussed were often explicitly reacting to the great traumas of the twentieth century, traumas that encompassed two world wars and innumerable civil and regional wars, as well as the Shoah and the atom-bombing of Hiroshima and Nagasaki. Neither art nor religion are ever just about themselves. Each is and must be an attempt to interpret the signs of the times, to find the human image in the midst of the inhuman.

It is vital that thinking about art directs itself to the specific, to specific artists and specific works. However, I should like now to begin with some more general reflections on culture that have come to shape some of our assumptions about the respec-

tive roles of art and religion in modern times. The first is from the early nineteenth-century German theologian Friedrich Schleiermacher, the second from the Marxist philosopher Walter Benjamin, and the third from the French man of letters André Malraux. Taken together they constitute an important horizon for the understanding of the relationship between art and religion in contemporary culture.

Schleiermacher, often referred to as 'the father of modern theology', was a massively influential figure in the German-speaking world throughout the nineteenth century, although in theological circles his work has been consistently under attack for much of the twentieth century. Part of the reason for this reversal of fortunes was precisely his view of the relationship between culture and religion. Here, for example, is Schleiermacher on the Church: 'The highest purpose of the Church is the shaping of an artistic inheritance, through which the feelings of each individual are given shape and to which each individual in turn contributes' (Schleiermacher 1990, p. 122). Elsewhere Schleiermacher describes the Church as the community of those reborn through faith, but here he seems to distance himself from any attempt to understand the Church in dogmatic or hierarchical terms. No one was more conscious than Schleiermacher of the need for teaching in the Church but, as he makes clear, the exercise of teaching, or for that matter of moral authority, is not the primary task of the Church qua Church. This primary task is the generation of cultural forms that could serve as vehicles for manifesting the inner feelings of the individual, feelings that, he believed, were also at the deepest level universal. (The view of culture underlying Schleiermacher's account is closely connected with what English readers might most associate with Matthew Arnold and the tradition of thinking about culture that he inspired.) From the perspective of much twentieth-century theology, this seemed to tie the Church uncritically to the 'official' culture of the bourgeois world. Church

becomes culture, culture becomes Church. Where, then, were the Christian's resources for criticizing culture?

The culture with which the mature Schleiermacher is mostly identified is what is sometimes referred to as the Biedermeier period and, whatever justification there may be for the negative associations of this word, it flags the fact that between Schleiermacher and ourselves lies a series of seismic shifts in the cultural fault-lines. But these shifts are not only to do with the modernist breakthrough in the arts and such traumas as two world wars, they are also to do with what can loosely be called the technologization of modern society.

Here I turn to Walter Benjamin and specifically to his essay 'The Work of Art in the Age of its Technical Reproducibility'. Benjamin argues that, around the middle of the nineteenth century, and largely as a result of the dissemination of new techniques of lithography and photography, a fundamental paradigm shift took place in the world of the visual arts. Art now became reproducible on a scale and with an accuracy that had never before been achieved. Parallel shifts follow with sound recording and the advent of motion pictures. Benjamin's own interest is primarily in the effect this has on the contemporary making of art that is aimed precisely at taking advantage of this reproducibility, as in arts such as recorded music or movies in which the work is made precisely in order to be reproduced. Yet he also notes how these new discoveries change our relation to the arts of the past. Under the impact of these new technologies art loses its special aura, its quality of once-offness. The work of art that was made to adorn a specific altar in a specific church can now be seen merely by turning a page, or (though Benjamin could not know of this) by a couple of clicks of the mouse. As he puts it, when I listen to a recording of a Mozart mass, 'The Cathedral leaves its place to be received into the apartment of the art-lover' (Benjamin 1978, p. 477). This tension between the pathos of

the aura and its inevitable disappearance under the conditions of art reproduction is, I suggest, pivotal to the role of the major exhibition in contemporary culture as well as to a range of other phenomena of the art world.

Malraux's concept of the 'imaginary museum' builds on Benjamin's insights only, as the eponymous title of his book on the subject indicates, with special reference to the question of the museum. On the one hand, we have the modern museum, itself a creation of the nineteenth century, presupposing and communicating a historical reconstruction of the 'history of art' and, at the same time, constructing this history on the premise of 'the original' as the definitive work of art (although, as Malraux reminds us, the very relocation of, say, a medieval crucifix into this museum changes its nature, for it was not conceived and executed as the 'statue' it has now become). On the other hand the rise of good quality reproductions meant that the museum was relativized in the very moment of its birth. As Malraux points out, prior to the advent of photography, even the great critics had what we would now regard as a very narrow knowledge of works of art. Even in the nineteenth century, he asks, 'How many artists then knew the ensemble of great works of European art? Gautier had seen Italy (without seeing Rome) at the age of thirty-nine, Edmund de Goncourt at thirty-three, Hugo as a child, Baudelaire and Verlaine – never' (Malraux 1965, p. 11). Photography enabled any interested amateur to become familiar with a range of art-works far surpassing that known by the great critics of the past.

The development of technologies of travel and transport and the financial and managerial restructuring of the arts are also worth mentioning at this point. To a degree that is almost beyond comparison with the situation at the start of the nineteenth century, it is now possible for individuals to travel easily across continents simply to see a particular exhibition, attend a particular concert, or visit a particular archaeological site. At the same

time works of art and ancient artefacts can be safely transported round the world, stored and exhibited. These processes are further underwritten by insurance and financing developments (e.g. sponsorship, the sine qua non of any major cultural event today). As a result, to take Benjamin's example of the Mozart Mass, while the CD or the radio allow me to transport the cathedral into my sitting-room, I can with almost equal ease transport myself to Salzburg Cathedral for a live performance. In these terms, the whole globe has itself become, potentially, a 'museum without walls' – that is, for those whose wealth gives access to such cultural goods.

If Benjamin had been correct in his prognostications, the advent of photography would have simply evacuated the previous desire for an encounter with the 'original'. We would be happy with the reproduction. But, typically, even though the reproduction lacks the aura of the original, it does not free us from the passion for 'the real thing'. Progress in such technologies is not simply linear, but complex and interactive. The fact that I am familiar with the 'Mona Lisa' from countless reproductions becomes a primary motive for wanting to see the original. In this connection, it is perhaps one of the attractions of the 'blockbuster' exhibition that it brings together as a 'unique event' works that are otherwise accessible and comparable only in reproduction – yet, at the same time, the exhibition pays its way precisely by the sale of books, prints, cards and other merchandise in which the artworks are submitted to the demystifying processes of 'technical reproducibility' and popularization. In a further extension of this mediating and disseminating process, the event is publicized in newspapers, TV and radio features and so on, so that even if I fail to see it, I can participate in the discussion around it. The exhibition thus lives in the tension between the aura of the original work, and the technological and managerial conditions of contemporary society. Can it then be a focus of recalling or renew-

ing religious experience for our time? Can it, in Schleiermacher's terms, be culture as a means of expressing and communicating Christian faith?

Commenting on the 2004 El Greco exhibition at the National Gallery in London, a leading article in the *Observer* stated that:

> Religion – in particular Christianity – has shaped Western society in a profound way, and has left us with a cultural legacy that enriches all. A visit to the new exhibition of El Greco's vivid, spiritual works at the National Gallery provides a glorious demonstration of the power of religious beliefs to stimulate great works'.[1]

However, the article as a whole made it clear that, whatever inspirational power it may have had in the past, the works that religion once inspired are available to us today as 'culture' without our having to buy in to their religious commitments. I am free to see El Greco's work simply as painting, as an 'El Greco', and not as an icon of the Christ.

The tensions reflected in such an approach are very prominent in Neil MacGregor's introductory essay to the catalogue of the 2000 exhibition 'Seeing Salvation'. MacGregor starts by noting that about a third of the works in the National Gallery have an explicitly Christian content. This means that for the many who lack Christian faith such works seem 'irrecoverably remote, now best approached in purely formal terms'. The aim of the exhibition, then, is 'to focus attention on the purpose for which the works of art were made, and to explore what they might have meant to their original viewers' (MacGregor 2000, p. 6). Central is the representation of Jesus as 'God who became man'. This appears to flag a theological approach to the material – however, the conclusion of his essay marks the same nineteenth-century cultural understanding as that of the *Observer* leader-writer.

In the hands of the great artists, the different moments and aspects of Christ's life become archetypes of all human experience. The Virgin nursing her son conveys the feelings every mother has for her child: they are love. Christ mocked is innocence and goodness beset by violence ... These are pictures that explore truths not just for Christians but for everybody. (MacGregor, 2000, p. 7)

The implication clearly is that whatever power the individual work might still have to move the individual viewer, an interpretation that sees the work in exclusively Christian terms must prove at best inadequate and at worst misleading.

A striking feature of the exhibition was the place given to images associated with the legend of St Veronica, who supposedly received an imprint of Christ's face on the cloth with which she compassionately wiped it as he bore the cross up towards Calvary. However, this signals another aspect of 'aura' in the history of Christian art: that early Christian art was often indistinguishable from the cult of relics, a connection especially prominent in traditions of 'images not made with hands' or images directly drawn from the life and death of Christ. Such works were not created primarily as representations of their subject but as ways in which that subject made it-(Him-)self present (a theme brilliantly explored by the art historian Hans Belting in his work on the 'image before art'). In the relic, the aura is not yet associated with any aesthetic qualities – it can be a bit of rotten bone – but reveals itself in the radiance of the power and presence of the holy life to which it testifies. In these terms there is a further step beyond the kind of aura surrounding, for example, an 'original' El Greco to the aura of the relic. Yet it is just this deeper aura that the explanatory presentation of the great exhibition must necessarily miss. In these terms such exhibitions will necessarily reinforce the whitewashing over of the original religious

context in which the work was first made and made meaning-ful. In this perspective, even a live religious event – the King's College Festival of Nine Lessons and Carols or a Papal blessing in St Peter's Square – enters into the irresistible gravitational field of the global culture industry, once it is perceived as an 'event' within the cultural calendar of the time.

Is this judgement on the negative effects of the culture indus-try on the mediation of religious art too harsh? Perhaps it would be wise to qualify it, and to do so in three ways.

First, we should be wary of sentimentalizing the past. Even in the age when the relic was imbued with supernatural powers, the cult of relics resembled that of the contemporary cultural indus-try in more than one respect. Mass production – or, as it was then believed, mass 'discovery' – of relics, special showings (together with privileged access for those who could pay for it) and asso-ciated commercial activities were ubiquitous in late medieval Europe. In one afternoon in Florence I saw three right index fingers of John the Baptist, and I have seen others elsewhere: here too issues of originality and cultural mediation proved, finally, unavoidable and, arguably, played a central role in the splitting of the Church in the Reformation.

Second, where faith in the power of the original is still living, even the migration of the work into the museum or onto the CD allows for a believing response. Nowhere is this more apparent than in Moscow's Tretyakov Gallery, where the visitor is likely to see groups of believers singing hymns or praying before some of the most highly treasured icons brought into the gallery at the time of Stalin's attack on the churches. 'To the pure all things are pure' and, in this sense, even the most pre-packaged work can become a resource for the believer.

Third, the exhibition (or concert or recording) can rarely lose a relation to its origin entirely – if only in the mode of provok-ing an awareness of the difference between the experience from

which the work developed and our own experience in the face of it. Jonathan Jones, writing from an avowedly secular standpoint, began an article occasioned by the blockbuster Fra Angelico exhibition at the Metropolitan Museum in New York (2005) with an anecdote about seeing a painting of the Annunciation in Florence that was completed with angelic assistance. As he commented:

> When the ceremony [of showing the painting] is over, a metal grille slides automatically into place, hiding the painting from secular eyes – from eyes like mine. My way of relating to images – my interest in 'art' – suddenly has no legitimacy, is all wrong. (Jones, 2005, p. 37)

In such moments, even when presented as part of an over-determined cultural event such as a blockbuster exhibition, the sacred art of the past or of other cultures can invite reflection on the limits of our own cultural horizons. If such events can be seen as exemplifying the secular world absorbing all previous forms of cultural life, including those shaped by religious beliefs and aspirations, into the global museum without walls, they can also sometimes witness to the final limitations of that world. For if the secular world once admits the presence of a past which it did not invent and cannot entirely comprehend, it becomes uncertain whether it entirely governs the present or, indeed, controls the future. At the same time, and more positively, the intrinsic relation of the work to its original meaning allows for the possibility that the work – in whatever form it is transmitted – can still shape or mould our contemporary response. This may be in the manner of instruction: as countless conversations overheard in art galleries testify, many consumers of culture simply do not know even the basic outlines of the Christian story in its classical form, and the painting may, and often clearly does, *teach*. At the same time, it may deepen what it has taught or what

is already known concerning Christian faith by unveiling possibilities of meaning that would otherwise remain covered over. That is to say, the work of art reveals dimensions of the human experience of religion that our time is ill-placed to know spontaneously. Fra Angelico and his assistants at San Marco are a case in point, for such works not only 'tell the story', they also show something of the joy, tenderness, reverence, sorrow, and even pain, that belonged to the existential world of Dominican spirituality. By such means, art not only continues to sustain a cultural memory of what Christianity teaches, but also to convey something of why and how it was able to transform minds and imaginations.

Even as the culture industry incorporates and reshapes the inheritance of Christian art, uprooting it from its original religious context and meaning, it nevertheless retains a vestige of an 'ecclesiastical' function, at least in the spirit of Schleiermacher's definition: 'The highest purpose of the Church is the shaping of an artistic inheritance, through which the feelings of each individual are given shape and to which each individual in turn contributes.' It will be the aim of the following chapters to explore how this occurs in the experience – inevitably mediated by the same culture industry – of what we have come to know as 'modern art'.

Notes

1 The *Observer*, leading article, 15 February 2004.

2

Art, Modernity and the Death of God

Perhaps it is nowhere more difficult to disentangle what is authentically Christian from what is secular or even nihilistic than in relation to the theme of the death of God. In this chapter I shall attempt to explore some of the ambiguities and complexities of the treatment of the death of God in modern art, but I begin with some introductory remarks on the related theme of iconoclasm.

Iconoclasm

Complaining of the resurgence of classicism in French art, those he called the 'neo-pagans', Baudelaire wrote that it had become:

Impossible to take a step, to speak a word without stumbling into something pagan ... To surround oneself exclusively with the charms of material art is to run the risk of damnation. For a long time, a very long time, you will be able to see, love and feel only the beautiful, and nothing but the beautiful. I am using the word in a restricted sense. The world will appear to you only in its material form ... Plastic! Plastic! The plastic – that frightful word gives me goose flesh – ... I understand the rage of iconoclasts and Moslems against images. I admit all

21

the remorse of St. Augustine for the too great pleasure of the eyes. The danger is so great that I excuse the suppression of the object. (Baudelaire 1964a, pp. 74–7)

Baudelaire's words, directed at a movement he regarded as blocking the emergence of an authentically modern art, show how the spirit of the second commandment has had an impact on western culture that cannot be limited to the narrow puritanical form of hostility to images.

The interpretation of the commandment has, of course, been controversial from the beginning. Not only Moses' own brother Aaron (maker of the Golden Calf), but many in Israel, over many generations, had great difficulty coming to terms with aniconic worship. The history of their resistance and its suppression exemplifies Nietzsche's dictum that the spilling of blood lies at the basis of all great cultural phenomena. The same story was to be repeated within the Christian Church, in the spasms of iconoclasm that rocked, first, the Eastern Church and then, in the Reformation era especially, the Western Church.

Yet we should not ignore the positive outcomes of iconoclastic controversies, old and new. They have heightened our collective awareness of what is at stake in the production and reception of images. Whatever one may say about the iconoclast, he does not dismiss art as trivial or unimportant. That such controversies occur at times of rapid and fundamental cultural change also signals that they involve an awareness, albeit in a negative form, of the way in which images are tied up with a whole way of representing the world, and are not just attempts to represent particular objects within it. The image focuses, transmits and reinforces a complex set of values and perceptions. By virtue of their sensitivity to such functions of the image, the iconoclasts helped to generate a nuanced response to images that is open to their power while seeking to keep that power under critical review. It

is important to add that the Judaeo-Christian tradition of icono-
clasm is also marked by a sense for the social values expressed in
images and their social use. Isaiah recognized long ago that the
manufacture and promotion of images was a power-related activ-
ity that stood in tension to the Law's prioritizing of justice and
mercy. The questions by whom and for whom are not irrelevant
to our overall reception of images, even if it is also important not
to obtrude them into the process of appropriation at the wrong
moment. To this we might add only that the iconoclastic cast of
mind that has been deeply internalized in modernity and that
is exemplified in the practice of modern art itself, is a practice
that, like iconoclasm, takes up an attitude of ultimate seriousness
towards art, while remaining profoundly critical and self-critical
with regard to all particular art-products – something we have
already seen in the quotation from Baudelaire at the start of this
section.

Yet whatever may be the case with Judaism and Islam, Chris-
tianity seems not to want to go all the way with the iconoclasts.
On the contrary, it seems to have an essential interest in speak-
ing of and offering a certain image of God. Does the Bible not
speak in Genesis 1 of the first human beings having been made
in the image of God? And if, because of their violent or malevo-
lent comportment towards one another, that image has been
obscured, surely it is central to everything Christian that the
original human image of God was not only restored but raised
to new glory in Christ? Does not faithfulness to the Incarnation
mean affirming Christ as the image or icon of God, and therefore
showing as well as telling the world what that image is? This is,
for example, the primary argument offered in defence of images
by such defenders of icons as John of Damascus. Yet our know-
ledge of Christ is at the same time inseparable from the vision of
his death on the cross: a death, at one and the same time, of the
man Jesus and of the human image of God restored in him. To

see how terribly ungodlike that death was, we have only to look at works such as Grünewald's famous Crucifixion. No more than in any other human being is the divine image presented to us in Christ in a direct or simple way. Rather, it is an image we have to learn to see even in what seems to be its ultimate eclipse: the God-forsakenness of the man on the cross. In this way, the challenge of Christian iconoclasm leads us on to a further and deeper challenge, the destruction of the one who was himself the 'icon', the true image of the eternal light. And even if we add, as doctrinally we ought, that this bodily icon was not finally destroyed on the cross but, ascended and glorified, is seated at the right hand of God, this merely displaces the issue, since this risen, ascended, glorified body is precisely and by definition not a body visible to the human eye. Since that day, that 'long Friday', the question of iconoclasm becomes the question of the death of God and the impossibility of the icon.

The Death of God

At first it might seem counter-intuitive to speak of the death of God as a Christian theme. Surely 'the death of God' is the cry of the modern atheist, and the prophet of the death of God the greatest of all modern atheists, the madman Zarathustra-Dionysius-Nietzsche who, nonetheless, in the terrifying paroxysm of his disintegrating sanity signed his final letter 'the Crucified One'. In its modern usage, the expression certainly does go back to the famous passage entitled 'the Madman' in Nietzsche's book *The Joyful Wisdom*. However – and long before Nietzsche – Martin Luther had referred to Christ as 'the crucified God' with a boldness of expression subsequently underwritten by the Lutheran doctrine of the communication of idioms, according to which terms applied to the divinity of the Godhead could be applied

to the humanity of Christ and vice versa. The crucifixes of the *devotio moderna* in the late Middle Ages could wring every last drop of human suffering out of their subject, but the Godhead itself was never imperilled in them. Returning to the nineteenth century, Hegel had spoken of the need for the God of abstract theism to die in order that the God who is spirit and who, as spirit, lives in and through the dynamics of human history, might appear. The decisive moment in Hegel's story is precisely the moment marked, on the one hand, by the death of Christ and, on the other, by the coming of the Spirit in the early Church.

Then, in Russia, was Dostoevsky, whose novel *The Idiot* debates the question of the meaning that human life can have in the face of a final and ineluctable death, a question sharpened by Dostoevsky's own experience of being only minutes away from death by firing squad before receiving a reprieve. This event is alluded to in the early pages of the novel. Later we are brought face to face with a painting that raises the question of whether God himself might be subject to death. It is Holbein's painting of the entombed Christ, seen by Dostoevsky in Basel Cathedral. It is indeed a picture that seems to strip its subject of all senti- mentality, all other- worldliness. It is simply a picture of a corpse, modelled, it is said, from the body of a Jew, dredged up from the river Rhine.

When we first 'see' the picture in the course of the novel, Prince Myshkin, the eponymous 'idiot', declares that 'a man might lose his faith looking at such a picture', and later on we meet a man who has lost his faith, the young nihilist Ippolit Terentiev, who actually talks about this loss of faith in terms of the very same picture. As Ippolit sees it, even the closest disciples would have lost their faith if they had seen this image of their Christ in the tomb. This is a corpse beyond resuscitation. Julia Kristeva connects the picture with the very secular portraits Holbein produced at the court of Henry VIII: in these portraits, she says, Holbein created, in effect,

the first 'modern' heroes, or rather non-heroes, faces that have looked into and absorbed the knowledge of their own finitude and mortality – 'humanist' in a more radical sense than contemporary humanists themselves realized. Holbein's most famous visual trick, the location in the painting of 'The Ambassadors' of a distorted skull that can only be seen from certain angles, might seem to resonate with such an interpretation.

In the same decade in which Dostoevsky wrote his novel, Manet painted his 'Dead Christ with Angels' (1864), a painting that produced similar reactions to those of Dostoevsky's characters in the face of Holbein's dead Christ: that this Christ was so dead as to negate all the religious meaning given by Christians to his death. Manet's contemporaries saw the body as ugly, dirty, vulgar and – offensively – dead: a cadaver and nothing more. Of course, Manet's intentions in producing such a work at such a time were complex, and there is certainly little evidence to suggest anything like a conscious 'Christian' motivation in any conventional sense. However, precisely for this reason, it is worth looking further into his painting of the dead Christ and its significance for his overall artistic vision.

One of the first things which any introductory text on Manet will argue is that he was one of the great founders of that distinctively modern art in which the illusion of reality is abandoned, in which painting no longer pretends to be showing us what is 'out there' (whether in the present or in historical space), but is simply a flat, two-dimensional work, entirely 'on the level'. It was in this sense that Zola said of Manet: 'He knows how to paint, and that's all . . .' (Hanson 1977, p. 26). The business of delivering 'a message' to the world was something different again. It was in this spirit that Georges Bataille wrote of Manet's painting of 'The Execution of the Emperor Maximilian' that, in contrast to Goya's harrowing 'Third of May' (which, he says, *signifies* what it represents), Manet's painting 'marks . . . the passage of painting,

from a language which narrates . . . to a language which is bare . . . it is expressly to Manet that we must attribute in the first instance the birth of this kind of painting devoid of any signification other than the art of painting itself which is "modern painting"' (Bataille 1979, p. 131). In Bataille's view Manet's work therefore inaugurates the refusal of all values exterior to the painting itself. Thus, in 'Maximilian' he 'painted the death of the condemned man with the same indifference he would have adopted had he chosen a flower or a fish as the subject of his work . . . this picture is the negation of eloquence, the negation of a kind of painting which expresses, as language expresses, a sentiment' (Bataille 1979, p. 132).

Applying these words to the 'Dead Christ with Angels', they provoke the question of what, exactly, we are looking at. Is it simply an arrangement of colours and shapes? A 'still life' – bearing in mind that in French the expression for 'still life' is 'nature morte', literally 'dead nature'? Or are we looking at what theology might see in the scene, a supernatural death, an unquiet death which must continue to disturb, and in disturbing, redeem humankind? As a first step towards answering such questions, let us consider further the 'event' of the work's first exhibition.

The 'Dead Christ' was first exhibited in the Paris Salon of 1864, when Manet was aged 32 and at a turning point in his career. Three years previously he had had two paintings, a portrait of his parents and 'The Guitarist', accepted by the Salon, and 'The Guitarist' in particular had met with some critical acclaim. Two years later, however, all three of the paintings which Manet entered for the Salon (including the 'Déjeuner sur l'herbe') were refused but, amid much controversy, were subsequently shown in the 'Salon des Refusés', one of the first 'great refusals' that have been so characteristic of the history of modern art. Who, then, was this young painter – and what were his artistic aims?

Let us go back four years to 1860 and to the picture 'The Con-

cert in the Tuileries'. This painting is not only remarkable in itself, but also in the way in which Manet shows himself (at the extreme left of the picture) in the company of those who might be identified as marking the horizons of his artistic and social world – Jacques Offenbach, Théophile Gautier, the painter's brother Eugène (later married to Berthe Morisot, who both modelled for Manet and was an outstanding painter in her own right), fellow artist Henri Fantin-Latour and, perhaps most significantly, the poet and critic Charles Baudelaire.

Baudelaire was not only one of the first critics to recognize Manet's talent and, to a certain extent, to 'sponsor' his career; he also provided, both in his critical and in his poetical works, a programme for anyone aspiring to the role of modern artist. Baudelaire had attacked the 'costume drama' of much contemporary French art, and called on artists to depict the reality of modern life. Beauty, he argued, is not timeless, but is always interacting with the contemporary world in which it appears. Our criteria for female beauty, for instance, change with changing fashions, fashions which not only include such elements as dress and make-up, but posture, gait and expression. It is only when the artist is true to this contemporary dimension of beauty, Baudelaire insisted, that he will also show something of eternal beauty. The great works of art of the past are great – 'classics' – only because they were thus true to the reality of their own day. If the modern artist wants his work to communicate to future generations he must start with today, the here-and-now, 'the age', 'its fashions, its morals, its emotions' (Baudelaire 1964b, p. 3). Art must show that quality of 'modernity' which Baudelaire defined as 'the ephemeral, the fugitive, the contingent, the half of art whose other half is the eternal and the immutable' (Baudelaire 1972, p. 13). The world of the modern artist is therefore the world of the modern city, its streets and gardens, its cafés and crowds.

The crowd is his element, as the air is that of birds and water of fishes. His passion and his profession are to become one flesh with the crowd. For the perfect flâneur, for the passionate spectator, it is an immense joy to set up home in the heart of the multitude, amid the ebb and flow of movement, in the midst of the fugitive and the infinite. (Baudelaire 1964b, p. 9)

On a rather more ambiguous note he also asked of the artist that he represent his subjects not in the antique robes of the schools but in the nineteenth century's own frock coat. 'Is it not the inevitable uniform of our suffering age, carrying on its very shoulders, black and narrow, the mark of perpetual mourning? . . . All of us are attending some funeral or other' (Baudelaire 1972, p. 105).

The modern world celebrated by Baudelaire is precisely the world depicted in 'The Concert in the Tuileries'. At first glance it is tempting to see in it merely the superficial hubbub of the crowd, yet we must also bear in mind Baudelaire's hint that these men in their dark frock-coats 'are all attending some funeral or other'. Something of this same ambiguity is revealed in Baudelaire's remarks about Manet himself: 'Manet . . . is simply a very loyal, very simple man, who does all that he can to be reasonable, but who has unfortunately been marked from birth by Romanticism' (quoted in Bataille 1979, p. 117).

It is not at all surprising that this man of the crowds, this 'perfect flâneur', only painted two works reflecting the Christian story of salvation: the 'Dead Christ' and, a year later, 'Christ Mocked'. Indeed, we might be surprised that he painted any such pictures. Do they indicate some fierce religious conviction – a 'Romanticism' – raging beneath the glittering surface of this most 'modern' painter? Or do they, perhaps, constitute a gesture of deference to the religious conventions of that bourgeois public whose rejection and misunderstanding of his work so grieved the artist? Or are they no more than an exercise in painting?

The 'Dead Christ' was exhibited one year after the appearance of Renan's historical study of the *Life of Jesus*, a humanistic 'life' which attempted to separate out the 'historical Jesus' from the dogmatic and mythological preconceptions in which he was embedded and, in doing so, deeply shocked the upholders of established religion. Renan's *Life* provided at least one critic with a source for Manet's painting: '. . . do not neglect Manet's Christ or the Poor Miner Rescued from a Coal Mine, executed for Renan' (Hamilton 1969, p. 60). Yet if anything, Manet's image was even more shocking to contemporaries. Renan's Jesus, though completely human, was nonetheless a highly sentimentalized figure – 'adorable', 'sublime', 'in him was condensed all that is good and elevated in our nature', he was 'the highest of the pillars which show to man whence he comes, and whither he ought to tend', whose 'sufferings will soften the best of hearts' (Renan 1935, pp. 216, 249). There was, however, nothing sentimental about Manet's 'Christ' as the critics saw it. 'We have never seen such audaciously bad taste, the negation of scientific anatomy, spoiled color, lampblack abased and applied to the face of the most beautiful of men, carried so far as by Manet in the "Dead Christ"' (Hamilton 1969, p. 60). Théophile Gautier, whose praise of 'The Guitarist' had been an important moment in Manet's success thus far, was similarly dismissive.

> The livid aspect of death is mixed with soiled half tones, with dirty, black shadows which the Resurrection will never wash clean, if a cadaver so far gone can ever be resurrected. The angels, one of whom has brilliant azure wings, have nothing celestial about them, and the artist hasn't tried to raise them above a vulgar level. (Hamilton 1969, pp. 57f.)

But why did the 'Dead Christ' elicit such a negative response? Seen from a certain angle, the work is not obviously revolutionary. As

in many of his other works, Manet had drawn on a number of precedents in the classical repertoire, some of which he would have seen himself, some of which he would have known through reproductions in Charles Blanc's *History of Painting*. Among possible sources are works by Mantegna, Veronese, Murillo, Ribalta and a painting in the Louvre thought at the time to be by Tintoretto. The theme of Christ being laid in the tomb by angels as well as, or instead of, his human companions (the three Marys, etc.), is one that became fashionable in the seventeenth century, but goes back to the older image known as 'The Man of Sorrows' (Mâle 1984, pp. 216, 249; also Belting 1981).

However, the way in which Manet uses earlier models is very distinctively his own. Indeed, it is in the way in which Manet deviates from pre-existent models that the 'scandalous' aspect of his work can most easily be seen. This is important because it is very difficult for a late-twentieth-century viewer to experience the shock that these paintings caused on their first showing. In this respect, a comparison with the 'The Incident in the Bull Ring' may prove helpful. This picture literally failed to survive the criticism levelled against it, having been subsequently cut up by Manet himself into three fragments (of which only two remain). The most striking of these fragments is that which shows the dead toreador. Here too the 'models' for the work are well-known, including Gérôme's 'Assassination of Caesar' and 'Execution of Marshal Ney' and a work depicting a dead soldier believed to be by Velazquez (an artist whom Manet particularly admired). And yet the differences are as striking as the similarities. For in each of these works the painting of a violent death is softened by the gradation of tone, light and shade. The event of death is not thrown down in front of us in all its stark unintelligibility and absurd singularity but is gradually blended in to the surrounding scene. Death may be a cruel breach in the course of life from which there is no return, these pictures could be saying, but nonetheless the event is not

totally isolated; there is a continuity between the dead man and his world, a pattern of gradation and thus a logic, a reason, a context in which our feelings can grow, take shape and relate to it. Imagination is stirred and sentiment aroused. In the face of Manet's dead toreador, however, there is no occasion for either imagination or sentiment. There is, as Bataille put it, nothing eloquent about this image. It says nothing. The body is just there. The sun does not veil or moderate its light because a man has died. He dies in the same light in which he lived. Abandoning the pathetic fallacy, the modern frock-coated man does not believe that nature accompanies him to the funeral. In death there is just fate and chance, while the world goes its way, untouched and unmoved. There is no romanticizing of either dying or death. It is just something that happens, an event like the presence of a flower or a fish on a table or a gathering of friends for a summer concert in the park. There is neither terror nor pity and therefore no tragedy. There are only events, rearrangements of the visual field, to be represented solely according to the logic governing that field. This applies to the dead toreador, the dying emperor and the dead Christ. They seem to be mere events, mere paintings. This, then, is what so shocked Manet's contemporaries: that they saw in his dead Christ a dead man – and nothing more. But is there really no 'metaphysical shock' in the painting itself? Is Manet, the painter, no more moved by what he paints than the crowd who amusedly watch the rantings of Nietzsche's madman tormentedly seeking God and proclaiming his death?

Let us think for a moment about some of Manet's portraits, ordinary domestic scenes of ordinary bourgeois people, such as the portrait of 'The Street Singer' or that of Madame Brunet. In the eyes of these portraits, I suggest, it is possible to see something quite different from what the textbooks prepare us to see. For what Manet depicts is not the absence of sentiment or feeling but their interiorization to the very lowest threshold of visibility.

In these eyes we see something of the 'metaphysical shock' which Tillich described as the 'shock of non-being', that is, the wordless recognition that each and every step we take is accompanied by the possibility of death, extinction, oblivion. 'Modern man', as Baudelaire understood so well, surrounds himself neither with the grim reminders of mortality nor with the promises of a better life hereafter, such as the religious art of previous ages had offered. Nor is he comforted for long by a heroic idealism that lacks metaphysical finality. But everywhere he goes in his frock coat he is on his way to 'some funeral or other', he is an 'infinitely suffering' being in the midst of this very ordinary, very bourgeois, very unheroic modern urban environment.

Having stated that Manet was the originator of modern art's reduction of the apparent subject matter of a painting to a mere 'pretext', even Bataille nevertheless also acknowledged that 'out of this absence [of the subject matter] ... emanates a heavy plenitude' (Bataille 1979, p. 133); 'the abolition of conventional sentimentality, silence – is produced, for its part, by an inner violence, which is its essence' (Bataille 1979, p. 134). Conceding Malraux's claim that in the modern world the museum or the art gallery has replaced the cathedral as the repository of what society holds to be sacred or numinous, Bataille adds that the sacredness of this cathedral is essentially secret:

> That which today counts as sacred cannot be proclaimed, that which is sacred is henceforth dumb. This present world can know only an inner, silent transfiguration, a kind of negative transfiguration: it is possible for me to speak of it, but only by speaking in a definitive silence. (Bataille 1979, p. 135)

In the non-expressive eyes of Manet's 'subjects' we see the shock of such an inner, violent silence: the secret suffering of the modern, cosmopolitan world. And if that is so, we may be right in

seeing more in those works in which Manet deals directly with violent death than simply a variation on the genre of still life and an agreeable arrangement of shapes and colours – or rather, in seeing that arrangement also simultaneously seeing the negative tension that causes the surface to exist as surface, as 'modern life', as a resolute turning away from romantic posturing, pathetic fallacies and tragedy and, in so doing, carrying the silence of death with it every step of the way.

I am not, however, ascribing to Manet himself a 'religious' or 'metaphysical' intention or suggesting that we should add a 'theological' or a 'metaphysical' Manet to the list of Manets produced by a century and a half of interpretation. What I am saying is that, whatever Manet's conscious intentions, we can see a fully painterly theological or metaphysical dimension to the way in which he painted, whether the subject matter was portraiture, still lifes, bourgeois Sunday afternoons, executions or dead bodies. Above all, it is in the 'Dead Christ' that Manet finds an object in which the otherwise indirect communication of the metaphysical shock of non-being becomes painfully direct. This, to recur to Baudelaire's incisive phrase, is the funeral we are all attending.

Like Dostoevsky, Manet confronts modernity with its own hidden assumptions. Such a 'death of God', however, is not – it certainly is not for Dostoevsky – the simple negation of Christianity. The pathos of this death is inseparable from the meanings and values which the one who died embodied. In handing us over to the almost unbearable secularity of a world in which God has died, the painting shows modernity's *memento mori dei*; modernity requires the continuing presence of that absence or death, for this is precisely the source of the tension that restrains it from slipping into what Heidegger was to call average 'everydayness'.

But there is a further link I should like to make between Manet's paintings and Dostoevsky's novel, focused on a picture

painted the year before the 'Dead Christ': 'Olympia', perhaps the most scandalous of all of modern art's many scandalous works. As with the 'Dead Christ', Manet's contemporaries saw this similarly almost totally naked body as ugly, dirty and badly painted. Of course, it also disturbed them in other ways. One reason for their disgust was, of course, that for all the talk of obscenity, 'Olympia' was not a sex-object in the manner of the conventional nudes enjoyed by the public. 'Olympia' is no mere passive object of the male gaze, but meets the viewer's eye and discomforts us as we stare at her by the manner in which she seems to stare back. There is no soft, warm 'feminine' welcome waiting here. Her expression not only conveys reserve, indifference and boredom, but also truculence, resentment and indignation. She is a woman conscious of her 'abandonment', understood precisely in Sartre's sense; that is, conscious of being handed over to an existence she has not chosen, an existence that denies, frustrates and smothers her aspirations to a 'higher' life, to beauty, truth or goodness or religious transfiguration.

As between Holbein's courtiers and his dead Christ, so too, I suggest, there is a cryptic correspondence between 'Olympia' and the 'Dead Christ' – and it is also striking that if Holbein's Christ is one point of visual reference in Dostoevsky's novel, another is a portrait of a 'fallen woman', the photograph of the unhappy Anastasia Phillipovna. Indeed, 'Olympia' might almost be a portrait of Anastasia Phillipovna herself, whose childhood rape and subsequent 'grooming' as her seducer's kept woman is one of the central themes of The Idiot. As, in the novel, these two images – the photograph of Anastasia Phillipovna and the painting of the dead Christ – mark out the metaphysical space within which the action moves, Manet's twinning of the fallen woman and the dead Christ establishes a force-field of extraordinary metaphysical potential. From here on, the 'surface' of modern life is no longer 'mere' surface, but the space in which the death of

God is obliquely reflected. In presenting the surface as surface and nothing more, the painter iconoclastically strips the world of its claim to offer adequate visualizations of the divine and asks us, in Simone Weil's phrase, 'to refuse to believe in everything that is not God'. Everything that the artist sees and depicts in the parks, boulevards, cafés and domestic interiors of modern life has become 'dead nature'. We are all attending some funeral or other, and Nietzsche and Baudelaire remind us whose.

I should now like, briefly, to run through several examples of where we can see this reflex of the death of God in modern art that we might also call a loss of belief in everything that is not God. In doing so, I am seeking to highlight a very particular tension. I am not looking for explicit allusions to the cross – although modern art has produced many of these – but for works that reveal the essential godlessness of the world, yet in such a way as to remind us that it is godless and not simply a neutral or value-free surface. Godlessness, thus seen, is the trace of the memory of God in the visual culture of modernity – and it is equally open to us to perceive it as a sign of thorough-going secularization or as a way of registering the impact of Christianity's own narrative of the death of God on the cross and, as such, an indirect and ambiguous moment of encounter between faith and modernity.

A World Without God

My first example is that of the Danish painter, Vilhelm Hammershøj, whose work has gradually been becoming better known outside Denmark since the early 1990s.[1] It is not inappropriate that an interior view by Hammershøj was chosen for the cover of a book on Kierkegaard called *Subjectivity and Negativity*. It is one of the many paintings he made of the interior of his house

in Copenhagen, probably his most frequently used subject. These paintings have a powerful sense of interiority. Even when we get to see out of a window, we do not see a view, but only more windows, or a wall. Nor does the presence of figures in the rooms change this. In fact, because they are often seen from behind or are absorbed in sewing, reading or resting, they accentuate it, defining an interiority to which the viewer has no access and for which the interiority of the apartment is only an outward and visible sign. And yet these are never closed spaces. Although the lighting is never direct, these rooms are typically illuminated by a light that floods in from elsewhere. Its source is never glimpsed yet it irradiates the whole canvas. The same is true of Hammershøj's landscapes. Light is always on the edge of bursting through the clouds or trees, yet the sun that gives this light is never seen. The light that makes these works what and as they are is – where, exactly? We never get to know; always and everywhere absent, the 'what' remains unknown and unnamed.

Or nearly always. One exception might be the painting called 'Five Portraits' that is sometimes regarded as Hammershøj's magnum opus. This is how it is described by the Danish critic Poul Vad:

> With the two candlesticks and the three empty glasses as the only table accessories, the arrangement is if anything an inversion, the depiction of an apparently familiar social universe in which emptiness has imperceptibly turned everything topsy-turvy: that is what shouts from the table, from the night outside, and from the non-contact between the men. (Vad 1992, p. 226)

In fact Vad sees 'Five Portraits' as a direct inversion of the Last Supper, with particular reference to an altar-piece in a well-known Copenhagen church by C. W. Eckersberg, one of the

founders of Danish Golden Age painting. Vad concludes that in this last supper:

> [W]hat he was portraying was the absence of the divine, the individual's . . . solitariness in a secularized individualistic society; and the night, the emptiness and the silence as an existential dimension, which by nature of the picture's monumental format is assigned social extent and import. (Vad 1992, p. 226)

There is some further evidence to corroborate this reading. The young man in the foreground closely resembles a sketch for a painting produced some years before and entitled 'Job', the archetype of suffering humanity seemingly abandoned by God. Perhaps it was not inappropriate that the painting for which this sketch was a preparation suffered an unusual chemical reaction in the pigment that caused it to darken over until it was entirely obliterated, so that the sketch is all the remains. In 'Five Portraits' the young man is holding a pipe, in the sketch the raised hand is empty, and could be read either as a gesture of pleading or surrender. Hammershøj himself claimed only to have named the picture ('Job') after completing it and not to have attached too much importance to the title, but unless we regard the process of producing a work as a mere chain of accidents, the mere possibility of naming the figure in this way says something important about its meaning.

A second piece of evidence is a sketch for a further evening interior, 'Evening in the Drawing Room', a work that Hammershøj abandoned, apparently disheartened by the negative response to 'Five Portraits'. In this later work we get a clearer view of the windows that dominate the scene, and we cannot but notice how their vertical and horizontal woodwork resembles five crosses. But this iconographical reference is not redemptive. The central cross, though illuminated, does not itself illuminate or give meaning to

the scene, except inversely. It is a mute witness, withdrawn and silent, offering a meaning that is not seen by any of the figures in the painting, who all have their backs to it. Hammershøj's painting, then, suggests a world from which God is not merely absent in the sense of 'not there', but a world from which God has departed, leaving only the sign of an empty cross.

There is little in the way of explicit religious imagery in the work of Edward Hopper, but the cultural and psychological force of his mature painting bears comparison with that of Hammershøj. 'House by the Railroad' (1925), 'Nighthawks' (1942) and 'Hotel Window' (1955) are only some of the paintings in which, having stripped away the Romanticism of his impressionist-influenced earlier work, Hopper has given us images of a world without consolation, a human world that has pitted itself against the vastness of the North American continent and installed 24-hour-a-day lighting to keep its ancient darkness at bay. This is not an overt assault on modern America, and Hopper offers nothing so simplistic as a bonfire of the vanities. It is almost the America of Norman Rockwell. But not quite.

Not without a backward glance to Hammershøj, let me quote Øystein Hjort on Hopper's figures. They are, he says,

> restless and rootless tourists in life. Seen from the outside the house contains possibilities for order, coherence and balance, but also a refuge. It is an address, a place to be ... But refuge from what? Almost without exception, Hopper's figures portray a failure to act, inactivity, purposelessness. Somewhere or other outside their windows life passes by, and there are powers out there they cannot control or live with. (Hjort 1992, p. 44)

But although there is a sense in which these characters do not see what is going on, they are not completely unaware of it. The

problem is that they are unable to bring what is missing into focus and consequently unable to make of it something that might transform their lives. They are living in a situation that exceeds their power of comprehension, and yet they know it. That is what is unsettling. The woman looking out of the hotel room, the man in 'Excursion into Philosophy' (1951), the usherette in 'New York Movie' (1939) may not be capable of articulating their situation, but the consciousness of a lack weighs heavy upon them. They are anxious, even if they cannot say about what. Hopper doesn't quite say either – perhaps because there is nothing to say. 'Anxiety and nothingness always correspond to one another', wrote Kierkegaard. But how could one depict nothingness? Perhaps by painting what there is to see in modern urban life – and nothing more.

My last example is also from North America: Andy Warhol.

Warhol's best known images are, of course, the prints of Campbell's soup tins and Marilyn Monroe. If Hopper shows us the darkness outside the window, the wild wood at the edge of town, the view beyond the city and all that the city means, Warhol never seems to leave mid-town Manhattan, the epicentre of the global advertising and pop culture that his work reflects and of which some have regarded him as a kind of high priest.

But that is only one side of the story. There is another. This is not just a matter of Warhol's personal religiosity. Rather, it is to do with the fact that, like Manet, Warhol was much obsessed by death. A substantial body of work testifies to this obsession: a multitude of car crash scenes ('Optical Car Crash', 'Green Disaster Ten Times', 'Ambulance Disaster', 'Five Deaths in Red', 'Five Deaths Twice on Orange and Green', 'Five Deaths Seventeen Times', 'Saturday Disaster' and 'White Burning Car'), 'Tunafish Disaster', and several series of prints of the electric chair ('Lavender', 'Red', 'Orange', 'Silver' and 'Blue' 'Disasters'). Such images – and the whole ethos of the 1960s New York scene asso-

ciated with Warhol and epitomized in the lyrics and life-style of the Velvet Underground – belong to the baroque-like return of the American repressed. This is no longer irony, but mute rage.

And there are also points at which the absolutely trivial and the absolutely shocking meet and are folded into one another in such a way that in the end product they have become indivisible. All one actually sees is the surface, but the absence is there, in the surface. The outstanding example of this is, I think, the 'Marilyn Diptych' of 1962. The images on the right (which are, interestingly, much more rarely reproduced than those on the left) are faded and smudged and in one case virtually obliterated. Perhaps we might just see that as part of Warhol's comment on the processes of mass reproduction. But perhaps it is also a reminder of the tragedy of Monroe's life, of the person obliterated by the image (see Daab 1996).

In all of this, I suggest, it is not just a matter of a generalized *memento mori* (remembrance of death) in the sense of remembering that each of us must die. It is rather the representation of a sense that life itself, the culture we inhabit, is governed, in a certain way, by death: that it has lost its link to the God who is life and who gives life.

All judgements about such ambiguous works as those we have been considering are, of course, *interpretative judgements* and not judgements of fact. Therefore they will always be open to revision. One might, for example, make a case for Damien Hirst, parallel to that I have made regarding Warhol, not least with reference to the notorious diamond-encrusted skull, 'For the Love of God', or his 'Last Supper', a series of thirteen posters in the form of advertisements for pharmaceutical products (supposedly pointing to the ambiguity of medicine and poison implicit also in the Christian Passion narrative). But many see mere cynicism in such works. Intimations of mortality – or a smart marketing move? The current balance of opinion seems to favour the latter and

41

I am inclined to agree, but it is always best to allow margins of uncertainty to such evaluations – something the critics who so roundly dismissed Manet's 'Dead Christ' clearly forgot.

I have been reflecting on the echoes of the death of God in modern art. But was the God who died on Calvary in fact the God of the Jewish–Christian Scriptures, the living God who is giver of life and God of the living? Or was the God who died there perhaps another God: the God of death, the God who demands sacrifice in order to sustain his necropolitan world domination? Such a God had already been unmasked and critiqued in many ways throughout the Hebrew tradition, from Abraham onwards, but the cross enacted and became a figure for its final exposure and, since it is a God that can 'live' only in concealment, a figure for its defeat. In its way, 'the death of God' theme in modern art can also be seen as contributing to drawing that God of death out of its residual hiding-places, at the edges or even on the surface of contemporary culture. In showing the absence of God in the worldly forms of modernity it shows that those gods our world still cherishes are, in fact, no-gods. And, if that is so, then even the apparent nihilism of such art can be a way of recalling our attention to what truly belongs to life and so to the God who first begins truly to live when death begins to be undone. The supposed nihilism of a work cannot, then, simply be read off its surface. What is called nihilism may prove to be iconoclasm. Context and reception must also be weighed, and the work's effects belong to the work, whatever the intention of the artist. And so the question that Christian theology asks of the work is simply this: does the death it reveals make us ever more powerless in the face of the God of death, or does it help us name that God for what it truly is and so open us to the possibility of the God who, out of the death on the cross, shines forth as the God of life, the God of the living and not of the dead?

Notes

1 When the talk on which this Chapter was based was given to a large audience at the Tate Gallery in 1997, virtually no one present had come across Hammershøj. Since then a television film on his work by Michael Palin and a major exhibition at the Royal Academy (2008) have done much to establish his reputation in Britain.

3

From Creation to Re-creation

Creativity is one of the great themes of modern art and, once more, we can read this either as a kind of secularizing of earlier theological ideas of creation or as a continuing trace of a fundamentally religious element in what at first seems like an entirely secular world – or we can read it as both, united in a single, complex and sometimes ambiguous reality. Just as the last chapter explored the interplay of theological and anti-theological meanings of the death of God in modern art, so here we shall look at similar patterns in the relationship between secular and religious ideas of creation and creativity.

Often the appeal to creativity involves invoking, reflecting or applying aspects of Christian beliefs about divine creativity – as when Coleridge spoke of imagination as an echo in the finite mind of the great 'I AM' or Jacques Maritain declared the artist to be 'an associate of God in the making of works of beauty' who does not merely imitate God's creation, 'but continues it' (Maritain 1933, p. 63). But already we sense something of the ambiguity of such claims in the way in which, for Coleridge as for other Romantics, the supreme exemplification of this creative capacity is the 'artist' or 'poet', in whom it is raised to the highest degree. Artists are not merely the producers of works worthy of admiration, but are in themselves a kind of blueprint for what we all can or could or perhaps even should be or become.

Although it has gained a wide currency, this is a view of the

nature of art and artistic activity that is relatively novel and relatively local. Up until the threshold of modernity, those persons we call 'artists' were largely to be regarded as artisans or craftsmen. As Larry Shiner has pointed out in this study *The Invention of Art: A Cultural History*, it is perhaps a nice irony that whereas the Greeks have been regarded from the Renaissance onwards as exemplifying the 'artistic genius of mankind', the Greeks themselves 'had no word for art' in our modern sense. As Shiner comments:

> What is strikingly absent in the ancient Greek view of the artisan/artist is our modern emphasis on imagination, originality, and autonomy. In a general way, imagination and autonomy were appreciated as part of the craftsmanship of commissioned production for a purpose, but not in their emphatic modern sense. Although the achievements of Greek naturalism in painting and sculpture of the fifth and fourth centuries B.C.E. were much admired, for the most part painters and sculptors were still viewed as manual workers, and Plutarch said that no talented young aristocrat upon seeing and admiring the famous Zeus of Phidias would want to *be* Phidias. (Shiner 2001, p. 23)

The Romantic cult of genius and the inflation of the value placed on artistic activity is therefore distinctively modern. As such we can see it as a particular instance of a more general modern emphasis on autonomy, a topic familiar in ethics, politics and many other spheres of life. And just as ethics has witnessed conflicts between the claims of divine law and human autonomy, so art has seen confrontations between autonomous artist-creators and God-the-creator. When it comes to such confrontations, the artist can then become the standard-bearer for a more general revolt on the part of the would-be Man-God, as when Nietzsche, having pronounced the death of God and called upon human

beings to a life of endless self-overcoming, also described this life as essentially artistic – a model he was as happy to apply to ethics and politics as to painting, writing and making music. The artist was the supreme self-inventor who, having become free of the guilt-consciousness instilled by Christianity's preachers of death, became the inventor of his own values, his own world, his own life.

This confrontation still reverberates in contemporary discussions of the relationship between art and religion, as evidenced by a recent collection of essays by the critic Peter Conrad, entitled *Creation: Artists, Gods and Origins.* According to the fly-leaf, Conrad 'describes the long illness and eventual demise of the Christian God, and shows how artists and scientists were ready and eager to take over a creative role that was once a heavenly prerogative' (Conrad 2007). The story Conrad tells is, broadly speaking, the story of art supplanting religion or (as was the case with Nietzsche) returning behind Christianity to the mythology of the ancient world. He begins this story with Mary Shelley's *Frankenstein* and appears to affirm the 'Promethean' implications of the story. It was, of course, Percy Shelley who declared poets to be 'the unacknowledged legislators of mankind', intended as a very deliberate counter to the view that human possibilities were prescribed by divine laws against which there was no appeal, and Conrad also quotes Hazlitt's comment on Shelley's poetic ambition to be 'the maker of his own poetry – out of nothing' (Conrad 2007, p. 13).

But if one is looking to the religious tradition for insights to illuminate creativity, is Genesis 1 the sole or even the best place to begin? Having in the last chapter looked at roots of the theme of the death of God in Christianity's own story of the death of Christ, I now want to suggest that here too the Passion narrative provides a powerful resource for rethinking what we might mean by creativity.

Conrad reproduces a well-known thirteenth-century illuminated picture of God creating the world (Conrad 2007, p. 28), in which 'God' is recognizable as Jesus, equipped with compasses that are poised to divide the sublunary sphere into its various constituent parts. This identification hinges on Jesus being 'the Word' that was in the beginning with God and by whom all things were made ('God said . . .' etc.). But the picture also reflects a distinctive theological approach to what Christians call 'the Old Testament', namely, that it is to be understood strictly and exclusively in its relation to the New Testament and, more particularly, in terms of its testimony to Christ. According to the complex system of types and anti-types developed from the early Christian centuries onwards, Christ was already the essential subject of each and every Old Testament text, whether this was the kingship of David, the crossing of the Red Sea, the drunkenness of Noah or the Creation itself. Now this could and did lead to what we might consider to be merely fantastical interpretations, and the vast majority of them have now been discontinued as material for doctrinal reflection and development (the drunkenness of Noah being a case in point). However, there is both practical and theoretical merit in the basic idea, even if we cannot return to the over-simplistic (and sometimes almost mechanical) one-to-one correlation of Old Testament texts and Christian doctrines that late classical and medieval commentators developed.

The chief aim of this older interpretative model (generally called 'typology') was to seek to understand the Old Testament text in the light of Christ's birth, death, resurrection and ascension. In the case of creation, this meant that what Christians knew of the redemption wrought in Christ provides a kind of interpretative key to the meaning of creation and not vice versa. Thus Paul could write of the experience of salvation that when anyone comes to be in Christ there is a new creation, and he described the process of redemption whereby God's children find

their glorious liberty as setting creation free from its bondage to decay so that it might become what it truly is, the 'good' creation that God made it to be 'in the beginning'.[1]

In Christian theology this means that the meaning of creation is not to be investigated by quasi- (or pseudo-) scientific or metaphysical speculations about origins, but is chiefly to be interpreted in the light of Christ and him crucified. This is the point at which the new creation is revealed, where 'what we shall be' is reflected in the face of Jesus Christ and, specifically, the Christ who lives in the memory of his suffering – as Christians pray in the Passiontide hymn 'turn thou thy face on me' (thus ritually identifying themselves with the penitent thief to whom, in Christian art, the face of the dying Christ is always turned as he speaks the eschatological words of promise: 'tonight you will be with me in paradise'). But if the Christian view of creation is localized in the event of the cross, this also allows for a certain re-thinking of what it means to say that creation is creation 'out of nothing'.

Common sense would say that the Passion narrative itself did not occur in a vacuum, since it clearly presupposes a world and a history within which, and within which alone, it makes sense. Precisely for this reason, the Church decided rather early on that its proclamation of salvation in Christ needed to be embedded in the specific context provided by the Old Testament Scriptures. The concrete historical content of the Christ event was meaningful only as reversing the Fall of Adam, only as the New Exodus, only as fulfilling the promise of a New Covenant. Alternative narrative frameworks such as Gnosticism and various speculations around Sibylline prophecies or mysterious verses in Virgil were for the most part rejected or marginalized. Instead, Israel, along with its history, its land, its cities and its countryside, even its Mediterranean agriculture – the vine, the olive and sheep-herding – entered into the very fabric of the Christian scheme of salvation. This scheme was never 'world-less' but always, from

the beginning, was as it was only as embedded in just this world and no other.

As Christianity moved into other cultural environments, that specific worldly heritage could prove problematic. Hegel would ask, rhetorically, 'Is Judaea, then, the Teuton's Fatherland?' (Hegel 1975, p. 149) and he himself would re-contextualize the Christ-event in the crisis of Greco-Roman civilization, letting the Old Testament preparation for the gospel more or less fall by the wayside. But however we depict or conceive it, the Christian message requires some kind of context, and therefore the 'new creation' in Christ cannot be 'out of nothing' in any literal cosmological sense. The new creation is not simply 'creation' but *new* creation or *re*-creation or a repetition. And yet it is also, in a sense, 'out of nothing'. How is this? The key to answering this question, I suggest, is to look at aspects of the Christian doctrine of the Fall.

Early Christian theology did not only look to the Old Testament to provide a world and a history in which to contextualize the Christ-event. It also turned to the prevailing philosophical movements of the ancient world to help interpret that world and that history. Especially, that meant Platonism and, as is especially clear in Augustine, it included a certain understanding of Being and nothingness. In its absolutely simplest outline, this meant a correlation to the point of identification between God and Being and a representation of creation as the communication of Being to all possible beings. However, apart from God Himself, all other beings were marked by some deficiency in being – having an admixture of non-being, we may say – and were thus unable simply to be themselves by themselves or to sustain their own being without depending on others. The greater the admixture of non-being, the less beings *are*, until the point is reached at which existence simply ceases and there is pure flux without limit, pure relativity, and nothing comes into or passes out of being. Consequently, while Augustine insists

that the fall came about through human freedom and was in a certain sense uncaused, he also suggests that there was a certain inevitability about it in that creatures are made 'out of nothing' and thereby have the possibility of falling away from God, back into the nothing, the non-existence out of which they were called into being. This thought is, of course, then taken up into what would be called the theory of evil as privation, that the nature of evil itself is not something positive but negative, namely, the lack of that measure of being that is appropriate to the kind of being it is. For human beings, the ultimate form of such non-being is, simply, death, and our existence in the world as a being-towards-death is transmitted from generation to generation by sexual reproduction.

Modern theology has abandoned much of the Augustinian account, and a case in point is the influential modern account of the Fall offered in Kierkegaard's pseudonymous work *The Concept of Anxiety.* This would become a key text of twentieth-century philosophy, when it was taken up into Heidegger's analysis of human existence in *Being and Time* and from there was incorporated also into Sartre's *Being and Nothingness.* In many respects *The Concept of Anxiety* is a profoundly anti-Augustinian text. This might seem surprising since Kierkegaard was by upbringing and theological education a Lutheran, and Lutheranism itself had been profoundly shaped in its origins by the Augustinian account of the Fall and, indeed, the darker versions of that account. 'Original sin' – or 'hereditary sin', as Luther's German and Kierkegaard's Danish have it – was an inescapable feature of human life, and freedom could only be regained by divine intervention from above. Yet Kierkegaard not only dismisses the mythical dimensions of the Fall story, making it clear that what he is concerned with is not the story of an event in prehistory but of what occurs in each human life, he also demolishes the core of the doctrine of hereditary sin, since he argues that the loss of freedom can only

ever be understood as a free act. Therefore, while a certain quant-
itative predisposition to sin might accumulate from generation
to generation, that quantitative accumulation can never neces-
sitate that you or I or our neighbour actually does 'fall'.

Yet at one point Kierkegaard reveals a trace of the Augustin-
ian inheritance, and this has to do with the relationship between
freedom and nothingness. Kierkegaard describes the situation of
the soul before the Fall as that of 'dreaming innocence'. Do not
be misled by the term 'soul': what is being described is a certain
stage of human psychological development, prior to the arising
of ego-consciousness and the corresponding consciousness of
a world upon which the ego acts. Beyond its own dream world
the future self has 'nothing'. But, Kierkegaard asks, 'what effect
does nothing have? It begets anxiety. This is the profound secret
of innocence, that it is at the same time anxiety. Dreamily, the
spirit projects its own actuality, but this actuality is nothing, and
innocence always sees this nothing outside itself' (Kierkegaard
1980, p. 41). In other words, every human life is – as Heidegger
would add to the Kierkegaardian account – 'thrown' towards a
future that does not yet exist, thrown towards possibilities it does
not yet understand and cannot yet realize. Its being human is
inseparable from its future possibility to choose and to become
who it will be – but this possibility does not yet exist and is there-
fore 'as nothing'. It can become what it is or is destined to be,
only by creating itself out of nothing. But here's the rub: noth-
ing 'begets anxiety'. Kierkegaard is far from attributing a causal
link between 'nothing' and the Fall, since it is always possible that
we do not swoon or succumb to vertigo in the face of nothing,
but really do 'become who we are'. Yet the sheer infinity of the
nothing and the pure openness of the possibilities towards which
life is thrown are unsettling. Human beings typically feel safer
with something than with nothing, and even if the 'something'
is a second-rate social identity offered at the bargain price of a

more or less conscious conformism it is, after all, something and it makes us some*one*.

This situation is heightened if we take into account that the world into which we are thrown is not a tabula rasa, that there is (as I have noted) a quantitative accumulation of 'sin', that is, a socially embodied history of human beings not becoming who we have it in us to become, a history – or histories – of, and a ready-made rationale for, not being otherwise than we are expected to be. We are raised in cultures that burden us with expectations of becoming warriors, social climbers, deceivers or just plain losers, and our models for what it is to be a good human being are vitiated and eroded by past failures of freedom. Kierkegaard argues that this situation cannot determine any given individual in an absolute sense; I *may* be otherwise, but it certainly makes the task more daunting as the nothingness that is our potential for freedom becomes a harbinger of our probable fall into some kind of inhumanity or other. In situations of trans-generational family dysfunctionality, communal conflict and war, nothingness becomes a weight under which human beings can scarcely move; the void opens beneath us at every footstep.

There might be many examples from one or other art that we could draw on to illustrate this, but the one that perhaps encapsulates the human, philosophical, and artistic issues is Neil Jordan's 1982 movie, *Angel*. *Angel* is in some respects a classic story of revenge. The film is set in Northern Ireland in the period of the troubles. The central character, Danny, known as 'the Stan Getz of South Armagh', is a sax player in a moderately successful band who, after a gig at a local dance hall, witnesses the murder of the band's manager by a gang of racketeers. One of the killers is wearing a surgical boot, and this later enables Danny to track the gang down. Taking a machine-gun from their safe-house he sets out to kill them, one by one. As the story progresses, the theme of nothingness comes more and more to the fore. When

Danny is leading George, one of the gang, away at gunpoint, George asks, 'Would you mind telling me who you are?' to which Danny replies, 'I'm nobody'. 'And that's nothing you've got stuck in my back', George replies – ironically but, in a way, entirely truly. Shortly after Danny has killed George, he is taken by the police to the morgue and confronted with the dead body of one of his victims. The senior detective, Bloom, asks him, 'What do you know, Danny?' 'Nothing.' 'I know nothing too. You've got to watch nothing. It can take hold of you. Be careful for those hands, Danny. You need them, don't you?' 'I'm a musician.' 'If music be the food of love . . . how does it go?' 'Play on.' 'You know, you can go places, Danny, where I couldn't. Do you understand me? It's a kind of poetic licence.'

There is much to comment on in this exchange, but one implication seems to be that the cycle of revenge really is born of 'nothing' because it is devoid of reason and purpose and is so far from adding anything to human reality that it merely tears away at it. Rooted as it is in 'nothing' the cycle of revenge can never entirely be settled by the objective methods of law and punishment. Only the artist, only the one with the poetic licence can find his way to the heart of darkness. But as the film shows, Danny (the artist) too needs redemption; he too is trapped in the nothing. One night, shortly after the encounter with Bloom, his girlfriend – aware that something is going on that Danny is not telling her about – turns away from him as he tries to kiss her. 'I can't', she says. 'Why not?' 'You have to tell me first.' 'It's nothing.' 'You're lying.' 'It's like a nothing you can feel. And it gets worse.' Indeed, it gets a lot worse, until, the cycle of killing having gone full circle, Danny finds an anguished redemption in the ruins of the burnt-out dance hall where it all began. Over the charred ruins, Danny's signature rendition of the 'Londonderry Air', raw and poignant, plays out the end credits.

The phenomena of the cycle of revenge perfectly epitomize

what Kierkegaard described as the 'quantitative accumulation' of sin: the development of a situation in relation to which the individual seems helpless, a 'wheel of fire' to which we are bound, a nothing we can feel, and into which all the things we could have been sink without trace. It is at the heart of the questions that all great tragedy proposes and, if we follow René Girard, at the base of all cultural practice and expression. Can we be redeemed from the burnt-out dance-halls that strew our collective and individual pasts? Can we find an art capable of relieving the monotony of violence, the binary mathematics of action and re-action, black and white, good and evil, and liberating us into a polychrome life-world of genuine richness and depth? Is it the case that 'nothing comes of nothing', as Lear angrily retorts, or can there be re-creation out of the nothing of history?

Which brings us back to the cross. The new creation to which Christian theology bears witness, the new creation brought about in and by 'Christ and him crucified', is not a new creation out of an absolute cosmic or metaphysical nothing. It is a new creation of a world and a history that has been degraded and diminished by suffering, violence and every possible manifestation of sin; it is precisely the transformation of the nothing that has eroded and eaten away at our world and our history and, as such, is also healing, restorative, regenerative, re-creational. It is the reversal of the quantitative accumulation of nothingness that has so long overwhelmed our individual and collective aspirations to something better.

This way of looking at it seems to me to address a problem with the high Romantic view of creativity modelled on Genesis 1 and which ascribes to the artists a kind of power that puts them on course for a direct confrontation with God. As an example of this high Romantic view in practice, Conrad cites the trailer Orson Welles made for *Citizen Kane*. This begins in darkness, until a disembodied voice calls for 'Light', whereupon a shaft of

light divides the darkness. 'Sound' – and a microphone swings into view, steadied by a hand that reaches out from the right of the picture and settles in a posture echoing that of God in Michelangelo's 'Creation of Adam'. Into the microphone a still hidden Welles narrates the trailer, 'an all-seeing autocrat who prefers to remain unseen, a creator who pervades his creation and yet is teasingly absent from it', as Conrad puts it (Conrad 2007, p. 14).

With or without Christian or religious presuppositions, such a model of artistic creativity seems to be prone to the charge of hubris. Such artist-creators are not only virtually super-human (as Nietzsche predicted) but also at risk of becoming in-human. This, for example, is the clear lesson of Thomas Mann's novel *Doktor Faustus*, which tells the life of the fictional Adrian Leverkühn, a German composer who abandons the ideals of humanism represented by the harmonic structures of classical music for the inorganic structures of musical modernism and thereby sinks, musically and humanly, to the level of the sub-human. For Mann this is also an allegory of the fate of Germany itself, abandoning the cultural ideals of the Goethean age – ideals that Schleiermacher, among others, represented – only to succumb to the barbarism of fascism. The artist-creator may find his exemplars and apologists in Leonardo and Michelangelo, in Shakespeare's Prospero, in the philosophy of Fichte, the poetic creed of a Shelley and the prophecies of the philosopher-poet Nietzsche, and he may seem almost to be realized in such extraordinarily genial figures as Welles himself or, perhaps most god-like of all twentieth-century artists, Picasso. Yet such figures and the kind of works associated with them actually represent only a small part of human beings' artistic creativity – and are they, in the event, what we most value? Is there not, after all, a certain inhumanity in Leonardo compared with his less masterful but ultimately more gracious contemporary Botticelli; and much

as we admire Michelangelo's titanic 'David', does it move us to the same depths as his own flawed and death-haunted 'Pietà'? Does Prospero offer more insight into the human condition than Shakespeare's own Poor Tom or our times' Primo Levi? Do Kierkegaard and Dostoevsky really know less than Nietzsche, merely because they refuse to dissociate themselves from the continuing afflictions in which human lives are entangled? Is mastery greater than healing, or power than suffering? Is it greater to save a life that has become habituated to self-destructive tendencies or to forget about such complications and invent a new world in which such awkward creatures do not exist? And there are other issues: Conrad himself, while broadly preferring artistic and mythological models of creativity to theological examples, contrasts the kind of poetic ideology espoused by Shelley with Mary Shelley's female insights into 'the messy organic business of engendering', a more complex and less absolute process.

There is, of course, much more to be said about each of these examples, for and against, but I offer them merely as indicative of how thinking about creativity in the light of the cross might engage ideas of creativity as they are seen in some characteristic figures of modern art. And note that, as opposed to notions of artistic creativity that take Genesis 1 as their prototype, there would seem to be no intrinsic conflict between divine and human in working to comfort, heal, restore and give hope to suffering human beings fallen or always on the edge of falling into nothingness. What matters here is not who gets the credit for creating 'in the beginning', but becoming committed to the grace and work of re-creation.

I have been suggesting that Christian theologizing about creativity would do better to be oriented by the Passion narrative than by Genesis 1. A primary reason for this is that the Genesis narrative enacts a rhetoric of power that allows for only one winner. Yet it could be argued that the problem with Genesis 1 is not simply

its valorization of absolute power, but the gesture of exclusiveness with which it is accompanied in theological discourse (note how often Christian theology has insisted on the distinctiveness of the Christian *ex nihilo* as a means of distinguishing Christianity from other religions). But doesn't my move from the generalized mono-theism of the creation myth to the specifically Christian theme of incarnation intensify Christian exclusivism? Isn't that what happened to twentieth-century theology when, following Karl Barth's attack on a certain version of abstract theism, it ended in a kind of dogmatism that cut Christian proclamation off from the human realities to which that proclamation was addressed and to which it sought to offer the transforming power of faith?

One, admittedly speculative, way past the challenge posed by such questions is found in the writings of the great Russian religious philosopher Nikolai Berdyaev. In his 1908 work *The Meaning of Creativity*, Berdyaev directly contests the view that the designation of God as 'Creator' obstructs human beings' discov-ery, exploration and practice of their own creative possibilities. On the contrary, precisely because God is Creator and human beings are made in the image and likeness of God, the creativ-ity of human beings must be a basic datum of Christian anthro-pology. Rather than the zero-sum game played out in debates between Nietzschean Romantics and Christian dogmatists, it is not the case that the more creativity and freedom there is on the one side, the less there must be on the other. Instead, the greater the creativity and freedom on one side, the more there will be on the other. The cycle of reciprocity is expansive, and each 'side' bears the interests of the other. In living creatively, I am assist-ing in the fulfilment of the divine will for creation: in affirm-ing the creativity of God, I am affirming the creative potential of humanity.

In a further step, Berdyaev suggests that our own human experiences of creativity and freedom therefore offer a genu-

ine analogy with what divine creativity itself means. With some help from the mystical tradition, especially Boehme and Eckhart, Berdyaev explains that divine creativity is not a simple matter of absolute 'Fiat!', but that God himself is engaged in a process of self-creation: that there is a kind of nothingness or abyss within the divine life, and that God 'becomes' Creator by self-creation out of this nothing. God is only 'Light' by transfiguring the darkness of his own pre-divine depths. Furthermore, this process of divine self-creation is not conceived by Berdyaev as something occurring temporally 'before' the world, but is understood as revealed within and through the interdependence of divine and human. In other words, it is precisely in and through the creative transformation of suffering and the creative contestation of the history of nothingness that is exemplified in the Passion narrative and encountered in innumerable instances of creative living, that God 'becomes' Creator.

Although possibly unaware of Berdyaev, a not dissimilar vision is encountered in the novels and spiritual writings of Nikos Kazantzakis (see Owens 2001). In his best-known work, *The Last Temptation of Christ*, we see just this inversion: that instead of a 'perfect' Christ arriving in the world to save it from itself, Christ becomes Christ through all the madness, physical suffering and human betrayal that he experiences. When Christ is also understood – as Kazantzakis understood him – as representing universal human possibilities, we may also say that through Christ human beings become 'Saviours of God', perhaps Kazantzakis' most provocative phrase but one that (despite his excommunication from the Orthodox Church) has a properly theological meaning. Again, we do not need to be forced into an either/or, but are at liberty to understand this in terms of an expansive reciprocal process, as divine creativity calls forth human creativity that calls forth divine creativity ... ad infinitum or, better, until we experience the breakthrough to the dimension of ultimacy, to the

eschatological reality that does not bring history to an end but makes history possible, to the re-creation of the image and likeness of God among striving, suffering, culpable human beings, to the end that is our beginning. In this perspective the question to be asked of art is not only 'Is it good?' but also 'Does it help?'

Notes

1 One of the problematic aspects of this Christocentric approach to Scripture was its association with tropes of anti-Semitism. In re-affirming a Christocentric approach, I am not doing so in order to legitimate an analogous Christian colonization of the Jewish Scriptures. Although Christian and Jewish communities both claim grounding in the Hebrew Scriptures, there is an important sense in which these are not, in fact, the 'same' text. Furthermore, the Jewish community has developed its own models of interpreting these texts that offer their own solutions to what many modern readers encounter as the 'scandalous' aspects of these ancient writings. For example, the Jewish tradition has been far more tolerant of divergent readings, allowing texts to bear multiple meanings in a manner not reducible to the Christocentric hierarchy of Christian allegorical interpretation.

4

George Frederick Watts and 'Hope'

If, as the previous chapter suggested, the task of the artist-creator is first and foremost to help humanity emerge from a chaotic nothingness into an ordered and richly manifold creation, how might he or she do so? Can the artist – who is also, after all, a member of the struggling, emergent human mass – presume to a knowledge of the road-map that would entitle him or her to take on the mantle of a prophet or a teacher of mankind? In the wake of Romanticism, many artists have thought so and, with Shelley, seen themselves as the 'unacknowledged legislators of mankind'. But whatever the more general – we might even say metaphysical – problems of such a view, it would seem to be doubly problematic in relation to painting. For how can painting *teach*? At least, how can it do so without losing or even betraying its character as painting and, more or less surreptitiously, turning itself into a kind of language? Only so, it would seem, could it ever really *tell* us something. One artist in whom this question is focused in an especially striking way is the great Victorian visionary, George Frederick Watts. Watts undoubtedly believed that the vocation of the artist was to help struggling humanity in its onwards and upwards journey towards the divine. However, the way in which Watts would figure the relationship between the human and the divine would not, in the end, be the way chosen by the major-

ity of modern artists. Yet precisely in the way in which he differs from the contemporary and subsequent European mainstream, Watts remains instructive – even if not instructive in the way that this most pedagogical of artists hoped. To consider how and why this is so, I shall focus here on what was probably the most successful of his many allegorical paintings, 'Hope' – a work that has recently received a certain amount of attention because of the inspiration it gave to the young Barack Obama. Nor is it coincidental that Obama first heard about the painting in a sermon by Jeremiah Wright since, since Watts's own time, 'Hope' has – as we shall see – inspired a sequence of theological commentators.

However, apart from the Watts Gallery at Compton, where many of the masterpieces are to be seen, Tate Britain – the largest single holder of Watts's work in Britain – continues to hide most of its large collection of his work away in a warehouse on an industrial estate at Acton.[1] The difficult fact is that it is hard for contemporary viewers to realize that Watts was one of the most lauded artists of his day. Had his 'House of Life' project for Euston station been realized, it would probably have proved an unsurpassed and abiding monument to public art. His New York exhibition in the 1880s attracted over half a million visitors – a tally which would be quite respectable even by the standards of today's 'blockbuster' exhibitions but was quite prodigious by the standards of its own time. He was the first painter to be offered a knighthood (which he twice refused), and was admitted to the Order of Merit shortly before his death. It is also fair to say that in many ways Watts was a genuinely *good* man who espoused the right causes: workers' education, the dissemination of art to the masses and, most poignantly, the project of a series of memorials to ordinary Londoners who died heroically in the service of others (in Postman's Park, the graveyard of the former St Botolph's in Aldersgate Street). Yet with the exception of his portraiture, his eclipse was rapid and almost total. In an extended essay (pub-

lished in 1904, the year of Watts's death), G. K. Chesterton spoke of him as having been an archetypical figure of the nineteenth century and thus, by the same token, strangely out of place in the newly emergent era of uncertainty and confusion. Chesterton singled out three aspects of Watts's 'Victorianism' for comment. First, he claimed, the Victorians manifested a paradoxical fusion of agnosticism and certainty, 'an attitude of devouring and concentrated interest in things which were by their own system impossible or unknowable' (Chesterton 1904, p. 8). In the place of the concreteness of the dogmatic kind of religious faith that the advance of science and free-thinking had made questionable, they 'fell in love with abstractions and became enamoured of great and desolate words' (Chesterton 1904, pp. 11–12). Even, perhaps especially, in their loss of faith they remained fiercely metaphysical. Second, they had 'the audacious faculty of mounting a pulpit' (Chesterton 1904, p. 13). Whereas the twentieth-century attitude is to be 'moral by ironies', Watts, like so many great Victorians, was fired by an immense didactic passion: he had a message for the world, of the importance and urgency of which he was absolutely certain. Last, they worked in the 'grand style', seeing the role of art in the context of national, cosmic and even religious issues and concerns. But already in 1904, Chesterton could write of this as an aesthetic atmosphere that has 'completely vanished from the world of art in which we now live' (Chesterton 1904, p. 23). If, in all these respects, Watts could already be regarded as a representative figure of the Victorian past in 1904, how much more must his artistic profile seem remote to those inhabiting the cultural climate of postmodernism?

To this question must be added a not dissimilar doubt with regard to Watts's religious stance. For although he was relatively restrained in his use of the traditional narrative sources of religious art on the grounds that he did not wish to constrain his message within the limits of any particular confession or creed

and thus avoided the kind of biographical sentimentality and bogus historicizing to which Holman Hunt so conspicuously succumbed, Watts's faith in the possibility of a universal religion, free from the trammels of historical and local conditionality is, by our criteria, unbelievably naive and, even, misconstrued.

But there are further problems for anyone attempting to reha-bilitate Watts as a 'modern master'. Chief among these (and we may, at this point, recall Chesterton's remarks about the didactic or preacherly character of Watts's art) is the problem of allegory. 'Hope' itself is just one of a sequence of paintings (others include: 'Faith', 'Love and Life', 'Love and Death', 'Love Triumphant' and 'Woman') of a distinctly allegorical stamp that not only invite but were intended to give the possibility of a literary 'reading'. Contemporary (or near contemporary) examples of such 'literary' interpretations of Watt's visual allegories abound: H. W. Shrews-bury, *The Visions of the Artist* (perhaps the worst), the Revd J. Burns, *Sermons in Art* and (with Watts's own seal of approval) P. T. Forsyth, *Religion in Recent Art* – this last comparing Watts both to Michelangelo and to Wagner (Forsyth 1905, p. 97).

'Hope' itself shows a single female figure sitting on top of a globe. Her head is bent low, apparently listening to (or listening for) the music of a lyre she holds in her left hand. The strings of the lyre are all broken, except for one, which she plucks with her right hand. She is blindfolded and her face is turned away from a single star, the sole source of light in the picture. The tonality of the paint is sombre and even depressive. The Revd J. Burns admits to his readers that some have even seen it as a figure of despair (Burns 1908, p. 6 – Chesterton says something simi-lar). Forsyth, theologically the most significant of the allegorical commentators, seems therefore right to warn us that the figure portrayed in the painting is not herself a representation of 'hope' 'but of that which hopes' (Forsyth 1905, p. 107). She is a personi-fication of the nineteenth century, an age that, by means of its

material and scientific progress, has surmounted the world – but whose bandaged eyes signify its essential scepticism, its inability to see a higher, more spiritual order of things. As Forsyth puts it, 'She *dare* not see . . . she has seen with her immense knowledge so much that is fatal to heart and hope, that she must deliberately bandage her eyes and refuse to look if she is to go on hoping at all' (Forsyth 1905, p. 110). Where, then, is the 'hope' that gives the picture its name? It is, Forsyth tells us, to be found in three details. First, in the single star, for 'though the poor soul sees it not, the painter sees it, and we see it' (Forsyth 1905, p. 108). Second, this strange scene is suffused with a light whose source lies outside the picture frame (and thus, allegorically, from outside the visible universe) that is interpreted as the light of a new dawn (Forsyth 1905, p. 109). Finally, there is a seed of hope in the music of the one remaining string of the broken lyre:

> The thirst to believe is still there. Look how the darkened soul stoops and strains for the one string's note, for the one voice to tell her a gospel that all her achievement has not yet attained, and all the round and mastered world cannot promise. The soul has in its own self and nature a note that Nature has not. (Forsyth 1905, p. 108)

A similar tone is struck by the Revd J. Burns. This time, Watts is compared with Cimabue and is said to have a 'commanding position in the art of today' (Burns 1908, p. 3). Again, the figure herself is seen as representing the age and the crisis of 'an age that has climbed to the mastery of the material world, but has lost faith in itself; that has won an empire and found it but folly and vexation of spirit . . . and whose eyes are bandaged so that she cannot see God and live' (Burns 1908, p. 7). The painting thus shows the true meaning of the age's 'attainment of earthly desire', its 'richer and material well-being', which, however, brings only 'disillusion-

ment and self-disdain' (Burns 1908, p. 7). 'The age has drained the cup of desire only to find that at the bottom there lie the dregs of despair' (Burns 1908, p. 8). But it is not only materialism that is condemned. Knowledge too is clouded and obscured. 'This, we take it, is what the artist means by the bandaged eyes . . . Notwithstanding all its immense advance, the age has lost its way; it sits athwart the world, but it cannot see beyond' (Burns 1908, p. 10). Where, then, is the hope?

> When we look at the picture, what is it that appeals to us most? It is, we venture to say, the fingers groping along the single string. All the others are snapped, but to listen to the low sweet music of the one that remaineth the head is bent. And we know that it is the music of the single string that will save. (Burns 1908, p. 15)

The preacher (remember that these are *sermons* in art) illustrates this point with a story about a prisoner saved from despair by the interest and sense of beauty aroused in him by a single flower growing in the prison yard, and concludes with another – in its time well-known – story about a young girl who was at the point of committing suicide when she was 'saved' by the sight of Watts's painting in a shop window. 'And is there,' he asks, 'a single life in all this dark country of the world that does not need it, or one that may not be blessed by it?' The message of the painting

> comes to the broken-hearted, to the sad fraternity of the suffering, to the prisoner in his lonely cell, to those whose loss of faith has emptied the world of its soul of loveliness, to all the bereaved, lonely, and crushed hearts of men, and it bids them Hope. (Burns 1908, p. 16)

To H. W. Shrewsbury, writing in 1918 (some years after Forsyth

and Burns and after Watts's reputation had already begun to fade), 'Hope' has a double message. First, it has a message for the individual:

> The globe of this earth is floating in space, and it has one solitary inhabitant, a woman whose attitude is expressive of the most intense sorrow. For there are times when the soul dwells absolutely alone in an unpeopled world . . . The world rolls on, and we feel that no heart can understand, no hand can help. (Shrewsbury 1918, p. 65)

Blinded by its grief the soul clutches a garlanded but broken lyre that 'tells a tale of past feasting and merriment. But the joys thus suggested are withered, dead, buried' (Shrewsbury 1918, p. 66). There remain, however, the one unbroken string and the solitary star to prevent us from interpreting the picture as a portrayal of inconsolable despair:

> And how can we miss the lesson of the picture? Surely it is this – that in our most desperate circumstances there is always something *within* our reach and something *beyond* us to base our hope upon; some one string at least that we can touch, some one star shining down upon us from afar. (Shrewsbury 1918, p. 67)

Shrewsbury then lists the various sorts and conditions of those who may benefit from the picture's message for the individual, ranging from the 'boy or girl discouraged by difficult tasks and uncongenial circumstances' to 'the aged sufferer drawing near to life's close'. But like Forsyth and Burns, he too sees in 'Hope' a message for society. His claims are more ambitious than those of previous interpreters, however, since he sees in the figure a representation not merely of the nineteenth century but of humanity

itself despairing of its own future in 'these dark years of terrible war . . . sore stricken, bowed down and blinded with sorrow'. And what does the single string mean in this situation? It is, he suggests, 'a race-consciousness of sin' (Shrewsbury 1918, p. 69).

This may seem an odd insight on which to base the renewal of hope but, Shrewsbury explains, the fact that 'the warring nations are waging war under a sense of the guilt of bloodshed' and the realization of the guilt of war encourages the belief that this will indeed be the war to end all wars (Shrewsbury 1918, p. 69). Yet even without the benefit of hindsight it is hard to see any connection between the world of Watts's art and the world of Ypres and the Somme. As another commentator wrote about Watts's 'warrior' paintings, his 'warriors are not clad in khaki; they do not crouch behind muddy earthworks. They are of the days before the shrapnel shell and Maxim gun; they wear bright steel armour, wield the sword and lance, and by preference they ride on horseback' (Hare 1910, pp. 72–3).

Shrewsbury's book is dedicated to the memory of a son ('one happy warrior') killed in the war, but even making allowances for the pathos of his personal tragedy it is hard not to feel that his interpretation moves beyond hope into the realms of wishful thinking. Yet perhaps the picture itself is at least partly responsible for encouraging such vacuous allegorizing at the very time when Cézanne and others were leading modern art ever further away from literature towards pure painting.

Chesterton was one commentator who realized that if Watts's work was to be of continuing relevance, it had to be seen and defended as *painting* and not as meaningful allegory. An allegorical representation of 'hope', he observes drily, would be equally served by 'a picture of a dancing flower-crowned figure in a rose-coloured robe' (Chesterton 1904, p. 94). Imagine, he suggests, an allegory of Commerce as a 'Greek lady with cornucopia' (Chesterton 1904, p. 104). But 'Can anyone say that by merely

looking at the Stock Exchange on a busy day we should think of a Greek lady with an argosy ... that Threadneedle Street ... would inspire our minds to move in the curves which centre in a cornucopia?' (Chesterton 1904, p. 107). Watts's painting of 'Mammon', however, works very differently: 'This is not a symbol of commerce: commerce is the symbol of this' (Chesterton 1904, p. 113). Watts's so-called 'allegories', Chesterton concludes, are not allegories at all, but direct, painterly representations of their subject. To return to 'Hope':

> This title is not (as those think who call it 'literary') the reality behind the symbol, but another symbol for the same thing, or to speak yet more strictly, another symbol describing another part or aspect of the same complex reality ... merely an approximate attempt to convey, by snatching up the tool of another craftsman, the direction attempted in the painter's own craft. (Chesterton 1904, pp. 101–2)

That is to say: the word 'hope' does one job, but 'a picture in blue and green paint' does another. Both are inadequate, 'but between them, like two angles in the calculation of a distance, they almost locate a mystery, a mystery that for hundreds of ages has been hunted by men and evaded them' (Chesterton 1904, p. 102).

If, despite an endorsement from Barack Obama, Watts's 'Hope' is ever to regain the kind of popularity and respect it had at the beginning of the twentieth century, it will depend on whether Chesterton's conviction that its power is more than allegorical is justified. If not, it can be for us no more than a curiosity, a relic or quaint byway of art history. In what direction, then, might such a non-allegorical interpretation lead? Or, to put the same question another way, how does 'Hope' affect us today *simply as a picture*: what do we see when we look at 'Hope' before we begin to read one or other allegorical interpretation into or out of it?

Let us look at the picture again. It is much darker than any of the reproductions (including the Tate's own current postcard) suggest. The blue-green of the sky surrounding the bowed figure and the brown of the globe on which she sits are heavy and featureless. The much-discussed star is scarcely visible. The figure herself is highly geometrical, with a queerly distorted elongation of the line running from her right shoulder-blade along her neck and head which makes her (like many of the female figures in Watts's allegorical works) strangely top-heavy. The lyre, the shape made by the head, neck and right arm, and the larger, enclosing shape of the body and legs are almost like three irregular quadrilateral shapes, awkwardly imposed on each other, and the overall effect is more an experiment in abstract shapes than the depiction of flowingly corporeal lines – a point, perhaps, to be exploited by those like Peter Fuller who see in Watts a proto-abstractionist (Fuller 1988a, p. 150). The picture feels motionless, almost transcendental in its stillness. This is not 'hope' in the sense of Ernst Bloch's spirit of utopia; it is no forward-thrusting, irrepressible life-force. This is more the hope – to take an example for a quite different art form – of the closing bars of Mahler's Ninth Symphony, an eerily serene surrender of this-worldly life in favour of another, intangible and inexpressible order of being.

A further (and not unconnected) feature of the painting is that the 'female' figure is decidedly asexual. This is, again, characteristic of Watts's allegorical figures – but it is also true of many of his portraits; compare, for example, the sad, child-like portraits of Ellen Terry (the actress, to whom he was, briefly, married) with Julia Cameron's photographs of her, and it becomes clear that the paintings express nothing of the vital, even sultry, sexuality that the photographic image still exudes. Only at one point in 'Hope' can we see anything like flesh – in the area of face framed by the bandage over the eyes, neck and chin. Now if we accept that *flesh* is precisely the stuff of art (see Pattison 1998, pp. 144–7),

what does the 'flesh' of this ethereal female figure reveal? One answer might be: not much. Why not? Because it is almost lost in the play of abstract forces in which it seems almost to drift. In fact, it is itself so undefined by muscle, bone and the pressures and contours of skin that it is scarcely like flesh at all. Our first impression seems to be confirmed: that this is flesh surrendering itself for – what, exactly? What exactly is Watts's 'Hope' saving us from? Perhaps from the embodied life that the term 'flesh' itself brings to the fore. In these terms, 'saved by hope' seems to offer little more than the possibility of freely surrendering to that final emptiness, to extinction, to that death for which the transcendental stillness and serenity of the picture as a whole is simply an elegant cipher. But isn't such a hope simply the Schopenhauerian hope of finally being able to slough off the agony of existence to which we are subjected by the will-to-life? And in a life-affirming age such as ours (and with apologies to Barack Obama), what sort of hope is that?

Think again of the analogy with Mahler's Ninth Symphony. It is curious that the musical expression of a similar mood (if my comparison is accepted) still elicits an immediate and positive reception in a way that Watts's painting does not. Is this perhaps because musical form is more suited to the aesthetic articulation of a purely abstract transcendence? Doesn't the very fleshiness of visual art tie it to a kind of sensuousness and at the same time render it incapable of attaining the purely formal beauty that music expresses so readily? There are, of course, big and controversial assumptions in these questions, but they may nonetheless help to make my point about 'Hope' clearer. It is this: that if Watts is to be freed from an incredible allegorical system of interpretation, then it is in the painterly (and thus fleshly) quality of his work that his 'message' (a word that we must, of course, now regard with deep suspicion) is to be found – but the very fleshiness of painting, the immediacy of seeing, sets up a significant

obstacle to the representation of the sort of transcendental values that have widely been regarded as the province of religion or spirituality. The question then broadens out from being a question about Watts to being a question about painting as such: can painting, a medium that, often literally, works with materials of earth, reveal things of heaven? And if so, how? Watts's strategic decision to subordinate painting's properly fleshly element to the exigencies of teaching 'sound, important truths' to mankind was mostly rejected by painters of the nineteenth and twentieth centuries who embraced the modernist agenda – although it might be argued that conceptual art has made a not dissimilar choice. To pursue such issues further, I now turn to a painter different in almost every respect from Watts, but who, at a certain point in the late twentieth century was, like Watts, hailed as the pre-eminent artist of spiritual reality revealed in visual form: Mark Rothko.

Notes

1 On Watts's relationship with the Tate Gallery, his extensive bequests to it and their subsequent fate, see Smith 2004.

5

After an End:
Unsaying Painting

Can Theology say anything about Rothko?

'... but what do you say about it?' – a remark overheard when going round 'The Late Series' exhibition held at the Tate Modern in 2008–9. Quite possibly a remark, or at least a sentiment, a question, repeated many times in the five months of the exhibition. What do you say about it? And what do you say when you speak not as an art historian or critic *or* Rothko specialist, but as a teacher of Christian theology?

Even allowing that there is anything to say about it at all (a question I'd like to leave open for now), is a Christian theologian not doubly debarred from being the one to say it? Why? In the first place because of being a Christian theologian, when, despite a reference to Kierkegaard (but, quite specifically, to Kierkegaard's Abraham), Rothko's religious allusions might be better understood against the background of either Judaism or the twentieth century's fascination with pre-Christian classical and archaic mythology. And then, in the second place, because of being a theologian, since theologians are notoriously and inveterately garrulous beings who talk far too much, mostly in a language that is far too arcane and over-complex, about what human beings can at best talk about only in fear and trembling,

72

and then in a faltering, broken and fragmentary way (meaning, of course, God). To their credit, I should add, the most thoughtful theologians have always understood this, and have spoken – though there's a paradox – of silence, unknowing and learned ignorance as integral to what they do.

Yet despite the reservations we may have about Christian theology saying anything about painting such as this, I think that there are also reasons why Christian theology might have an interest in at least trying to say something. In the first place, the Christian theologian is a human being before being a theologian, and has the same possibilities of a human response to Rothko's work as anyone else. And many theologians (though not all), like many others (though not all), find in their experience of Rothko's painting something that moves, draws and even shakes them, something that they sense has a certain proximity to what they have also experienced in their own religious lives. Being theologians, they then want to talk about it, to find words to make the connections between these different areas of experience and find out what's going on. Does this sense of proximity indicate a convergence between our experiences of art and our religious experience? Many – both from the side of the arts and from the side of religion – have wanted to deny that, insisting on a clear line being drawn between religion and the secular business of art. On the other hand, many – especially in the wake of Romanticism – have wanted to speak for convergence to the point of identity: art, some want to say, is our modern and postmodern way of living religiously or of practising spirituality. This, in turn, elicits a counter-response from those (also many) who sense that this is all too sloppy a drift not into religion but pseudo-religion, religion without content or challenge or perhaps even an alternative religion, 'the religion of art'. Even at the very human level of response, then, it does not take the theologian long to find that whether or not these paintings are themselves asking such questions, they do

provoke basic theological questions, questions of just what the experiential element in religion is, what makes a certain experience or a certain kind of response to experience, or a certain kind of understanding of experience, religious – and how that is to be evaluated in relation to the range of religious (and anti-religious) options facing someone living in this modern and postmodern world. All of this could be, and has been, said not only in relation to Rothko but also to the work of just about any artist or to any artefact (as, for example, in Martin Heidegger's meditation on the meaning of the ruined Greek temple in his essay, 'On the Origin of the Work of Art'). But Rothko's painting seems to raise these issues in an especially sharp way, and it does so precisely because it is so hard to say anything about it – which brings me to the second reason why Christian theologians might want to give more than usual attention to these paintings in particular. As I already mentioned, the task of Christian theology is of a kind that ineluctably and repeatedly brings those who undertake it up against the limits of the sayable. The Bible itself already testifies to the problems that will face those who take it upon themselves to speak of or for God, and from the early centuries to the present each theological generation has had to confront the question of its own limits, with such high-points as the ancient text known as *The Mystical Theology* of Saint Dionysius, the medieval mystical tradition, especially in Meister Eckhart, and some more popular texts such as the English *Cloud of Unknowing*, and the nineteenth century's preoccupation with the 'ineffable' quality of religious experience.

But the modern Christian theologian has a further reason for being drawn to the limits of the sayable. This has to do with the way in which modern culture itself has experienced a deep, wide-ranging and, some might say, shattering experience of the unsayable – and not only the unsayable but the unrepresentable. Since the beginnings of the Romantic Movement there has

been an incremental expansion of the sense that our words, our images and even our feelings are somehow incapable of engaging, reflecting or communicating reality. This phenomenon has its philosophical forms, from Kantian transcendentalism through to Derridean deconstruction, and it has its artistic or aesthetic forms, as manifested in the search for authenticity and originality in opposition to the constraints of academies and schools. But it is also wider than that. For our world itself has been growing. It has become older, vaster and almost infinitely more complex than even nineteenth-century human beings imagined it to be. Many of Darwin's most vigorous early opponents *were* geologists, who simply did not believe that the earth was old enough to allow for the time-scale projected by the upstart biologist. Nor is it so long since scientists confidently spoke of the 'atom' as the smallest unit of matter, whereas we now know that the atom contains within itself a seemingly infinite complexity whose 'secret' continues to elude those who research it – while, at the other end of the scale, the time and space of contemporary astrophysics seem utterly to beggar our human capacities for representation. If it was already possible for Pascal, writing in the mid-seventeenth century, to respond to the new scientific view of the universe by confessing that 'the silence of these infinite spaces terrifies me', are we not justified in being still more terrified?

But the inconceivability and unrepresentability of our new reality has not only to do with the expanding universe of scientific knowledge. It also has to do more directly with our common human experience. Where early nineteenth-century religion and early nineteenth-century humanism were both equally confident in their descriptions of the nature of human beings and in the values that they believed should be normative for human beings, the course of that century saw the unravelling of such confidence, not least under the impact of the thought of Friedrich Nietzsche, who saw human self-images and human values as essentially

fictions, masks with which to conceal and beautify the terrifying energy of the 'will to power' that each of us is – a vision to which Freud would give systematic and (he believed) scientific, form. All of which was, of course, only a prelude to the 'unmasking' of the real nature of the European Empires in the series of catastrophes that began in the summer of 1914, and that culminated in the unspeakable and unrepresentable events of Nazi criminality – what the French philosopher Vladimir Jankélévitch called the '*indicible*' – and the atom-bombing of two Japanese cities. Religion and humanism alike seemed powerless to offer anything like an adequate explanation for these events and for what they showed us about ourselves. 'If God does not exist, then everything is permitted', Dostoevsky had written, and in the wake of the catastrophe of the twentieth century, one is tempted to add that since it is clear that everything is permitted, then neither God nor any of the systems of values that human beings contrive for themselves really exist. And if that is so, what are we to say about ourselves, our world, our beliefs?

I have been saying quite a lot about the unsayable, but I have not yet said anything about Rothko. Nevertheless, I think it not coincidental that the period of Rothko's best-known work, which was also the period in which the defining responses to it were shaped, was in the two decades subsequent to World War Two. If we are to think about a theological response to Rothko, then it is appropriate to think about the religious situation of that period and, more specifically, how Christian theology related to it – a period, we may say, 'after an end'.

Waiting

Eliot's *Four Quartets* (1944) flagged a theme that would work powerfully on the imagination of the post-war period:

I said to my soul, be still, and wait without hope
For hope would be hope for the wrong thing; there is yet faith
But the faith and the love and the hope are all in the waiting.
Wait without thought, for you are not yet ready for thought:
So the darkness shall be the light, and the stillness the
 dancing.

<div align="right">(Eliot 1944, p. 28)</div>

I do not know whether Tillich knew the *Four Quartets* (though it is likely), but he too was taken by the figure of waiting, as we can read in his sermon 'Waiting'. There are several rather important things to mention about this sermon and its author before coming to what it actually says. The first is that it is from a collection, *The Shaking of the Foundations*, published in 1949 and going into many reprints on both sides of the Atlantic, that established itself as one of the most influential Christian writings of the 1950s and early 1960s. Since the theme of waiting itself is found in several other significant and influential religious texts of that time (perhaps the best-known of which is the title given to Simone Weil's *Waiting for God*), 'waiting' clearly addressed an important current of the contemporary world. The sermon also belongs to a particular moment in Tillich's own career. Like most of the sermons in *The Shaking of the Foundations*, it was given in the chapel of the Union Theological Seminary in New York, where Tillich was teaching – not very far from where Rothko was painting at the same time. Tillich himself was a refugee from Nazi Germany and a close associate of the Frankfurt School theorists who had also emigrated to New York, establishing the School for Social Research there. As an army padre in World War One and a left-wing activist in the interwar years, his thinking was deeply marked by the traumas of the historic events of those times. But also, and not least important for us, he was also a theologian extensively occupied with the religious meaning of art, since, he

believed, art offered both an exceptionally sensitive revelation of the spiritual state of society and, more fundamentally, was capable, under certain conditions, of providing something like a religious revelation. Although art is not mentioned in the sermon to which I now turn, there is no doubt that Tillich thought that what he was saying here would also find its correlate in the art of his time.

The sermon begins by noting that both Old and New Testaments emphasize the aspect of 'waiting' in human beings' relation to God. Tillich comments, 'The condition of man's relation to God is first of all one of not having, not seeing, not knowing, and not grasping. A religion in which that is forgotten, no matter how ecstatic or active or reasonable, replaces God by its own creation of an image of God' (Tillich 1949, pp. 149–50). Unfortunately, he continues, most Christians give the impression that they think they do possess God in one way or another. 'The prophets and apostles, however, did not possess God; they waited for Him.' Moreover, 'even in the most intimate communion among human beings, there is an element of not having and not knowing, and of waiting. Therefore, since God is infinitely hidden, free and incalculable, we must wait for Him in the most absolute and radical way. He is God for us just in so far as we do not possess Him . . . We have God through not having Him' (Tillich 1949, pp. 150–1). All this is said as characterizing the human God-relationship in general, in all times and in all places. But the sermon concludes with some comments about the contemporary age in particular. This, Tillich says, is very much an age marked in a special way by doubt and despair. This exposes us to the temptation to make a kind of 'boast' of not possessing God, a boast Tillich might have heard from Sartrean existentialism, then at the high-point of its influence, with its resounding declaration that atheism and metaphysical despair are the foundation of all future philosophy. 'The divine answer to such an attempt,' Tillich says, 'is utter emptiness.'

Waiting is not despair, but 'the acceptance of our not having'. So, he concludes, 'Our time is a time of waiting; waiting is its special destiny' – but then, he adds, 'every time is a time of waiting . . . Time itself is waiting, waiting not for another time, but for that which is eternal' (Tillich 1949, p. 152). Waiting is not despair, because waiting means looking for 'the eternal', for something, a 'ground of being' (to use another Tillichian formulation) that is incommensurable with time, that cannot ever be fully expressed in any historical form or cultural product or in any word or in any image. Yet when we accept our 'not having', our 'not possessing', when we just wait – then we may have the possibility of experiencing the power of that Being, filling our emptiness and opening a way into a future of hope.

As an aside – and illustrating from another angle the 'timeliness' of Tillich's approach – we find a similar thought in Thomas Merton's talks for monks published as *Contemplative Prayer*. Despite the confessional differences, Merton too drew on many of the writers of contemporary existentialist thought and literature and in the 1950s and 1960s had an impact on Catholics in America not dissimilar to that of Tillich in the Protestant world:

> the true contemplative is not the one who prepares his mind for a particular message that he wants or expects to hear, but who remains empty because he knows that he can never expect or anticipate the word that will transform his darkness into light. He does not even anticipate a special kind of transformation. He does not demand light instead of darkness. He waits on the Word of God in silence, and when he is 'answered,' it is not so much by a word that bursts into his silence. It is by his silence itself suddenly, inexplicably revealing itself to him as a word of great power, full of the voice of God. (Merton 1973, pp. 112–3)

Is, this, then the religious context in which to begin making sense of Rothko's paintings as religious or spiritual? Are these large, brooding, uneventful canvasses a visual correlate of pure waiting, 'without thought', a gathering darkness that is not so much looking for light as for something – perhaps 'eternal' – beyond the duality of darkness and light, something that could just as well be expressed in darkness as in light? Painting – not as communication of a determinate content, a message, but as expression of a state, a mood, a way of being (or even of not-being)?

Painting and Spirituality

Leaving these questions hanging, I should like to turn to another aspect of the question of 'saying' something about painting, and the particular difficulty of saying something about Rothko. This also connects with what it might mean to call a work of art, in this case a painting or series of paintings by Rothko, 'spiritual'.

'Spirit' is a basic word in the modern vocabulary, but it is a word with deep roots in the biblical tradition. It was the Spirit that breathed on the waters in the beginning of Creation, signifying the power of God, the energy that synthesized the cosmic chaos of primeval matter into an ordered world (incredible power therefore), but also the Spirit that inspired the prophets, driving them into ecstatic frenzies and, later, the soft, gentle spirit that came in the form of a dove, the spirit of love, the Spirit that came upon the Virgin in the sanctuary of her walled garden. It would also become a – arguably the – key term in the philosophy of Hegel, a philosophy that shaped, and continues in its subterranean way to shape, subsequent discussions of the relations between art, religion, society and philosophy. For Hegel, art, religion and philosophy are the three pre-eminent forms of 'spirit'. But what is spirit?

Hegel's conception of spirit, it has to be said, is rather different from our contemporary idea of 'spirituality' and, in many ways, Hegelian spirit is diametrically opposed to what is sought in New Age 'spirituality'. According to Hegel, 'spirit' means reason that is conscious of its own power of intellectual and imaginative production and that is capable of expressing that consciousness in appropriate images and words. And as he saw it, spirit has three main forms: art, religion and philosophy. Of these, art and religion expressed the interests of spirit in forms that were still, as he would put it, 'encumbered' with sensuousness, as images, mythology or 'picture-thinking'. Philosophy, on the other hand, was capable of thinking the true content of human spiritual activity in the absolutely precise language of systematic logic. Leaving philosophy to its 'pure thoughts', let us focus on what Hegel has to say about art. Here he depicts a hierarchical system of art and forms of art, which is determined by the balance, within a particular form or style, of the polarities of sensuousness and Spirit. On this basis, the hierarchy of the fine arts runs progressively from architecture, through sculpture, painting and music to poetry, drama and other literary arts, before art transcends itself and, in nineteenth-century realism, enters into the prose of everyday life.

We note two things. First, painting is ranked 'lower' than any of the arts of language, and it is integral to Hegel's view of painting that painting does not speak. Yet, second, painting is also ranked higher than sculpture. Why? Because, Hegel thinks, its task is to depict the divine with regard to its subjectivity and inner meaning. In accordance with this task the two-dimensionality of painting is itself significant, since it calls for the interpretative activity of human consciousness in a way that sculpture does not. The sculpture is a real object in three-dimensional space, but the painting is not what it represents. It may show a landscape, a city, a battle or a mother and child in the stable – but it does so in the confines of a surface that may be but a few inches square. To see

this flat surface as a landscape or a battle, we the viewers have actively to imagine what we are seeing, even if we mostly do so in an entirely spontaneous and unreflective way. We have to imaginatively live ourselves into it, if we are to see what it is 'saying'.

Hegel does not quote Shakespeare's Prologue to *Henry V*, but it would have been to his purpose to have done so:

Suppose within the girdle of these walls
Are now confined two mighty monarchies,
Whose high upreared and abutting fronts
The perilous narrow ocean parts asunder:
Piece out our imperfections with your thoughts;
Into a thousand parts divide one man,
And make imaginary puissance;
Think when we talk of horses, that you see them
Printing their proud hoofs i' the receiving earth;
For 'tis your thoughts that now must deck our kings,
Carry them here and there; jumping o'er times,
Turning the accomplishment of many years
Into an hour-glass . . .

To see the painting as what it represents, we have not merely to be passive recipients: we have, in a way, to be co-creators and use our 'imaginary forces' (as Shakespeare calls them) to 'piece out' and give life to kings, madonnas, mountains and oceans. And it is this mental activity, even if it does not yet find expression in language that, for Hegel, marks painting out as spiritually superior to sculpture. The 'event' of painting does not happen 'out there', in physical space, but 'in here', in mental space. As he puts it in the introduction to his lectures on aesthetics, a drawing of a landscape has more value than the landscape itself because of the spiritual activity invested in it, because it is the creative product of a thinking mind (Hegel 1993, pp. 33–4).

Painting does not speak, but we can perhaps begin to see how, on a Hegelian view, the kind of painting produced by Rothko might qualify as 'spiritual' in a way that more directly representational painting would not. That is because, in a consistent and unyielding way, Rothko confronts us with the question: 'But what do you say about it?' The painting 'tells' us nothing: the burden of deciding how to see it is thrown back on us, the viewers – as Rothko explicitly says when he comments that he is equally open to his work being seen in a sacred or in a secular way. With regard to 'what' it means, the painting does not offer any determinate content or specific message. Instead, it opens up a field of pure possibilities, a 'potential space' that invites the co-creativity of the viewer. Thus, Rothko's own comments about the physical relationship between viewer and painting: the 'space' of the painting and the 'space' of the viewer are to blend into a common space, and it is in and out of this common space that the work of creation is to occur – but in the first instance, as waiting: not as waiting for a revelation of the meaning 'in' the painting, but as a waiting that is an opening to all that the painting potentially 'is'.

Let me go back a step. Painting, according to Hegel, does not speak. Yet there is a sense in which much painting, including the realist painting of which Hegel himself was especially fond, does speak. It tells us what it is. In medieval art it often does this literally, in that the saint depicted in the painting is explicitly named, in writing, or is accompanied by a biblical text that explains his or her significance or role in salvation history. But even when such conventions have been left behind, there is a sense in which a painting of a naval battle, a domestic interior or a bowl of fruit still 'tells us' what it is. Of course, we all know that '*ceci n'est pas une pipe*', and that the painting and what the painting represents are two different things, but it is perhaps no mere convention that paintings are still today displayed with a title, telling the viewer 'what' it is.

And the same is true of painting that attempts to show things unseen, mystical and heavenly truths or sublime ideas that do not have, as you or I or Dutch houses or Italian landscapes have, a bodily presence in the world. As we have seen, G. F. Watts was one painter who was very much concerned to tell us things, eager to instruct us in the mysteries of life, love, time, faith, progress and death that provide the subject matter for so many of his canvases.

In a review of the 1987 Tate Gallery Rothko Exhibition, Peter Fuller attempted to draw a comparison between Watts and Rothko, commenting that, 'Like Rothko, Watts wished to give expression to the great universal truths which lay behind the pagan and Christian myths.' And, he adds, 'like Rothko, he became increasingly uncomfortable with specific representations as the means to the realization of such truths' (Fuller 1987, p. 547). The work in which he sees this approximation as most fully realized is one of Watts's last paintings, 'The Sower of the Systems'. Mary Watts, the artist's widow, wrote in her hagiographical *Annals of the Artist's Life* that this painting 'was an attempt made to paint an unpaintable subject. In a scheme of deepening blue colour, the vision is of a figure impelled rapidly forward, while stars, suns, and planets fly from hands that scatter them as seeds are scattered.' She continues with Watts's own comments on his search for transcendent meaning in painting, suggesting that they might apply more to this picture than to any other: 'My attempts at giving utterance and form to my ideas, are like the child's design, who, being asked by his little sister to draw God, made a great number of circular scribbles, and putting his paper on a soft surface, struck his pencil through the centre, making a great void. This was utterly absurd as a picture, but there was a greater idea in it than Michael Angelo's old man with a long beard' (Watts 1912, p. 302). Quoting G. K. Chesterton, Fuller suggests that, far from being mere allegory, 'Watts's technique "does almost startlingly correspond to the structure of his spiritual sense"', and

he sees 'The Sower of the Systems' as a work that goes 'beyond the brink of abstraction' (Fuller 1987, p. 547).

I remain sceptical, and it seems to me that even here, Watts remains the great Victorian, eager to tell us the 'sound, important truths' he believes we need to hear. Far from taking us into the potential space, the space of empty waiting beyond all myths and doctrines, Watts's technique is closer to that of those in the twentieth century who would use large-scale public art for the propagation of new mythologies rather than to those, like (I think) Rothko, who leave us to work out our own meanings for ourselves.

Let me recall what I said in the previous chapter about Watts's 'Hope': 'This is not "hope" in the sense of Ernst Bloch's spirit of utopia; it is no forward-thrusting, irrepressible life-force. This is more the hope ... of the closing bars of Mahler's Ninth Symphony, an eerily serene surrender of this-worldly life in favour of another, intangible and inexpressible order of being' – which is by no means self-evidently the Christian heaven. In fact, if we look at it simply as a painting and not as an allegory, its mood might indeed be analogous to what we experience in looking at some of Rothko's late work; for example, a painting from the series 'Brown on Gray'. Yet the difference is, after all, that the one is symbolic and representational, and is called 'Hope', while the other is without shape or form, entirely open to the movement of the viewer's creative spirit across its abyssal surface. And if we are prepared to think in Hegelian terms, it is precisely for this reason that the epithet 'spiritual' might be better applied to Rothko than to Watts. Unlike the work of the great Victorian allegorist, it tells us nothing, but in telling us nothing it invites us to think about what we might have to say about it. That is, it invites us to spiritual activity. But to repeat, in the first instance this spiritual activity will take the form of waiting, of not having, and not hoping: waiting without thought, in utter emptiness.

'Without thought?' 'In utter emptiness?' But how do these injunctions square with the suggestion that the spiritual value of these paintings (and, if we follow Hegel, of all painting) is precisely to stimulate our creative and interpretative activity?

The answer to that is, I think, twofold.

First, we have already noted that the work of the imagination in mentally creating the picture that we see when we look at a painting is, on Hegel's own account, entirely spontaneous: we look and we see the fruit, the mother and child, the battle, without consciously thinking about it. Even before 'thought' happens, in the sense of thinking specific, definite thoughts, we are in a relation to what we experience and what we see that is not a mere blank: there is always a certain attentiveness, a certain intentionality, as modern philosophy puts it, that may reach far beyond what, in any given moment, we are capable of articulating. The thought may be sown in us or, as we look, may be being sown in us, but we are not yet thinking it. And we may never find the words to think the thoughts that most move us. But second, and following on from this first point, waiting 'without thought' and in 'utter emptiness' is an event, an activity that stretches out beyond the simple spontaneity of 'I see it!' Waiting is holding ourselves open for what is to come and holding ourselves back from imagining that we have seen it or that we have grasped it or that we possess it already. As such, even waiting, 'without thought' and in 'utter emptiness', is undoubtedly a form of intentional activity. Even if the one waiting cannot say of himself who he is or what he is waiting for, there is nevertheless a waiting going on, a concrete and particular event within the time–space continuum, a vortex in the flow of time in which time flows back on itself, circles round and disappears into itself. Waiting is not nothing. The possibility of waiting, even in an utterly relativistic universe, gives a certain coherence and continuity to the self, awakens us to possibilities of what we might become, and is, in this sense, a necessary

first movement towards becoming spirit, which, as Kierkegaard once said, is a matter of becoming 'older than the moment', rising above the flux of time and becoming a definite someone, a someone who does not alter when he alteration finds.

Rothko says nothing, but in the way in which his work challenges us to say something, or to think of what we might say, it invites us to enter on a journey that we are entirely free to experience as a spiritual journey, but, as he says, a journey we are also free to construct in secular terms – though that too would, in Hegel's sense, be in its way 'spiritual'.

I have emphasized the context of Rothko's work as that of an age that, in a very particular way, was an age of waiting, an age after an end, and an age in which, in the disillusionment following the failure of the great ideologies of the twentieth century (including some of the ideologies of artistic modernism), no new or obvious beginning had emerged. Since then, many new beginnings have emerged in culture, politics and religion. But it can scarcely be said that any of them have as yet sunk deep roots in our collective psyche. If we do know for sure that we are now entering an era of Asian rather than European dominance in the international order, there seems little clear view as to what this might mean with regard to art and religion. But is it so impossible to say anything at all about what we might be waiting for? Are there not, after all, certain universal human aspirations regarding the demand for justice, respect for persons and access to the means of life that need to be expressed, that are proper objects not just of waiting but of hope?

I connected the theme of waiting with the cultural crisis associated with the traumas of the early to mid-twentieth century; but where Rothko seems to have come closer than anyone to painting the 'utter emptiness' of that time, wasn't there – isn't there – also a value in the work of artists such as Joseph Beuys and Anselm Kiefer that makes quite explicit connections with those

traumas yet also works through to concrete expressions of hope, but without becoming allegorical in the manner of Watts? Are we really capable, for long, of pure waiting? And if we are not, do we not need to be helped to find forms that can feed and nourish us while we wait, so that even abstraction needs from time to time to sink its roots into history, time and nature if it is not to run dry? This, I think, is what we find in the American abstractionist Robert Natkin, the contemporary Danish painter Per Kirkeby or Antonio Tapiès's distinctive way of drawing the materiality of the world into the painterly work.

Fuller concluded his review of the 1987 exhibition with reflections on the fact that Watts, so highly rated in his own time (Roger Fry compared him to Rubens and Titian), fell from critical favour almost immediately after his death in 1904 and is scarcely even a household name any more. And he seems to foresee a similar fate awaiting Rothko. 'On leaving this exhibition,' he wrote, 'I became convinced that the claims currently made on his behalf may one day, quite soon, come to seem almost fanciful. Perhaps in the early twenty-first century, we will look back on Rothko's funereal tablets, and see only an attempt to "paint the unpaintable" [the phrase, recall, is that of Watts], a primeval vagueness, passing through time into oblivion . . . nothing but motherhood, and the dead' (Fuller 1987, p. 547). [1] We are now in the early twenty-first century, so is it true that all we see when we look at Rothko is 'a primeval vagueness, passing through time into oblivion'?

As my previous comments suggest, I do not think Rothko is 'enough'. But whoever said that he was, or that we should think this kind of abstraction alone was all that art could or should be producing? Equally, I am unpersuaded by Fuller's scepticism, and for three reasons. First, Rothko, unlike Watts, did not try to paint the unpaintable. He painted the unsayable, but the unsayable, in at least one of its forms, is also eminently paintable. Second, because he painted the unsayable, Rothko invites us into a space

of waiting that is rich potential space for experiments in spiritual living, experiments in which, as we wait and as we struggle to say just what it is that is going on in our encounter with these works, we learn something about what would be required of us if we were to live with the depths of responsibility and self-commitment that would justify the use of the term 'spiritual'. And third, there is, after all, the encounter with the works themselves. Something still happens when we stand in front of or in the midst of them and, as with all great art, that 'something' (even if in this case we can scarcely put it into words) is quite unique to just these works.

None of this means that Rothko's 'unsayable' is the same as the 'unsayable' mystery of God with which Christian theology is concerned. But, equally, our struggle to say something about Rothko's unsayable paintings may lead us also to reflect on the unsayable depths of the human spirit in which 'deep cries to deep' and our waiting undergoes a shift in which it is no longer a waiting for this or that change in the cultural or social order but a waiting for God, the infinitely and utterly unsayable God, in whom and from whom and to whom all saying originates, proceeds and ends – why not? But if it is true that the religious attitude of the 1950s and early 1960s can be described as a time of waiting, who is to say that we have now got what they were waiting for? Maybe we too are still waiting or maybe, even, not waiting, not yet waiting, since – perhaps – maybe we have forgotten what we might be waiting for and, if we don't know what we're waiting for, how can we be waiting? Who's to say?

Notes

1 The reference to 'motherhood' relates to Fuller's idea that the 'potential space' of abstract art echoes that of the mother–child relationship, as developed in the psychological theories of D. W. Winnicott.

6

Joseph Beuys: A Leaf from the Book of Jeremiah

In considering Rothko's painting of the unsayable, we have seen how both the production and the reception of art are inextricably associated with particular historical moments. For Rothko this was the crisis of human values that resulted from the traumas of the twentieth-century experience, above all the *indicible* event of the Shoah. This was also – only in this case, quite explicitly – a decisive context for the work of Joseph Beuys. Beuys (born in 1921) had, in a sense, seen this event from the other side, having been a *Luftwaffe* pilot, but in his post-war career as an artist he became an inspiration for the 1960s student movement that sought to challenge all the residual authoritarian structures of German society that, as they saw it, were complicit in Nazism. 'We are the revolution,' one of his slogans declared, and much of his persona was developed around lectures that involved quasi-economic, quasi-political slogans attacking capitalism and the industrial world, with dashes of Rudolf Steiner thrown in for good measure. These also established him as one of the inaugurators of the contemporary green movement in Germany. He was a charismatic teacher, although he was dismissed from his post at the Düsseldorf Akademie for admitting all students to the course without discrimination.

Beuys, it has to be said, is an artist – he himself claimed

'everybody is an artist' – who certainly does not fit many people's preconception of what an artist should be. Many of his works are not 'works' at all, but the leftovers or photographic records of one or other of his 'actions'. These included caking himself in honey and whispering to a dead hare; being collected in an ambulance from Kennedy airport to spend several days in a cage with a coyote; running through a peat bog in Ireland and at one point disappearing beneath the surface of the water only to end spread-eagled in a cross-shape on a large rock. In Italy he demonstrated to Italians how to plant olive trees and in Kassel he set out to plant 7,000 oaks. Many of Beuys's works involve felt and fat, sometimes with pieces of rusting electrical apparatus, materials that, in his private mythology, recall the occasion when, after having been shot down, he was kept alive by Crimean Tartars by being wrapped in felt and animal fat.

Radical artists of various kinds are often given (and sometimes crave) the description 'prophetic'. Beuys was, I think, 'prophetic' in a very specific and entirely biblical sense, at least as far as the form of his communicative practice was concerned. However, to find an angle from which to begin making sense of Beuys's work in a theological context, I am not going to start with the Bible itself but with the Pitt-Rivers Museum in Oxford, described in its publicity as a museum of ethnography. Yet the museum is arranged on anything but scientific lines, with glass cabinets containing the most diverse materials juxtaposed in bizarre combinations: next to a display entitled 'treatment of enemies', largely made up of shrunken heads and pierced skulls, one might find a cabinet of musical instruments or depictions of gods in human form; Egyptian mummies rub shoulders, so to speak, with Hawaiian chiefs' robes and Eskimo shamans. Beneath many of the display cases are drawers crammed with amulets, charms and idols, in paper and plastic wrappings. Confronted with this kind of material, mostly presented with minimal context or explanation, I

experience a strange kind of fascination and bewilderment. I sense that what I am seeing is the residue of a humanly import-ant event, belief or practice – the beliefs, lives, happiness and despair of living human beings have perhaps hung upon these items; I recognize the ingenuity and, sometimes, great skill with which the work was produced, but I have no context with which to make sense of it, I don't know *why* it should have been impor-tant. The shaman's cloak retains its aura, but not knowing how or why it was once a part of a living cult, I just don't know what to make of it. I am left with a question I don't even quite know how to pose. And I'm not convinced that, if I became an ethno-grapher and got to know all there is to know about this particular shamanic world, my puzzlement or mystification would be dis-solved. Somehow the object has set a more fundamental 'Why?' in motion.

Similar feelings are likely to be evoked by an encounter with work by Beuys. Clearly, the context of his work is closer to us than that of Siberian shamans, and he himself commented on it in ways that enable us to link it with theoretical and interpretative perspectives that are still current. Yet, somehow, there is a lack of connection; these are leftovers (in the case of 'Sweepings-Up', literally the leftovers, the rubbish, he swept up from the street after a political demonstration) that cannot be fitted into any given frame of interpretation: they are too awkward, clumsy, broken or just odd to make sense of. But like the shrunken heads, amu-lets and shaman's cloaks in the museum, I am puzzled, mystified and, thus, engaged, drawn in, or at least towards, the lost world of lived action of which they are the residue. And that lost world brings me to the edge of questions and challenges that might be described as metaphysical, existential or religious – which, in turn, brings us to the biblical prophets.

Like the idea of the artist-as-creator, the idea of artist-as-prophet has been popular among artists and art-writers since

the era of Romanticism, and artists and critics alike tend to use the term 'prophetic' as a resounding endorsement. But what does prophecy really mean? And what was prophecy in its biblical context (remembering that prophecy itself is often seen as a very distinctive feature of specifically biblical religiosity)?

In the biblical context we mostly think of prophecy as verbal or literary. The prophet was a man of words, the writer, or the subject, of prophetic *books*. Often, indeed, he was a kind of poet, speaking oracles, riddles, dreams and visions in poetic form – poetry so strong that it often still speaks to us through long traditions of translation. But not all biblical prophecy is exclusively verbal, and the prophetic books also testify to other forms of prophetic communication. My favourite example is what I think of as 'the pants of Jeremiah' (on the basis of an older translation in which what is now, probably correctly, referred to as a loincloth is designated as 'linen shorts').

Thus said the LORD to me, 'Go and buy yourself a linen loincloth, and put it on your loins, but do not dip it in water.' So I bought a loincloth according to the word of the LORD, and put it on my loins. And the word of the LORD came to me a second time, saying, 'Take the loincloth that you bought and are wearing, and go now to the Euphrates, and hide it there in a cleft of the rock.' So I went and hid it by the Euphrates, as the LORD commanded me. And after many days the LORD said to me, 'Go now to the Euphrates, and take from there the loincloth that I commanded you to hide there.' Then I went to the Euphrates, and dug, and I took the loincloth from the place where I had hidden it. But now the loincloth was ruined, it was good for nothing. Then the word of the LORD came to me: 'Thus says the LORD: Just so I will ruin the pride of Judah and the great pride of Jerusalem. This evil people, who refuse to hear my words, who stubbornly follow their own will and have gone after other

gods to serve them and worship them, shall be like this loin-cloth, which is good for nothing.' (Jer. 13.1–11 NRSV)[1]

If we think of the whole action of this sequence – the buying, wearing, burying and retrieval of the loincloth – as a single Beuys-ian 'action', we will not, I think, be far wrong; nor, conversely, will we be mistaken if we think of the Beuysian work in terms of the ruined loincloth, the residue of an action that has meaning, not in itself, but only by provoking us to think about the whole.

Jeremiah has become a byword for a prophet of doom (and this particular prophetic action shows why, as do such 'actions' as wandering around with a yoke on his neck to show that the peo-ple would fall under the yoke of Babylon), but he also performed actions of prophetic hope, as when, at the time of the impending fall of Jerusalem, he bought a field as a sign, an action, publicly handing over the deeds to a lawyer with instructions to put them in an earthenware jar for preservation. This was intended to show that there would be a future in which crops would be sown and harvested and the people would return to the land (Jer. 32). That kind of hope too bears significant analogy with the overall thrust of Beuys's actions – think of '7,000 Oaks'.

Of course, the prophets did have their own very specific set of concerns, mostly about the destiny of Israel and its relation to God. That is not our question, or not in the same way. To see Beuys religiously in terms of shamanic prophecy is, therefore, only to have indicated why he interests us in what are still fairly abstract terms. Again we have to come back to his specific cultural and political context.

This context goes back, perhaps, to the 1790s, the seed years of Romanticism and the time of the cultural and political upheaval inaugurated by the French Revolution. All that was once thought solid was melting into air. But the progress of that revolution soon led many of its admirers to the view that the solution to

superstition, injustice and hierarchical power relations could not lie in reason alone, since reason alone seemed to lead straight to the Terror. The problem of being human was not just a problem of knowledge or social organization. Something more was needed.

The thinker, essayist, poet and dramatist Friedrich Schiller would define the problem in an epochal way in his *On the Aesthetic Education of Mankind in a Series of Letters* of 1795. Despite 2,000 years of historical development, Schiller looks around at his contemporaries and judges that, in comparison with the best men of ancient Athens, there is no one living to compete in terms of all-round humanity. Of course, we are better at many things, but our superiority has been won at the cost of a specialization that simultaneously damages our integrity and wholeness: 'With us ... the image of the human species is projected in magnified form into separate individuals – but as fragments, not in different combinations, with the result that one has to go the rounds from one individual to another in order to be able to piece together a complete image of the species' (Schiller 1967, p. 33). And Schiller is in no doubt as to why this has come about:

It was civilization itself that inflicted this wound upon modern man. Once the increase of empirical knowledge, and more exact modes of thought, made sharper divisions between the sciences inevitable, and once the increasingly complex machinery of State necessitated a more rigorous separation of ranks and occupations, then the inner unity of human nature was severed too, and a disastrous conflict set its harmonious powers at variance. The intuitive and the speculative understanding now withdrew in hostility to take up positions in their respective fields, whose frontiers they now began to guard with jealous mistrust; and with this confining of our activity to a particular sphere we have given ourselves a master within, who

not infrequently ends by suppressing the rest of our potential-ities. While in the one a riotous imagination ravages the hard-won fruits of the intellect, in another the spirit of abstraction stifles the fire at which the heart should have warmed itself and the imagination been kindled. (Schiller 1967, pp. 33–5)

What, then, is to be done?

For Schiller – as nearly 100 years later it would be for Nietzsche – the answer is, basically: art. Only art, only the artist has the power to re-unite what civilization has put asunder. A key part of Schiller's idea of the artist (an idea that Romanticism would inherit) was that the artist was concerned not so much to express feeling or emotion but rather to balance, integrate and harmon-ize feeling and intellect, individual and society. The key to this act of harmonizing was to be the imagination, conceived not as a kind of free-floating fantasy, but as the instrument of a holistic vision and experience of life. In Britain, the most familiar and concise expression of this is in Coleridge's short chapter on the imagination in his rambling *Biographia Literaria*, in which he speaks of the imagination as 'a repetition in the finite mind of the eternal act of creation in the infinite I AM'. This – which he calls the primary imagination – is the imagination that each of us pos-sesses, that each of us constantly, spontaneously uses: that I see the world at all as a world and not just as a chaos of buzzing sense impressions is because, in every conscious moment, I have always spontaneously synthesized what I am experiencing into a kind of whole. In this mostly unconscious process I am constantly selecting, suppressing, forming or adapting the sensory impact of the external world and the humming of my brain cells, and producing out of all this teeming material an inhabitable world. And there is a further step, according to Coleridge. For although all of us all the time are bringing our world into being by the unconscious operation of the imagination, there is another kind

of imagination that works consciously and deliberately. Calling this the secondary imagination, he says that 'it dissolves, diffuses, dissipates, in order to recreate: or where this process is rendered impossible, yet still at all events it struggles to idealize and to unify. It is essentially *vital*, even as all its objects (*as* objects) are essentially fixed and dead' (Coleridge 1906, p. 166). This 'secondary' imagination is, Coleridge says, an 'echo' of the primary, just as this is an echo of 'the eternal act of creation'. Thus we have a kind of hierarchy of creative, world-making acts: the primal act of God, the derived act of humanity and, within this, the further derived act of those who have become conscious of their own creative ability, the poets.

But as we have seen, the world in which the Romantic poets found themselves was a world subject to radical distortion, a split, disorganized, fragmented world. It was a world in which human beings experienced themselves as intellects or as emotional bundles, but not as whole human beings. In such a situation, only a conscious, willed re-creation will be able to restore us to ourselves, and it is this that is the peculiar office of the poet. The poetic word is the word that synthesizes sense-experience and intellectual creation, matter and mind, image and idea. The poet shows us what it would mean to be a whole human being in a broken world and, in doing so, enables us to become whole human beings again – or, at least, to set out on the journey that would lead us to such wholeness, lead us home again, back to ourselves. In this task, the poet and the philosopher are, ultimately, engaged in one and the same task. Poetry and art are a continuation of philosophy by other means, gathering in dimensions of the ultimate plenitude that abstract philosophy alone cannot reach.

F. J. W. Schelling, one of the leading philosophers of German Romanticism and an important source of Coleridge's thought, spoke of history as the 'Odyssey of the spirit', humanity's journey

to rediscover in itself the source of all its experience of nature and the world. Novalis, the most admired and venerated of all the early Romantics, spoke in his novel *Heinrich von Ofterdingen* of the eponymous hero's quest for 'the blue flower' he had once seen in a dream, an image in which is condensed the communion of earth and heaven, a communion that, as Novalis comments, is no longer a matter of immediate experience in the age in which we live. The uniquely visionary Marxist thinker, Ernst Bloch, also spoke of history as a journey towards a homeland that 'has shone into the childhood of all and in which no one has yet been' – a pure Romantic ideal (Bloch 1986, p. 1376)!

This Romantic vision combines a sense of infinite loss – loss of its connection with its divine or absolute origin – with a more or less clearly focused hope that art and poetry themselves serve to kindle. The way back is possible. We *can* become what we shall be – and even if we cannot claim to have got there yet, the creative process itself, the struggle to create, the dynamism revealed in art is a kind of foretaste or anticipation of the promised end. The visionary artist is not, perhaps, someone who has been there, but someone whose vision opens a way for us to go. It is in this sense that the true artist comes to be seen among the Romantics as a kind of prophet, as a foreteller of what is to be, someone who gives us a vision of how to find our lost communion with the divine world.[2]

In this connection we can see both the elitist and the democratic aspects of Romanticism. It is elitist in the sense that, in the world as it is, not everyone has or is open to this vision. The masses, chained to bourgeois, mercantile values, must be elevated above themselves. Yet the aim is also democratic, in that it is assumed that everyone is, in principle, capable of being thus raised: what we are to be raised to is nothing other than true humanity. Probably, only some will make it, but potentially, everyone can. 'Everybody is an artist'.

I think that the relevance of this to much of Beuys's work is fairly self-evident, but in order to make the connections as clear as possible I want to emphasize three further features of Romantic theory.

The first is that, as opposed to classicism, the Romantic conception of art and of the task of the artist does not aim at producing final, perfect or finished works. Each work is itself only a stage on the journey or only a fragment of the whole. The idealizing, unifying spirit of art pervaded the whole socially interactive field of those caught up in the quest of the blue flower. Art points us towards this goal, it does not consummate it.

The second is that not only is the creative process more important than producing finished works of art, but the person of the artist himself is what is most important of all. The true meaning of art is the creativity of the artist, which can never be exhausted in any single work or even in any finite series of works, because the creative spirit itself is infinite and inexhaustible, to be satisfied only when it finally wins through to perfect communion with the divine source of all. In this regard, Novalis is again instructive. If we look at his artistic output, it is somewhat meagre and, in qualitative terms, rather patchy. Many other early Romantics were far more technically competent in their various fields of artistic endeavour. Yet it was Novalis of whom they all, collectively, spoke in the most hushed of tones. For, as they experienced it, what communicated itself in his work was a unique spiritual personality.

Third, connected with this, it is generally the case that in Romanticism itself this relationship between artist and work is construed in terms of expression. The work – poem, image, whatever it may be – is only a fragment but, as such, it is nevertheless an expression, product or external form of the inner creative spirit of the artist. It is a revelation in external form of what has its source within. It mirrors, exhales or bodies forth the mind of the artist. That is its essence and its value.

The early Romantic approach to art, therefore, offers much that is immediately applicable to Beuys, and that justifies us in seeing Beuys as a modern continuer of this Romantic tradition. Of course, there are also real differences. A poem by Coleridge or Novalis and a work by Beuys obviously do not immediately affect us in the same way. But these differences are more clearly defined if we are first conscious of the continuities. As a good Romantic, Beuys saw the mission of art as a means of healing the experienced disorder and division of the world. In a situation of disorder and fragmentation, art offers a way back towards a wholeness that is always already lost. It does so, not by offering finished works for contemplative or disinterested pleasure, but by awakening our capacity for creativity, for actively participating in the making and shaping of our world. Beyond the form of the work is the dynamic, socially interactive process in which this spirit of creativity is communicated. If, in the first instance, we must be awakened and led by the prophetically gifted, what we are being led towards is ourselves. It is a task for everyone: 'Everybody is an artist' and 'We are the revolution'. Art is transformative social action. But what of the ways in which Beuys differed from the Romantics, the ways in which a work of Beuys affects us very differently from any Romantic work we have ever encountered?

Inevitably, this has to do with everything that happened between the 1790s and the decades in which Beuys was artistically active. In the twentieth century many of the elements of Schiller's analysis of modernity have remained influential, although the terminology has often shifted. His account of the effects of the division of labour and the complexification of the social condition of humanity has been extended in terms of such now commonplace observations as the anomie and anonymity of urban life, the pace of social and technical change, the dehumanizing effects of technology and the marketization of social relations. Perhaps most dramatic of all has been the

shadow of techno-war, and the sheer power of modern warfare to neutralize human differences of imagination and courage by the use of technical planning and equipment. World War One saw the deployment of the machine-gun, the tank, gas and air-power, and World War Two upped the effect of these to hitherto unimagined proportions.

For Central and Eastern Europe in particular, World War Two meant destruction on a previously inconceivable scale. Here, nothingness became visible in ruined cities and the newsreels of the liberated concentration camps. For Germans it was Year Zero, when society was reduced to the very lowest threshold of sustain-ability, and as the film *Downfall* reminded us, if Hitler's desired scorched-earth policy had been put into effect, it would probably have been even worse. The years of Beuys's work were, of course, years lived in the shadow of an even more terrible techno-war, one that through the feared use of nuclear weapons might have brought about the extinction of humanity. If we are used to the label 'the Cold War', it didn't always feel too 'cold' in Germany itself – expected to be the front-line of any new conflict between NATO and the Warsaw Pact.

When Beuys re-enacted the tropes of Romantic thought in such a situation, then, it was no wonder that the character of the works he produced was 'poorer', more broken, more fragmented, more fractured than the luminous works of the Romantics themselves. True or not, the legend of Beuys's plane crash in the Crimea and his care at the hands of the Tartars is an extraordinary epitome of the way in which his time refigured the Romantic analysis: the fighter plane as a supreme exemplification of all that is involved in techno-war, the animal fat and felt used on him by the Tartars standing for the most basic forms of life's spontaneous warmth and vitality. For me, it is especially 'The Pack' and 'The End of the Twentieth Century' that project this personal experience (or, it may be, personal myth) into the realm of our common experi-

ence, fear and hope. In the former we see a VW camper van trailing twenty or more sleds, each loaded with felt, animal fat and a torch – a basic shamanistic survival pack. The latter consists of a number of roughly worked pieces of basalt shaped like sarcophagi, with cone-shaped cuttings around where we might expect the head to be and lined with clay or felt: it is a vision of a civilization shattered and strewn in all directions, leaving only the form of archaic burial rites. It is what might be left after techno-war had bombed us back to the origins of civilization.

But the difference between Beuys's artistic world and that of the Romantics is not simply that the world had grown so much darker, the hour so much later. It is also, perhaps, that Beuys was more Romantic than the Romantics themselves.

We have seen that the Romantics regarded the artistic personality as even more important than the work, and Beuys's work is, in the event, inseparable from his person. That he publishes an image of himself with the message 'We are the revolution' is already indicative of this; that this image of himself is made canonical by its consistency – the vest, the hat, the boots – is also significant; and, of course, he himself, in the flesh (at the time) and as a filmed or photographed image (now) is 'in', at the centre of, many of what we call his 'works'. So too, often, are his audience. The work is not just Beuys, what he said or did, but the whole 'action', the community of artists in which it happens.

Beuys was also more consistent than the Romantic theorists in thinking through the emphasis on the social aspect of creativity. One thing it means is that there is a certain inconsistency in still holding on to the idea of the work as the expression or external representation of the creative idea of the individual artist. In the way they saw art as fundamentally expressive, the Romantics did after all betray a residual classicism or, it may be, artisanship, a focus on the work as work, rather than the work as a mere moment within the process. With Beuys the work is no longer an

expression of the genial spirit of the artist, it is a monument to the action of the artist with and among his audience. The work is not there to be looked at or enjoyed, but to provoke and stimulate our engagement with the quest for the genuinely human in a world in which humanity is systematically obscured and distorted by techno-politics. Beuys's '7,000 Oaks' is, in one sense, the 'idea' of an artist, but its reality literally outgrows any possible artistic conception.

Some commentators have taken this to mean that it is entirely inappropriate to museumize Beuys, to make his work into 'art' by putting it into an exhibition. I suggest that is not necessarily so, not as long as the work continues to provoke, in the way I have suggested. And that is why, for me, these works perhaps have more in common with the amulets, charms and other shamanic apparatus to be found in the drawers of the Pitt-Rivers Museum than with 'art' in any usual sense. They are the residue, the tokens, the remains of rituals whose immediate horizon has been lost. They move me to puzzlement, to the question: 'What is it about human beings that can make them want to make works such as this, what is it that can make of such works vehicles of meanings that are lost when they are no longer lived?' They drive me to thought, to philosophy (if you like), as the Romantics always thought art should – although in practice they often settled for admiration.

Strangely, there is a curious link here to western Christian art. We are by no means surprised to find altarpieces, reliquaries and other pieces of sacred art hanging on the walls of museums and galleries, nor are we much surprised to find Churches with historically or aesthetically important works of art treated as if they were galleries. It is not uncommon to go to such and such a church primarily in order to see the Chagall, the Rubens or the Giotto. We relate to the religious art of the western Middle Ages as work to be looked at, as if its meaning is there, in the work. But

we should take note of the sub-title of Hans Belting's wonderful book *Likeness and Presence* – namely, *A History of the Image Before the Era of Art* (Belting 1994). What was originally important about these 'images' was not that they were images, that is to say, visual objects to be looked at. Rather they were the means whereby the saint or saving event depicted was made present to the worshipper. As mentioned in Chapter 1, a striking instance of how this can survive the removal of the works into the museum, where they become 'art' to be looked at, is the sight of Russian Orthodox believers singing hymns to the icons in Moscow's Tretyakov Gallery. Indeed, some museums with icon collections contain warnings not to kiss the icons. What is the significance of this? It is that the icons are not there primarily to be looked at, in the way they have been used over the last generation by many Westerners. The icon, in Orthodox belief, is the mode of presence of the saint whom it represents. It is the saint whom the worshipper greets in kissing the icon (just as we kiss our friends when we arrive at a party) – which is something very different from the admiring contemplation of an image. In this regard an icon is actually closer to a relic than to a work of art.

The same would originally have been true of the liturgically contextualized art of the early Middle Ages. We can still experience something of that in places such as the Baptistery in Florence, where the massive mosaic-covered vault really seems to make the heavenly world present. But in the West, at least, something happened to change this. This 'something' was, of course, extremely complex and developed over a long period. The doctrine of transubstantiation had something to do with it, as did the transformation of the Eucharist into a visual display. The influence of sculpture (not generally admitted in the East as a legitimate form of Christian art) also had a role. The net result, in any case, was that sacred art became something to look at. Once those producing sacred art had internalized this understanding,

they did, of course, produce works that are intensely satisfying as visual objects. But there is also a sense in which the interior of a Christian church, perhaps especially the sanctuary area, adorned with carving, painting and images in glass is, outside the hour when it is put to liturgical use, a profoundly unsatisfying space, like the amulets, charms and robes of the shamans. They are objects that are just there, but what they are there for has gone missing. In the age of Christendom, perhaps, most people would have been imaginatively able to fill that gap out of their Christian education. Today, however, they are probably as alien to most of our contemporaries as shamanic charms. In this situation Beuys provides one example of how we might begin again to connect art and action, including, I think, sacred action.

Yet, finally, I do have a reservation. There is much to take away from and to think about in relation to Beuys's ultra-Romantic anti-aesthetic. But if the goal is the rediscovery of the lost image of the whole, warm human being, can we go along with Beuys as more than a corrective? Does the making of beautiful things, the stilling of singing colours and the conjuring of good forms not *also* nourish us in our journey home? Does the right blue, the struggle to find and paint the right blue, not sometimes serve to reawaken the unimaginable blueness of Novalis's blue flower? And, through that, does that search and that struggle not help lead us to beyond admiration, to something more, something we might, provisionally, call the sacredness of the blue of Mary's robe? In certain times and contexts, the poverty of materials may serve as powerful witness to the spirit having-been and having-moved-on, and remind us that the fullness is not in the work, but in the action. The practitioners of beauty may need to be reminded of the extremity of our predicament, and they may need to be cautioned not to become entranced by the goodness of the work at the cost of the humanity served by the work. Yet the quarrel, but also the mutual need of prophet and priest, continues.

Notes

1 The prophet Ezekiel is perhaps even more extreme and dramatic in his actions than Jeremiah, being instructed at one point (Ezek. 4) to lie, tied up, on his left side for 390 days and then for 40 days on his right side, as a sign of the time of the siege of Jerusalem.

2 This can, of course, be seen as supplementing the role of artistic creation as healing, set out in Chapter 3 above and, from within Romanticism itself, potentially moderating some of the more extreme Romantic claims to absolute creativity. It is striking that Berdyaev's idea of creativity as the theogonic overcoming of suffering is itself rooted in his reading of such Romantic sources as Schelling.

Anselm Kiefer's 'Palm Sunday'

My first encounter with the work of Anselm Kiefer, a onetime pupil of Joseph Beuys, happened more or less by chance. In January 1986 I was in Amsterdam in quest of a set of stolen medieval carvings and found myself with a Monday afternoon to spare. My plan had been to visit the Rijksmuseum and absorb myself for a couple of hours in Rembrandt and other Dutch Masters. However, as more experienced visitors will know, the museum was closed on Mondays, leaving me with what seemed like a depressingly long afternoon. Wandering rather disconsolately through the grey winter streets I found myself outside the Stedelijk (City) museum, which was open – so I went in. As I remember it (and memory can, of course, deceive), the entrance hall led to a flight of broad stairs dominated by Kiefer's imposing and disturbingly fascistic sculpture of two outstretched eagle's wings. From that spectacular beginning the exhibition led me through numerous rooms containing many of his then best-known works. These were mostly large paintings – some of them very large – heavily worked in oil and acrylic and often thickened with materials such as earth, sand, metal and straw. They were predominantly painted in dark tones of black, brown and grey, and sometimes hung with rocks, wire and, in one case, an aeroplane propeller.

The titles made explicit what the images themselves suggested: that these were work originating in the devastated world into which Kiefer was born in March 1945, Germany's Year Zero. This

was the year in which the country reached zero-point: militarily annihilated, its cities razed to the ground, its countryside ravaged by the armoured march of million-strong armies, its national psyche shattered by the forced confrontation with the inconceivable criminal acts that it had perpetrated. Rarely, if ever, in modern times, has a great nation been so humiliated, materially and psychologically, as the Germany of Kiefer's infancy.

It is no wonder that much German art and literature in the following decade simply avoided the inevitable confrontation with the past, just as it was no wonder that artists and writers of Kiefer's generation would need to make their reckoning with the painful legacy that history had bequeathed to them. That reckoning was being worked out in every work in that exhibition, and continued to be so in many that followed. Here, more or less literally, were images of scorched earth, landscapes blighted by the ruin of war, history-painting (of a kind) from which all heroism had been stripped away, monumental industrial architecture that hinted at unspeakable uses, railway tracks that might lead to destinations of often-narrated horror, a ruined mythology that was too culpable even to begin offering the consolations of religion. From the gods of Valhalla, through the antique battles of Romans and Germans, and on through works representing the cultural heroes of German Romanticism, Kiefer's accounting led ineluctably to Auschwitz, often implicitly, but also explicitly, as in the canvases 'Sulamith' and 'Margarethe'. These allude to Paul Celan's poem 'Fugue of Death', in which the fate of the golden-haired Margarethe is contrasted with that of the ash-haired Sulamith: Margarethe, the beloved of Faust, himself the incarnation of Germanic modernity, and the Sulamith (English: Shulamith or 'the Shulammite') of the Song of Songs 6.13, the 'queenly maiden' to whom Solomon addresses his poem, and who is sometimes conceived of as a symbol of Israel itself, God's own beloved bride. Further references to biblical and to Jewish and

Christian mystical themes, to the Kabbalah and to the mystical theology of Pseudo-Dionysius, were apparent in other works.

It was not difficult to sense that, in and through this almost compulsively dark transformation into art of the world of Year Zero, Kiefer was attempting to break a double embargo. The sheer scale and horror of the crimes of National Socialism had provoked an anguished reappraisal on the part of artists and writers as well as of religious believers. How could one write poetry after Auschwitz? (Adorno, famously, decreed that you could not.) How could one go on believing in God after Auschwitz? What could either art or belief do to redeem the desolation of Europe's blasted landscape?[1]

Of course, if art and religion are happy to settle for the role of merely offering entertainment – distraction, in the Pascalian sense – then people after Auschwitz have proved themselves willing to be entertained. But if it is a question of metaphysical consolation, which is something that much serious art and most modern forms of religion have sought to address, then nothing that either artists or believers are able to do, create, or say would seem to go any significant distance towards consoling us for that still unbelievable and unbelievably cruel wastage of human life. It was telling that one of Kiefer's works of this period was entitled 'The Iconoclastic Controversy' and included an image of tank-battle – as if to say that the experience of the war had, in its own way, reopened the ancient controversy as to the power of images to tell of divine or ultimate things. The work relating to Pseudo-Dionysius seemed further to hint that, as in Dionysius's own mystical theology, any talk of God must be prepared to enter upon a 'way of negation', in which all existing images, names and concepts of God are abandoned, and that God can only be known beyond knowledge, experienced beyond experience and spoken of only in silence.

As someone more or less of Kiefer's generation (whose own

childhood landscape was very much 'post-war') and as someone trying to formulate my own Christian inheritance in a way that did not shirk the metaphysical confrontation with the Shoah, it is not surprising that I experienced this first encounter with Kiefer's work as almost overwhelming. As in many of our more profound experiences with art, it was even quite shattering physically: this was art made of strong, forceful matter, and it hit me at the material level. But as with all profound experiences that go on also to feed the spirit, it left me with questions to ponder, and possibilities for further reflection.

I was at the time rather surprised that I had not previously heard mention of an artist of this stature. I found this doubly surprising in that I was spending quite a lot of time with artists and with people who liked talking about art. One of these was the critic Peter Fuller. It seemed to me, naively perhaps, that Kiefer was someone who would provide Fuller with a positive focus for his own argument concerning the role of art in an age of 'lost illusions' and, at the same time, someone who offered an example of the continuing power of representational painting to nourish those spiritual longings left unfulfilled in the wake of God's much-advertised decease. When I put this to Fuller, however, his reply was along the lines of, 'That may be true, but I'm not really interested in him because he's German'. Being used, in my philosophical and theological work, to the Anglo-Saxon refusal to engage with modern European thought, I found this somewhat irritating and, dare I say, provincial. Afterwards, I could see a relative justification for Fuller's response in terms of his own critical project. Art, he insisted, always has a strong local colour, since it is necessarily embedded in concrete traditions of transmission. Whereas philosophy would seem scarcely to merit the name 'philosophy' if it limited itself to appropriating and celebrating the local and particular rather than striving for maximum universality, the specificity of time and place might be seen

as integral to art, not least the art of painting. Only through the 'here, now' does art reach the 'always'. Thus, for someone focused especially on contemporary issues of British and American art, Germany was, in a quite real sense, another world.[2]

And there was probably something more. Even if this was not true of Fuller himself, it is probably true for many Anglo-Saxons that Kiefer's art is simply too 'Germanic' in the pejorative sense associated with the self-mythicizing grand narratives of a Hegel, a Wagner or a Heidegger.[3] It is an art of big statements, of large metaphysical and historical claims, and if our native empiricism was not sufficient to warn us away from such things, we had the more recent – and then very topical – pronouncement by post-modern philosophy that grand narratives were dubious things, and that 'we' had become congenitally suspicious of them. Even if Kiefer's tonality is very different from that of a Goethe, a Caspar David Friedrich or a Wagner, and even if his personal mythology is more fragmented and scarred than theirs, it can still strike those who do not like such things as, simply, over-inflated. The last example of that in our own British tradition was probably George Frederick Watts, and we have already seen some of the difficult issues around the contemporary reception of his work.[4]

These reservations are understandable, yet evasion is rarely a good substitute for critical engagement. Kiefer's world, and the history that his work explicitly confronts, is German history. That is undeniable. Yet German history is not an isolated specimen in a laboratory. German history – and not least in the twentieth century – is a history that has affected and shaped us all, and the reflections of German thinkers and artists on the meaning of that history have also permeated much wider debates about the meaning, goal and purpose (or lack of meaning, goal and purpose) of history. German history and the meaning of history seen through German eyes are matters that continue to be of importance far beyond the geographical limits of the German-speaking world.

At the same time, suspicions about grand narratives do not, in the end, seem to have finally silenced human beings' desire (and perhaps need) to interpret their world and their lives in more or less grandly narrative terms. The catastrophes of the twentieth century were events on a scale and of a significance no less than those of other archetypal ages. The traumas of the twentieth century, including the rise and fall of the Third Reich and all that is associated with that, impacted massively on the way human beings experienced and understood themselves, and they continue to haunt our collective memory. Evidence for this can be found in the history section of any bookstore, where this piece of history continues to provide the subject matter for a seemingly endless stream of best-selling works. It would be strange if art simply had to abandon all the possibilities of human self-understanding offered by that era to the historian, including our possibilities for evil as well as for good.

This is not to say that we are to revert to an earlier view of painting in which grand-scale history painting was viewed as the summit of the painter's art, the goal towards which all studies of still lives, interiors, faces and landscapes were ultimately being steered. Contemporary art is simply too pluralistic for that kind of hierarchical ordering of the genres of painting to have much appeal. My point is merely that we should be pluralistic enough not to exclude those artists who do, for good or ill, take on the grand narratives. Fuller, of course, allowed himself to be guided in many crucial matters by Ruskin, and we might recall that Ruskin's own exemplar of 'modern painting', J. M. W. Turner, was not simply on a journey towards the impression or the abstraction of nature but also, and in his own way and on his own terms, engaged the historical and the mythical (see Gage 1989).

To return to Kiefer. At the time of writing it is more than twenty years since the Amsterdam exhibition, and Kiefer has been moving on. Based on the work up to and including the work of the

early 1980s, it might be possible to concur with Mark C. Taylor's view that Kiefer is unqualifiedly an artist of the God-forsakenness of modernity. For Kiefer, he writes (with metaphors borrowed from Derrida),

> To be opened by the tears of art is to suffer a wound that never heals ... The end of art: Desert ... Desertion ... The errant immensity of an eternity gone astray in the desert in which we are destined to err endlessly. (Taylor 1992, p. 307)

But is this correct? Is Kiefer merely transcribing into visual form the darkness of Year Zero, or is he – think again of Beuys – attempting some kind of alchemical transformation of his dark materials?

Much could, for example, be said about the 1989 work entitled in English 'The High Priestess' or, more literally translated from the German, 'Mesopotamia', a diptych constructed as two massive racks of shelves, laden with lead-bound books. Made in a period of intense nuclear instability, the work can be seen as a return to the origins of western civilization in the eponymous region of Mesopotamia (also the locus of the origin of writing) and the symbolic preservation of the world mirrored in western literature in the radioactivity-resistant casing of lead covers. Many of the photographs (written over or otherwise reworked by Kiefer) that are contained in these books represent different facets of nature, as if the task is at one and the same time the protection and con-servation both of the natural world and of human beings' living and creative memory of that world. At the same time, the dark material, absorbing and deadening all luminosity, and the recur-rent imagery of ruined factory buildings, seems to hold the work in the perspective of Year Zero. If the work conjures the memory of a world worth saving, it is having to be saved in a devastated and cheerless contemporary reality – and saved for better times

the advent of which is, at best, uncertain and, at worst, infinitely deferred. Thus far, at least, Taylor's analysis would seem to have continuing force.

However, the 2007 exhibition at the White Cube Gallery (London) of the work entitled 'Palm Sunday' and of a number of accompanying paintings might be taken as marking a decisive breakthrough in Kiefer's journey from the bleak landscapes of Year Zero. Palm Sunday is, of course, the festival on which the Church celebrates Christ's arrival in Jerusalem, when he is hailed by the welcoming crowds as the Messiah, and the imminent realization of God's long-delayed salvation is in the air. So what does it mean in the iconography of the painter of 'Margarethe' and 'Sulamith'?

'Palm Sunday' was exhibited at the White Cube in a luminous white ground-floor room and consisted of a sequence of twenty-two framed works hung in two rows, one above the other. An 'installation' dimension was provided by the trunk of a palm tree, laid diagonally across the floor. Each of the framed works contained a centrally placed palm branch or stalk, drenched in whitewash and laid against backgrounds consisting variously of paint, cracked clay and other media that were formed into swirling patterns of white, grey, mauve, yellow, orange and brown. On many of the works are written the words 'Palm Sunday' in one or other European language, including German, Swedish, English, French, Spanish and Russian – as if to say: this is a moment of celebration for all peoples, not just a private artistic catharsis.

If we associate the word 'lightness' with fragility, or if we demand that 'warmth' be provided by layered depths of colour, then 'Palm Sunday' is neither light nor warm. Yet its first impact is of light, colour and joy – as the title would leave us to expect. Rather than the oppressive atmosphere of the earlier works, where heaven is closed and the earth is burdened with its own battle-scarred weight, several of these images open out upwards,

creating bursts of light from the upwards-flowing currents of patterned ground. Even where heavy materials, such as clay, are used, they are readable in the spirit of Christ's words about the welcoming crowd, that 'if these were silent, the very stones would cry out'. Kiefer's interest in alchemy is well documented, and 'Palm Sunday' is a kind of alchemical transformation of the base materials of earthly reality (including literal earth) into a shout of messianic joy. Kiefer is not, of course, a painter in whom we see a fine observation of light and shade, he is not in the line of either Monet or Cézanne. Yet if, as Heidegger suggested in his essay 'On the Origin of the Work of Art', the work of art lets the world – whether in the particularization of earth, sky, sea, plant or rock – show itself as it is in its own way of being, Kiefer presents his palms and their earthy base in such a way as to make apparent the delicacy and wonder of their formation, and thereby achieves an outcome at least analogous to that achieved by one who might be called a more painterly painter. The natural world is celebrated and redeemed.

This interpretation is reinforced by the larger works exhibited with 'Palm Sunday'. These return in some ways to the large, dark fieldscapes of earlier works. Two of these take their titles from the Latin text of Isaiah used in the Palm Sunday liturgy, breaking it into two parts: (1) 'Drop down, O heavens, from above and let the skies [clouds] pour down righteousness' and (2) 'Let the earth open, that salvation may spring forth'. The work 'Drop down, O heavens'[5] shows a brown, yellow and black-flecked field in which a host of yellow, pink and mauve flowers are opening out. The plough-lines run horizontally across the picture, and the field is crossed by a path leading away from the viewer and bending slightly, before disappearing into the distance. Above the path the smudged glow of a sunset or dawn appears low on the horizon. In overall structure it recalls such works as 'Brandenburg Heath' (1974), 'Iron Path' (1986), the photographs of 'The Burn-

ing of the Rural District of Buchen' (1974), or the abandoned railway tracks in the book *Siegfried's Difficult Way to Brünhilde* (1977).[6] Yet where those were saturated in the symbolic world of Year Zero, arousing dread as to where the path was leading, this is a path we might want to journey on. Where is it leading? Even if we see it illumined by the first light of dawn, perhaps it is leading nowhere in particular, but like the footpath evoked in a 1949 essay by Heidegger, it nevertheless offers a path to human beings who feel themselves to have lost their way in the face of the terrors of the atomic age. As Heidegger remarks, the person who is distracted by either the fear or the fascination of our technological world will see the simple uniformity of the landscape as monotonous and oppressive, but the one who is content simply to walk will see the blessing concealed in what seems, at first glance, to be merely the same. And, the philosopher adds, 'in what is unspoken in the language of [the path]', those who are prepared to take the time to walk it will find that, 'as that old master of reading and living, Eckhart, put it: God is first God' (Heidegger 1983, p. 39). He is not, of course, referring explicitly to Kiefer's painting, but the words are apt.

In the second work, 'Let the earth open' ('*Aperiatur Terra et Germinet Salvatorem*' – the text is a continuation of Isa. 45.8), the receding lines of the ploughed field, converging on a central vanishing-point, once more recall earlier work (for example, 'Nero Paints'), but now the dark landscape has been transmuted by a pervasive creamy yellow and orange light. White, pink, blue, purple and orange, the flowers we see springing up on all sides are almost gaudy. Earth lives: salvation is born from its cracked surface and the stones cry out to greet their Messiah of justice.

Is it that simple, however? In a BBC interview, Kiefer comments that 'nothing in the world has one sense only' and 'even the truth is wandering around'.[7] Matthew Biro's study on Kiefer and Heidegger has emphasized Kiefer's tendency towards 'unde-

cidability' (Biro 1998),[8] which (in the context of Kiefer's earlier work) he sees as resisting the Heideggerian temptation to see the age of technology as necessarily totalizing and violent. Here, however, we may say that that same 'undecidability' should warn us against an over-simplistic ascription to Kiefer of the theology of the happy ending. As Kiefer says with regard to 'Palm Sunday': 'I would never say I'm pessimist or optimist. I'm desperate ... The more we know, the more the realm of the unknown grows.'[9] 'Palm Sunday' and its associated works do not, then, offer a final resolution of the tensions of the dark times of the post-war years, nor do they mark a safe arrival at a point of religious consolation. What they do offer is both more subtle and more realistic. The biblical Palm Sunday was, as we know, followed by the betrayal and execution of the Christ hailed by the welcoming crowds. So too, Kiefer's 'Palm Sunday' may not be more than a Messianic moment in a world in which violence will continue to make and break great nations, and we have no guarantees that, on the plane of history, darkness will not return. Yet what Kiefer offers – and perhaps neither art nor faith should presume to offer more – is a festival day, a joyful and splendid anticipation of justice and salvation, and a glimpse into what cannot be seen (because it has not yet come). We are all desperate for what such days anticipate and we ache for justice and salvation to 'come quickly', but that desperation does not mean that we can either dispense with or be ungrateful for such provisional festivals as art and religion can give us.

Notes

1 On the issue of Kiefer and 'Art after Auschwitz', see Saltzmann 1990.

2 In a lecture of 1990 on 'British Romantic Landscape Painting', Fuller would offer a short comment on Kiefer and, rather oddly, draw a contrastive

comparison with Cecil Collins. The work at issue is 'Scarab' (1989), of which Fuller says: 'Gone are all hints and traces of redemption, of resurrection, of the ghost of a redeemer. Kiefer's work consists of nothing but inert matter. Not even that last and most tenuous transformation of all – aesthetic redemption, redemption through form – has taken place . . . might has subsumed all' (Fuller 1993, p. 31). Fuller there fails, to my mind, to see that, indeed, Kiefer is confronting darkness – how could he not, born when and where he was – but he is confronting it precisely in order to reckon with it and, even in the early works, to struggle for a way through it.

3 On the relationship between Kiefer and Heidegger, see Biro 1998.

4 Again, we might recall from Chapter 4 that P. T. Forsyth had likened him to Wagner!

5 Kiefer gives it the Latin title '*Rorate caeli desuper et nubes pluant iustum*'. The text is from Isaiah 48.5 and is liturgically associated with Advent.

6 Kiefer himself says that they are based on older photographs.

7 See: http://www.bbc.co.uk/mediaselector/check/collective/anselm?size= 16x9&bgc=8A9EC3&nbram=1&bbram=1&nbwm=1&bbwm=1

8 Which he – mistakenly in my view – contrasts with Heidegger's decisiveness.

9 See Note 7.

8

Letters from America: Robert Natkin and Friends

Peter Fuller, whose scepticism regarding Keifer was discussed in the last chapter, died in a car accident in 1990. Following his death an annual memorial lecture was established, the second of which was given by the American abstract painter Robert Natkin. Fuller's controversial career led via gambling, Marxism and psychoanalysis to the pages of the *Daily Telegraph* and the journal *Modern Painters*, of which he was founding editor. The title of the journal refers to Ruskin's classic five-volume magnum opus, and Ruskin was a constant point of reference throughout Fuller's career. Fuller's book *Theoria: Art and the Absence of Grace* remains his most significant theoretical work. Although the subtitle refers specifically to the *absence* of grace, Fuller was increasingly sympathetic to religion despite remaining a declared atheist. With regard both to Ruskin and to the progress of modern art, he came to give a very positive evaluation of the role religion can play in providing soil and support for art.

The choice of Robert Natkin to give the second memorial lecture was doubly appropriate. On the one hand, Natkin had himself been the subject of a major monograph by Fuller (an event that grew out of and fed back into Fuller's admiration for the work of, and friendship with, the man) and, on the other, he had been making a not dissimilar move with regard to religion,

119

reaching a point at which he seemed increasingly accepting of God-talk (though, happily, still wary of the ideologies and institutions that go along with religion) and worked in the 1990s on a Stations of the Cross. The very title he gave the lecture, 'Subject Matter and Abstraction', refers not only to one of the major aesthetic issues connected with his work but also – in his view – to a motif that is rooted in the deepest levels of Judaic spirituality, a motif that is provocatively and movingly explored in the lecture. I have used the term 'lecture', but the form is somewhat unusual. Natkin has no pretensions to be a writer or lecturer and, in a moment of inspiration, hit upon the idea of making a text out of a series of letters to friends, comprising fellow artists, critics, philosophers, nuns, clergy and, poignantly, Peter Fuller himself. This could have resulted in chaos and confusion, but the themes that run through the letters are strong and compelling enough to give the lecture a powerful and passionate unity. For a theologically-oriented reader it raises in a particularly sharp manner the question of how, or in what way, we can speak of an abstract work of art as 'religious'. I shall return both to this question and to Natkin's lecture later, but first I should like to go back to Fuller's interpretation of his work and, subsequently, to an important interview Natkin gave the British critic, Sister Wendy Beckett.

Fuller's view of Natkin is most readily accessible in a seminar paper given at Goldsmith's College, London, and published as 'Abstraction and "The Potential Space"'. The paper opens with a brilliant verbal description of what it is like to look at a Natkin painting, worth quoting at some length:

At first your eye responds to the painting's superficial seductiveness and decorative inducements: it is shamelessly beguiling, immediately pleasurable and *engaging*. Nothing in it shouts loudly at you but the apparent taut, stretched surface of

paint easily receives your gaze and having done so entertains it ... Threads of many different colours and iconographic devices like the passages of cross-hatching, the row of dots, and the little blue circle seem to have been woven together to form this surface ... You are aware of the shimmering presence of a myriad of colours including gentle reds and modulating tinges of purple, green, orange and blue; but one is dominant over the others, the intimately sensual pinkness of white flesh. (Fuller 1988a, p. 177)

After this initial encounter with the attractive surface of the work we are drawn further:

deeper and deeper *inside* the painting. You may even experience anxiety as you realise that there is no fixed viewpoint which you can continue to adopt outside the work which will allow you to perpetuate a detached observation of its skin. The iconographic marks, dots, circles and cross-hatchings become more distinct as they seem to detach themselves from the surrounding paint. They too now seem to be floating in space rather than sewn in a fixed position into a surface; because they are drifting as if without gravity you cannot orientate yourself in relation to them ... It is almost as if ... the skin had reformed ... *around you* so that you, originally an exterior observer, feel yourself to be literally and precariously suspended within a wholly illusory space ... (Fuller 1988b, p. 179)

Fuller relates this experience to D. W. Winnicott's psychoanalytic concept of 'potential space' and, in doing so, offers some more general suggestions relating to the power of abstraction. Winnicott's term refers to the phase in an infant's development when it first begins to differentiate itself from its mother and to experience its own space as a space within which it can explore and expand its own possibilities. At the same time it is essential for the

creative utilization of such space that the mother remains present to provide 'a continuous sense of *being* ... which later becomes the basis of trust' (Fuller 1988b, p. 203). What Natkin's painting does, in other words, like other successful works of abstraction, is put the viewer back into that space that lies at the origin of human creativity. Interestingly, even though he denies its theistic content, Fuller also relates this state to Rudolf Otto's category of 'the numinous' or 'holy' (Fuller 1988b, p. 215).

The abiding value of the experience of 'potential space' in human life and of art's capacity to re-open that space for us in the midst of adult, socially organized life is regarded by Fuller as setting a limit to the claims of cultural relativizers and of those, like Marxists, who seek to reduce art to social condition-ing – although in this way of placing art he finds an ally in the unorthodox Marxist Herbert Marcuse, whose book *The Aesthetic Dimension* argued for the relative autonomy of art as a reservoir of non-historically determined instinctual affects and passions. Art – and here that means Natkin's art – reconnects us to a primal milieu that is irreducible to any particular cultural determina-tion (although, it should be added, Fuller never precluded the possibility of some kind of biological reduction of art).

Natkin's achievement received a strong endorsement at the conclusion of Sister Wendy Beckett's *Story of Painting* (Beckett 2001), and in an interview with the artist she moved rapidly towards getting him onto the subject of what Tillich had called 'ultimate concerns'.

Natkin: We live in a time that denies death ... that denies how suffering as well as joy can be a celebration of being alive. I am an artist that people have often called a hedonist. Fine. I am. I have always wanted what I call the tongue of my eye to engage, even to indulge in, visual pleasures. But this hedonism is not just an aimless or superficial pleasure. (Natkin 1990, p. 50)

Enough should already have been said to make clear the pleasurable, sensuous quality of Natkin's work: to stand in Natkin's studio, to look with him at his glorious, glowing canvases and hear him (literally) lick his lips and say 'Yummy' is to learn something very important about his painting (or, simply, about painting). This is art that relishes the 'flesh' – but this does not mean it is closed to other dimensions of existence. As Fuller had noted, Natkin's works evoke anxiety, suffering and even death. For her part, Sister Wendy does not hesitate to give a religious interpretation of the state out of which Natkin works and that is in turn evoked by his pictures:

> you're really talking about a mystical state ... If you're to approach God, you must enter into a cloud of unknowing, of uncertainty, because all certain and clear knowledge means you are not coming close to Him, who is essential Mystery. You're saying that for you the act of painting is analogous to that. (Natkin 1990, p. 50)

Natkin goes halfway towards accepting this, but remains enough of the Chicago-Jewish abstract expressionist to refuse the closure of any system: 'I always tell people I'm an atheist because it's much easier than the more complicated truth ... Certainly my sense of humour and my "Old Testament" anger are very Jewish ... But I really have to live in a state of spiritual wilderness' (Natkin 1990, p. 50). For Sister Wendy this refusal of objective certainty is central to the enterprise of prayer, and she gets close to persuading Natkin that the creative process as he experiences and expresses it has a God-directed dimension. The emphasis on 'wilderness' of which Natkin speaks in this interview resonates powerfully within both Jewish and Christian traditions, and it is a theme taken up in the notion of exile, developed in the Fuller Memorial Lecture. It is importantly focused in a quotation that Natkin

attributes to an unnamed Rabbi (which also provides the title for a painting from the early 1980s): 'Remembrance is the secret of redemption; forgetfulness leads to exile' (Natkin 1993, p. 39). Natkin is unabashed in speaking of the childhood sources of his own psycho-sexual 'fall' into exile, but the tone is not always that of the analytic couch. Thus, he describes – hilariously – how, as a child, he ran and hurled himself at a cinema screen in an attempt to break through to what he believed was the reality on 'the other side'. This anecdote is a telling summary of his artistic quest, more soberly stated in a remark to Sister Wendy: 'you seem to live peacefully in mystery, while I mostly live in agony, working to paint what can be called both clarity and mystery' (Natkin 1993, p. 25). The artist lives in the wilderness, in exile, as 'fallen' – and the agony of art is the never-ending quest to find the way back, to remember and, in remembering, gain redemption. Not that we should become too lofty-minded about this: another favourite Natkin story concerns his childhood fascination with the story in Exodus 33 of how God showed Moses only his 'back parts'.

> When I made enquiries about this episode in Hebrew school, all the other children immediately threw erasers, pencils and chalk at me and the Rabbi kicked me out for the day. As a grown-up still fretting over God's rudeness, I finally figured it out. It is only occasionally that we can experience the ineffable. I've worked my whole life for those moments where I intuit more than God's ass. (Natkin 1993, p. 5)

In the lecture he is increasingly willing to name such moments religiously, as 'timeless' or, simply, as having to do with God. (To Peter Fuller:)

> we can't escape the perception and need for timelessness – a euphemism for God. We yearn for that which is of timelessness – of narrative, memory and metaphor ... Abstract sculpture

or painting must embody such depth of metaphoric resonance and burn as revelation and then rise out of its own ashes of narcissism (or style) into a state of soliloquy . . . In soliloquy, where the artist talks to himself, he is heard or observed by the world or by God who stands for that ultimate inner voice. (Natkin 1993, pp. 8–9)

But it is not only among Natkin's later work that we find 'religious' titles such as 'David Dancing Naked Before the Ark', 'Kaddish for Peter Fuller'; biblical and theological themes are also more than hinted at in such earlier works as 'Ishmael', 'Isaac Sacrificed – We Watch, Entertained', 'Isaac Saved', 'Joshua', 'The Lord Will Speak and Not Show His Face' and 'Epiphany'. Even more explicit would seem to be the series of Stations of the Cross he undertook in the 1990s. What is especially striking in these works is how Natkin has chosen to rework the traditional sequence by adding two further images, one at the beginning and one at the end. The one at the beginning is a Star of David, symbolizing Mary (he says) who, as the mother of Jesus, is also an embodiment of Israel. This Star of David recurs in each of the following Passion scenes, such that the whole story becomes something of a debate between Israel and the cross. Natkin's second addition to the traditional arrangement is a resurrection, in which both the cross and the Star of David are still present, but in a transformed relationship. Although he has worked up each image as a separate work, Natkin also produced several strip-cartoon format 'story-boards', emphasizing that he sees this as very much a *story*, a narrative that means whatever it means only by virtue of its continuing passage through time. There is no single image that captures the essence of the whole, but only the story, the constant recycling of the same materials until something new emerges (Natkin often likens his own experience of the creative process to recycling failure until it turns into success).

Alongside such 'edifying' works we will find considerably more that evoke the worlds of jazz, blues and popular entertainment: 'Nina Simone', 'B. B. King', 'Around Midnight, for Miles Davis', 'Redeemed through Sarah Vaughan', 'Sylvie in Oz', not to mention the dedication of the 'Hitchcock Series' to Alfred of that name (though here too Natkin makes clear that his admiration is for Hitchcock's ability to evoke and confront the demons of our time). Yet it would be a mistake to speak as if this were some kind of contradiction.

The references to jazz and to cinema remind us that Natkin is very much an *urban* painter. Although he lives deep in the backwoods of Connecticut, the world he conjures up in his art is the world of urban America, a world of skyscrapers, traffic, parks, restaurants, jazz; of Jews and Blacks and Poles and Irish and any number of other exiles. To say 'urban' is often to evoke images of urban decay, deprivation, riots, violence and fear. But that is only one aspect (or only one myth) of the modern city. If the kind of celebration of *The Secular City* (Harvey Cox) does not come too easily these days, cities remain places where many of us still have to live, like it or not, and many of us do in fact like it. And we more than 'like' it, because *this* is where, today, we typically find our consoling myths, our loves, our paths to redemption. I am not therefore trivializing Natkin if I say that there is something about his work of the urban poetry of Woody Allen's *Manhattan* (and subsequent films). When I look at the poster on my wall from a 1986 New Britain Museum of Fine Art exhibition, the image I see is not entirely 'abstract'. Just as Midtown Manhattan remains a very plausible referent for Mondrian's geometrical abstractions, so it might equally serve as 'object' of Natkin's soft-focus cross-hatched, grill-patterned, reticulated, dotted angular shapes that mingle and overlap in a hundred nuanced shades of grey and blue and orange and green and purple beneath a blurred and flattened orange 'sun'. This is not what I would 'see' in a cinematic

sense if I drove into town at night, looking for a place to eat and some good music to listen to with someone I loved, and with that peculiar heightening of the senses that always accompanies the urban nightfall – but it is pretty nearly how I would feel. It's the same city in which Hopper's 'Nighthawks' pass their alienated nights, yet seen from another angle: it's the city the 'nighthawks' would like to find or to be in. It offers the maternal comfort of the abstractionist's 'potential space' (it is literally 'metropolitan'), but lives this comfort from an adult point of view. It is utopian in the spirit of Ernst Bloch's previously quoted reference to a homeland that 'has shone into the childhood of all and in which no one has yet been'.

These comments do not require us to reject either Fuller's psychological interpretation or Sister Wendy's mystical view. The point is that this (the modern urban world) is the ineluctable external environment within which most of us are fated – and I do not imply anything negative by that word: remember Nietzsche's *amor fati* – to seek out and to actualize our inner springs of creativity; to make, in the very middle of this monstrosity of concrete, steel and people, 'potential space' for art and love; to have whatever epiphanies of God (back parts or face, as the case allows) may be granted to us; to give shape and form to those remembrances that transform and transfigure this, our exile. Nor is the relevance of such art confined to those who happen to live in the centre of urban conglomerations. In the contemporary global culture cities such as New York, London or Paris are images and metaphors for us all. Even those of us who are not technically 'city-dwellers' are to a very considerable degree touched and even moulded by the contemporary experience (and perhaps especially the contemporary American experience) of urbanity. In this context Natkin's art is an art that is thoroughly secular, thoroughly urban and *precisely as such* potentially 'art' in the highest sense: truthful, beautiful and redemptive; art that

persuades us that 'it is good that we are here'; art that goes on winning us – in the midst of all that would persuade us otherwise – to the cause of valuing and reverencing life; art that 'through remembrance' makes straight the ways of homecoming even in the time of exile. In an image to which Natkin repeatedly recurs, it is art that helps us to continue recycling the constant failures of modern living into meaning and (maybe) religion. 'Yummy!'

9

Antony Gormley's 'Still Moving'

In 1996, on the occasion of the controversial installation of Bill Viola's video work 'The Messenger' in Durham Cathedral (see Pattison 1998, pp. 184–6), the North East Chaplaincy to the Arts and Recreation convened a conference in which theologians were invited to respond to presentations by artists in a variety of fields. Antony Gormley's paper on this occasion, entitled 'Still Moving', offered a reminder that, even as his audience sat listening to him, their minds were still moving, just as we all, even now, are still moving onwards through time. Yet moving and mobility are not unproblematic phenomena and can readily mutate into what, following the culture critic Paul Virilio, Gormley calls 'displacement'. Examples of such displacement are not only to be seen in the constant mobility of modern society, exemplified above all in the exponential growth of air and road traffic, but also in the constant extension of the virtual world in which more and more of us are spending more and more time. This, then, presents art, and especially the artist who, like Gormley, creates highly public art, with a challenge: 'whether it is possible for art to resist the flow of displacement by creating places' (Gormley 2003, p. 12). Can we learn how to be still, to be 'in place', even in the midst of all this movement? Gormley turns to Heidegger's evocation of the abiding power of a Greek temple as an example of what this might mean:

A building, a Greek temple, portrays nothing. It simply stands in the middle of the rock cleft valley. The building encloses the figure of the god, and in this concealment, lets it stand out into the holy precinct through the open portico. By means of the temple the god is present in the temple. This presence of the god is itself the extension and limitation of the precinct as a holy precinct. The temple and its precinct however, do not fade away into the indefinite. It is the temple work that first fits together and at the same time gathers round itself the unity of those paths and relations in which birth and death, disaster and blessing, victory and disgrace, endurance and decline acquire the shape of destiny for human beings. (Quoted in Gormley 2003, p. 14)

In this spirit, Gormley proposes to himself the task of creating, through art, a possibility of presence, a re-rooting of the perpetually mobile world. From the colossal masterpiece of 'The Angel of the North' to the multitude of clay figures entitled 'Field', his work returns us to the body, the earth, the rhythms of the planet and, therein, also finds the spiritual, providing us with an occasion for regeneration and renewal.

In response to these thoughts, and with images of Gormley's work very much in mind, I should like to focus on three words from the talk 'Still Moving', namely: resistance, communion and regeneration (Gormley's term is actually 'generation' but I shall take the liberty – justifiable, I think in terms of what he is saying – of stretching the meaning somewhat).

In his paper, Gormley relates his own artistic concerns to contemporary culture, touching on a familiar complex of issues: globalization, the development of the noosphere, the dislocation and fragmentation of persons and communities occasioned by what Ernst Jünger called 'the total mobilization' of humanity. A further, and subtler, dimension of this is the crisis of signification

and representation in which signs are reduced to mere signifiers caught up in an endless play that, objectively, signifies nothing. This complex of issues reflects an approach to culture that goes back at least as far Schiller's basically similar critique of modernity in his *On the Aesthetic Education of Mankind* at the end of the eighteenth century (discussed in Chapter 6 above). Nevertheless, the processes described by Schiller seem to have accelerated ever more quickly in the course of the last generation. Not only have the supposed 'eternal values' of beauty, truth and goodness – to which Schiller himself could still appeal as an 'answer' to the crisis of the age – disappeared from the cultural horizons of our time, but even their modernist substitutes such as 'meaning' and 'expressiveness' and 'authenticity' are widely reported to have gone the same way.

But why should we *resist* this? Whether they are for it or against it, many might argue that resistance is futile, and can never be anything but a reactionary attempt to impose uniformity and order and a fake monumentality on the free play of signifiers; a Quixotic effort to make something permanent in place of the continuous self-consumption of signs. Some would also suspect a hidden political agenda in such anti-modernist rhetoric, seeing it as preparing the way for some sort of political Romanticism. Gormley strikingly quotes Heidegger, yet the reference is troubling. For Heidegger's vision of a revaluation of aesthetic values that would point away from the bloated cult of genius towards a greater receptiveness to the deeper, more mysterious ground of meaning bequeathed us by what he calls 'earth', is hard to separate from the fateful and disastrous gesture of assuming the Nazi Rectorship of Freiburg University in 1933. As Heidegger then understood it, Hitler's assumption of power provided a historic opportunity for the German nation to tear itself away from an obsessive and self-destructive individualism and redefine itself as the guardian of a deeper planetary truth, serving as a collective 'Shepherd of Being'.

The point I am making is not a political one, however, and I want especially to emphasize this in the light of some of the misplaced jibes about totalitarian sculpture that were made in connection with Gormley's own most celebrated work, 'The Angel of the North', but that time has proved ill-founded. My point is rather to do with the relationship between the creative individual and the whole. Heidegger's problem was not simply that he made a massive political error. It was, still more fundamentally, to do with his belief that an individual person or nation could define itself as the advocate of the earth in the face of the growing wilderness brought about by the 'total mobilization' set in motion by modern technology. Even apart from such perversions as its Anti-Semitism, the Nazi catastrophe was, in this perspective, necessarily built on a false foundation, namely that a single people could designate itself as the bearers of the values of humanity and of earth in opposition to the flux of history. And for all the political differences between them, something similar can be said of the Communist development in the Soviet Union, which likewise claimed to speak for the totality of history against the mythological spirits of the ancient gods of earth, and yet to do so in the name of one particular class. The Heidegger problem, then, is precisely the problem of how to authenticate any claims made on behalf of an individual political or aesthetic vision to speak for the whole, meaning by this not only the whole human community but also the whole planetary community of what Heidegger was so evocatively to call 'earth, sky, mortals and gods'. It is, once more, the problem of re-enchantment, for how can any individual or group re-enchant the world unless they themselves have been enchanted by it?

The characteristic postmodern move was, of course, to say that since a vision of the whole is unavailable, we should just go with the flow and enjoy the fragmentation and learn to be happy playing with this endless dispersal of meanings: anything else is bound to be reactionary and, ultimately, violent. But Gormley's

way of talking about resistance is not that of a political Romantic. He likes the internet. He does not believe that the garden was paradisal, not in all respects anyway. He is *very* firmly in the present and does not seem to wish to get out of it to restore some *ancien régime* of primal significations. His resistance to the condition of postmodernity cannot be dismissed as a reaction on behalf of some imaginary organic holism.

Whence, then, talk of resistance? I suppose there are a number of social reasons why we might be moved to become resisters. We might point to the real human cost of modern and postmodern rootlessness. This can be seen either in terms of the familiar conservative agenda concerning the breakdown of family, law and order, and lack of consensus on values, or in terms of the agenda of the left: job insecurity, the alienation and marginalization of minorities and systemic global injustice. Looking around the contemporary world, left and right (and the apolitical) can readily adduce experiences of futility, of social isolation, the replacement of being by having, and the feeling that there's something a bit too unreal about virtual reality. There is, then, much to hold us back from unquestioningly going with the flow; there is a pervasive sense of something going missing, of something essentially human being lost, and this sense is not just the prerogative of political romantics.

But there are positive as well as negative reasons for seeking some kind of way out of this situation. This is where we might begin to speak of the second of my keywords: communion. Resistance is not simply a matter of reacting negatively to a particular situation, it also involves a sense of there being positive values, positive human experiences and insights that do not get reflected in the rhetoric or the representations of postmodernity. It is interesting that in his paper Gormley connects communion in the first instance to time and to the experience of history, the linking together of past and future. He did not, but might well

have, use the word 'tradition' – not in the sense of traditional-ism (that is to say, maintaining a rigid set of beliefs or artistic practices opposed to modernity) but as a living counter-balance to the vilification and diminution of the human image that is a recurrent feature of the modern and postmodern experience. Tradition in this sense means binding together past, present and future in such a way that the present is not just a kind of 'now' devoid of history, with no before or after, but a present that has come from somewhere and that is going to somewhere. Gormley speaks in the paper of destiny and hope. And he also speaks of presence, another 'time' word perhaps, if we understand 'pres-ence' as that which abides within the flux of time. Such 'presence' is not an eternal value outside time but is what shows itself as enduring and remaining present in its being in time. But presence and communion are not only time words, they are also, of course, *personal* words. 'Communion' speaks of personal relatedness, of communion between persons. As Gabriel Marcel, a Catholic exis-tentialist philosopher, said, 'objects can never be present to us: only persons can be fully present to us'.[1] A person who has 'pres-ence' is someone who claims our attention. But that is not some-thing that can be manufactured or produced in a charm school. Presence is not argued for, since it is not an abstract quality. It is a claim, an appeal, a demand made upon us. To speak of presence in these terms is, once more, to signal a point of resistance to the rhetoric of postmodernism, because it was an article of the post-modern consensus of the 1990s that presence and a longing for presence – nostalgia for presence – is one of the fundamental dis-torting elements in the whole western intellectual tradition, from Plato down to the present. Even Heidegger and other existential-ists, it is said, were still in the grip of presence – but it is only when we get away from presence that we will truly have liberated language into its own proper medium. Every re-representation is also a de-presentation.

It is important that Gormley links presence to body and to the fact that we are present to ourselves bodily before we can start thinking about being present to ourselves. The American philosopher David Michael Levin entitled one of his books *The Body's Recollection of Being*, and just the title nicely pinpoints the insight that it is the body that calls us to the presence of being and there is no other way to it. And it is also the body that opens us to communion: the fact that each of us has been born out of another person, and our very survival as infants and in the face of danger and sickness, depends on the network of other physical bodies around us.

My last term is re-generation, or to use another word, reconstruction. Again embodiment is understood by Gormley as the only possible medium in which generation can take place. And if *re*generation is to occur, we have to be brought back to our embodiment, to be made present to ourselves in a communion in the flesh. Now it is precisely the distinctiveness of the sculpture, Gormley's chosen medium, that it is eminently bodily. Like the human body it exists in all three dimensions; like us it is solid and, unlike painting's requirement that we imaginatively invent the space we see in the work (see the discussion of Hegel in Chapter 5 above), it is inseparable from the obscurity of its bodily presence. It is non-rationalizable, a kind of present darkness that, as the philosopher Merleau-Ponty put it, is 'just as necessary as the clarity of true thoughts'(Merleau-Ponty 1974, p. 298). You do not understand a sculpture by understanding an intellectual meaning that the sculpture somehow represents, but by engaging with its being there in its physical obscurity and darkness. Connected with this is Gormley's preference for the word 'spirit' as opposed to 'soul', because, of course, in the western tradition 'soul' has generally been understood as precisely in-corporeal and non-bodily. Soul is that which survives when the body dies, that which leaves the body, perhaps, according to Plato, that which is there

before the body is born such that the life of the body, incarnation, is merely an accident that befalls it. But spirit is perhaps something that can only be understood as arising on the ground of the body. And if that is so, then spirit can only be itself when it embraces everything that belongs to the body.

But here we encounter a problem. For one of the things that makes us recoil from our existence as embodied beings is that embodied beings are beings that die, and that, when they are dead, decompose into something else. Embodied existence is existence that has to face the question of death. With this I am moving (though really, perhaps, standing still, moving on the spot, journeying into the presuppositions of what has already been said) to questions that I think Gormley did not foreground in his presentation, but that are, nevertheless, implicit in it. And it is a curious conjunction that the place of regeneration, the body, is also the place where we experience our mortality, our finitude.

Before I go on to bring out further aspects of that, however, let me note that although we seem to be getting into an area that is very 'subjective' in an almost existentialist sense, we are not just talking about what is going on in the insides of individuals, in their individual thoughts, but about something that takes place in shared public space. This is very important, because, of course, embodiment is always a shared thing: we have bodies only as members of a species that live together in open space, and our death, despite the best efforts of the twentieth century's medical and mortician experts, still remains a very public thing, perhaps one of the few public rituals in which nearly everybody, sooner or later, has to participate. But to proceed: the questions that arise for me that go beyond what Gormley said in the paper – although I do not think these are questions that are alien to his work or to his thought – can be focused in three words; death, risk and tragedy.

These three terms hang together. Of course, Gormley's body-casts are themselves produced by a creative process that is remin-

iscent of the processes of death and burial, as his body is encased in plaster to provide the mould for the production of a leaden figure – and this material is itself associated with death, coffins and tombs. The whole process is something like a dying and rebirth. But that does not mean we can immediately graft on to it the whole Christian rhetoric about resurrection. It is important that the embodiment that is at issue here is not to be understood in the sense of mechanical physicality or the kind of bodily life that is the object of scientific physiology. Rather, it is the experience of embodiment as experienced by the living human being. The difference between this lived body and the body as understood by science is neatly illustrated in the Disney movie *The Lion King*. In the movie there is a scene in which the Father, the Lion King, takes his baby son out to look up at the stars, and tells him to 'Look up at the stars, son, those are the Kings of old who now look down on you and they will keep you up to the level of being a King when you come to be a Lion.' Later on the young lion, the Prince, runs away after his evil Uncle has brought about all sorts of mayhem, and he falls into the company of a couple of very peculiar characters. One of these is a very strange pig, who says that when he looks at the stars he thinks they are just balls of gas (this is a joke because he is very gaseous himself, in the most vulgar sense of the term). The example is, perhaps, bathetic, but it does give a vivid example of what I mean by double vision: on the one hand we have had several centuries of scientific enlightenment. We know that the stars, the hills and the sea are just matter, bound by physical laws; we know that the pathetic fallacy is not true, and that the whole cosmos is just the product of a blind evolutionary chance. It is just burning gas. And yet, there is the possibility for us to see it another way as well, to see it both ways at once. Even for us, the stars may still shine as Kings. In fact, that is more how we experience it in the actuality of our lives.

The second of these three terms is risk. For me risk is one of

the most important things about the making of art, and is integral to what makes art art, rather than just production. Already at the level of the watercolour class in the village hall, there are moments when people are learning to paint and just doing very ordinary flowers or landscapes and so on, when they suddenly take a risk and do something they have never done before, something the result of which they cannot foresee. It is at that moment that their art comes alive and is filled with excitement. Even if the end product is not great art and will never sell for six-figure sums, it is genuinely and truly art, a moment of pure creativity – and this is because the painter dared to take a risk. Of course, if art is being produced on the basis of embodiment, then it has to be risky because we are very fragile, very exposed, very vulnerable bodily entities. We are finite in such a way that no individual can get on top of themselves and, as it were, 'manage' the total process of being in the world. We have to wait upon events. And any production of a work of art is a risk. In his paper, Gormley describes how the sculpture entitled 'Sea Man' did not quite work out the way he wanted it to at first. There is always that unexpectedness between the beginning of a process of producing a work of art and what comes out at the end. And even the end is not really the end, because a permanent public work has an ongoing history in the course of which it might become something else. Nor is that necessarily a bad thing. The kind of worship that is offered today in a medieval cathedral is very different as regards its form and its language from what would have been performed and experienced when it was first built. A totally different world-view now holds sway, and the cathedral is seen and experienced in a totally different way from that envisaged by its founders. That does not diminish it, it does not destroy its meaning, but it means that if we are aware of that then we accept that the future of our work does not belong to us: it has a life of its own, beyond us.

Death, risk and tragedy. Tragedy? Yes, because tragedy is

inherent in the risk, in the real possibility that the work might go wrong, that the creative struggle of spirit might be cut short by death before it can be brought to fruition or that the product might be exposed to radical misappropriation when it passes from our hands. Two images from films by Andrei Tarkovsky beautifully illustrate this. The first is from *Andrei Rublev*. At the end of the film there is a wonderful sequence in which a group of monks are looking for a master bellmaker, and they come upon the village where he lived, only to find that it has been devastated by the Tartars. One of the few survivors is the bellmaker's son. They ask him if his father passed on to him his knowledge of bell-making and he says that he did. He adds that the secret is having the right mud for making the mould in which to cast the bell. And so he spends a long time looking around until he can find the right mud and – just when the whole search is starting to look futile – he suddenly exclaims, 'this is it'. Using this 'secret' mud he gathers a mighty team of workers to make a massive bell for the monastery. Finally it is hoisted up and is to be rung for the very first time. If there is any fault in it, then it will crack and all the combined efforts of labourers and craftsmen will have been for nothing – and, if it has not had the right mud, then crack it will (which will also have as a consequence the execution of the bellmaker!). At the very last minute before the new bell is rung we learn that the boy was never taught how to make bells at all and did not know anything about what the right mud was; it was just a hunch. But it worked.

In 'Still Moving', Gormley himself refers to another Tarkovsky film, *The Sacrifice* (to which we shall be returning in a later chapter), with particular reference to the story it contains of a little boy who regularly waters a dead tree in the belief, suggested to him by his father, that if such a ritual action is performed faithfully it will produce its result and the dead tree will come back to life. However, there is a further twist to the tale, and it is provided by

the very closing image of that film. This is the image of the dead tree itself, outlined against the glittering black sea. The central character of the film (the boy's father) has been dragged off to the mental hospital, having burnt down his beautiful summer-house. But as we the viewers know (although the other characters in the film do not), this crazy act is carried out in fulfilment of his promise to sacrifice everything dear to him if the world could be saved from the nuclear war that the first part of the film has led us to believe has already taken place. As we look at that image of the dead tree, the music we hear is from Bach's *St Matthew Passion*. It is, in fact, the soprano aria taking up the penitential lament of St Peter after his threefold denial: 'Have mercy upon me, my God, for the sake of my tears, my wailing'. Perhaps, then, it is not just water that the boy carries in the pail but the tears of his father's repentance, of Peter's repentance, of our repentance. But this means that our most urgent task is not to re-establish ritual but to confront those frightful depths that are the ground of ritual. These are the springs whence flow the tears elicited by the subjection to finitude and to the death that is inherent in our existence as bodily beings. But that closing image is ambiguous. You can see it as a tragic image, a call to heroic but Sisyphean labour, or you can see it as something more, as an expression of faith, a faith that is itself a response to a calling that comes from the far side of mortality. The little boy puts down his pail. Since the start of the film he has been dumb, having lost his voice as the result of an operation. Lying on his back he looks up through the dead branches of the tree at the sky above and speaks. The words he speaks are these: 'In the beginning was the Word.' From a Christian perspective it is not in the artist's skill or luck alone but in this Word, a Word that is at one and the same time the Word of creation, of grace, of forgiveness, that we find the ground of resistance, communion and regeneration.

Notes

1 I have not been able to rediscover this quotation, but the thought is central to Lecture 10 of Marcel's first series of Gifford lectures on *The Mystery of Being*. See Marcel, 1950, pp. 197–209.

10

A Central Asian Pietà

Whether it is said in English, Russian, French, German or one of the languages of Asia, the word 'art' is a word that will perhaps forever bear the imprint of the West. 'Art' as we now practise, understand and receive it is a western invention. When we look back into prehistory and describe cave paintings or the treasures excavated from a Scythian burial site as 'art', we are thinking in western categories. Those who produced these works did not think of themselves as artists, nor did they think of what they produced as 'art'. The sub-title of a great work of recent art history has reminded us that even many of the works that we think of as examples of early religious art in the West are better described as 'images before art' (see Belting 1994). Connected with this are, for example, the many legends of 'images not made with hands', works whose sacredness and power resided in the fact of their miraculous production, entirely without the assistance of human skill and human ideas. And even if some of the icons of the Eastern Church are also great works of art (one naturally thinks first of all of the great Moscow school connected with Andrei Rublev), it is not their artistic quality that makes them 'icons'. Yet, subsequent to a strange alchemical event that seems to have had its epicentre in Italy sometime in the period between 1300 and 1500, we cannot live without our knowledge of art and we cannot help but see a certain range of objects and practices as 'art', whatever the original intentions of those who created it. At least, if we are to do

so we have to make a conscious effort to tear ourselves away from our presuppositions as to what we call art, and from the concepts and categories of the aesthetic theories that we have devised to account for artistic production. This, for example, is the thrust of Heidegger's 'Conversation on Language', in which – precisely as a self-conscious inheritor of the western philosophical tradition – Heidegger challenges the application of European aesthetic concepts to Japanese experiences of 'art' (Heidegger 1959).

At the same time, and really for rather a long time already, both the theory and the practice of art in the West have been riven by a series of crises that has led some commentators to speak of 'the death of art'. Even in the early nineteenth century Hegel could speak of how humanity's highest needs were no longer served by art (as those of his contemporaries we customarily call 'Romantics' claimed), but by philosophy. Rather than art itself, he taught, what our times need is a philosophy of art. 'The peculiar mode to which artistic production and works of art belong no longer satisfies our supreme need', he wrote. 'We are above the level at which works of art can be venerated as divine, and actually worshipped ... Thought and reflection have taken their flight above fine art ... In all these respects, art is, and remains for us, on the side of its highest destiny, a thing of the past' (Hegel 1993, pp. 12–13). Nor was it long before artists themselves seemed to be saying something similar. The critic Robert Hughes has written of the 'shock of the new', and from the mid-nineteenth century onwards each generation of artists has seemed committed to trashing what the previous generation or the official art of the academies regarded as 'art'. It is hard for us today to recover the sense of shock and even scandal that greeted works we now think of as integral to the canon of great art, as, for example, Manet's 'Olympia' and the other early impressionists (see Chapter 2 above) – or else, as in the case of van Gogh, to understand the indifference of the critical, commercial and academic institutions of art. Yet we do

still recognize the defiant gesture of Duchamp's *pissoir* and the strange distortions of cubism and surrealism, while the often deliberate obscenities or transgressive meanings of more recent art remain controversial. Will art continue – and, if not, what will take its place?

Such questions multiply when we look beyond the West itself. Not only have the canons and aesthetic theories of the West been subject to massive internal revolts, they have also been assailed from outside for being, precisely, western, a cultural analogue of the imperialist hegemony of the West in the last five or so centuries. In this spirit, post-colonialism not only offers a rallying-cry for political thinking, it also registers a plea for a far more pluralistic approach to the world of the arts, and for the acceptance of traditions and ways of working that were ignored or excluded by the western academies. In this development, the history of the Soviet Union played an especially complex and ambiguous role. On the one hand, communist ideology provided a basis for critiquing the 'bourgeois' character of much western art. On the other hand, the Russian domination of the Soviet system ensured a certain continuity with nineteenth-century notions of culture and, paradoxically, the late Soviet era perhaps enshrined those cultural values far longer than did the West, where the freedom to challenge and subvert established models was much greater.

Nevertheless, whether with regard to its internal revolutions or to the dynamics of global pluralism, it seems that western art is not going to go away. Even if in the future it ceases to provide the paradigm for what is still currently (or at least mostly) called 'art', it will, for a long time to come, provide a reference point to be drawn on, contested or even rejected by those working in widely divergent cultural situations. This is perhaps analogous to the West's own relation to its historical cultural sources in the visual and poetic arts of ancient Greece and the poetry of the Bible. Greek tragedy by no means determines the means, meth-

ods or subject matter of modern western drama or film, and we no longer believe in the power of Zeus, Athena or the Furies to interfere with human lives; yet even in the very un-Greek dramas of a Shakespeare or the battle scenes of a modern war movie, the Greeks and the Bible still haunt us.

All of this is said by way of preamble to the work of Erkin Mergenov and, in particular, the sculpture 'Pietà: The Return of the Prodigals'. I hope that the relevance of the preamble – especially to this work – will be fairly plain. The title of the work immediately signals its affiliation to the western tradition – although, as the sub-title implies, affiliation should not be taken as immediately implying unconditional obedience to the parental or especially paternal model.

The Pietà, Mary cradling the body of the dead Christ, is one of the great canonical images of western art. The evidence of some early Italian examples of the image suggests that the canonical version, in which the dead Christ is cradled in the arms of his mother, developed out of a fusion of two distinct Byzantine images: the Deposition and the Man of Sorrows, although some later icons, particularly in the western Mediterranean, reflect the western image. Michelangelo alone produced three (each very different) versions of it, including the Rondanini Pietà that many regard as his most tragic and existential self-portrayal, in which (as opposed to the polished perfection of the St Peter's version) the whole weight of human mortality becomes almost too much for the form and matter with which the artist has to work. And if the secular gallery art of the eighteenth and nineteenth centuries seemed to have left the image behind, the terror of the twentieth century has produced its own Pietàs, such as that of Käthe Koll-witz (1937) or more personal recent work by Paula Rego – while a Google search soon reveals many examples of how the image has been incorporated into the working vocabulary even of comic-book art. Not every Pietà (least of all the 'Pietà' motifs used in

Marvel comics!) can be assumed to express the religious values associated with the origins of the image, and the grief of a mother for a son cut down before his time may be said to be a universal human theme. Nevertheless, even if – as many secular observers are likely to do – we interpret the image 'merely' as expressing the sorrow and anguish of terrible and violent bereavement, the fact that a work is called 'Pietà' calls on us to stop and think further about what is being said in it.

In the case of Mergenov's work, the sub-title offers another scriptural reference, namely to the parable of the Prodigal Son – but although this is how it is rendered in the English translation in the catalogue, we note that the Russian version has the plural 'sons', and there are, in fact, more than one of them in the work! Moreover, whereas the English 'prodigal' refers specifically to the financial wastefulness of the young man who took and wasted his father's fortune, the Russian *blyudnye*, in this respect like several other major European languages, emphasizes the 'wandering' or 'vagrant' character of the young man's errancy. This is perhaps not irrelevant, when we think of the relation of an artist whose origins lie outside Europe, to a European tradition that has, as it were, 'wandered' to Central Asia (or, to put it the other way round, the story of an artist who, via the Soviet cultural system, has 'wandered' from his Central Asian roots into a certain rela-tion to the western European tradition). Potentially, at least, this gives us another example of what we have heard Gormley refer to as the 'displacement' of contemporary mobility.

We can develop these thoughts further with the help of some of the photographs reproduced in the 2003 catalogue of Mergenov's work. The first is a family photograph from 1935. In the front row we see the artist's mother and grandparents. They are dressed in a traditional Central Asian way, perhaps not very differently from how their ancestors would have dressed one, two, three hundred or more years previously. In the back row, however, Mergenov's

father is wearing a black leather jacket and peaked cap with red star and looking every inch the Bolshevik. And, of course, in their own distinct way, the Bolsheviks were the agents of a European-ization of the empire conquered in preceding centuries by the Tsars but that had often in practice been left to enjoy a consid-erable degree of cultural, religious and even political autonomy. The tide of continuing Europeanization is further evidenced by a photo of the artist and his sister from 1940. Here we see a little girl in the sailor suit that had become an international children's outfit in the early years of the twentieth century (although, by then, already out of fashion in the West) and a little boy seated in a high chair with a lacy outfit that could have been worn by any child in France, Germany or Britain. And so, by the time of the 1944 family photo, the residual traces of traditional costume have all but vanished, with just the grandmother retaining an echo of older ways. Now we fast-forward to a group-portrait of young Kazakh artists in 1976. Mergenov is seated, one leg placed casu-ally over the other. With his dark glasses, roll-neck jumper, rather flashy watch, cigarette and challengingly self-confident pose, he epitomizes a style of post-war radical youth recognizable in the heroes of Italian realist movies, French beatniks and Swinging London. It is an international style that crosses and undercuts surface political and ideological differences, equally at home in Moscow, Paris, New York or Berlin. Just imagine the grandfather from the 1935 picture walking down Fifth Avenue: he would have a crowd around him in five minutes. No one (apart perhaps from admiring young women) would give the Mergenov of 1976 a second look.

These pictures tell a story of an individual and collective 'wan-dering', a displacement that encompasses massive social, politi-cal and cultural changes – and, as we know, the wheels have not stopped turning since 1976, as the collapse of the Soviet Union and the emergence of a global economy have brought further

changes in their wake. But they're also – and this is the point of these reflections – a series of peregrinations and transformations that is significant, decisive even, for the contemporary cultural situation. The questions that these changes pose go something like this: are we to see the artistic task of our time as the creation of a new international art from which all traces of the traditions and convulsions of the past have been eliminated, an art as clinical as the sterile walls and lighting favoured by so many contemporary galleries? Or is it to be a return to a kind of communitarianism, a valorization of the local, ethnic and particular against the West and against the new world order? Is our art now and in time to come to be an art that is not only ours, not only of the present, but recapitulating, remembering and learning from the past – in this case from the ancient traditions of Central Asia, from the experience of modernization and westernization, from historical trauma and rupture as well as from the canonical models of 'great art'? Such an art would acknowledge its inheritance from the West, but would no longer be imprisoned by the assumptions of the West, nor necessarily prey to the West's anxieties.

I suggest that the work of Mergenov points us towards this last possibility, to a rich, transformative mix, an alchemical sublimation, of this very particular local realization of the story of the twentieth century. Different works have different emphases: from social realist busts, through pure abstraction, and on to attenuated figures reminiscent of Giacometti; from images invoking Kazakh traditions to the figure of the cosmonaut; there is the sheer *jouissance* of 'Nike' and 'Premonition' and the serious mood of the memorial to the victims of political repression. All of this points to synthesis and richness, rather than to a flattening-out of style (that is really style-less) or to a return to some kind of regionalism.

And there is the 'Pietà' – and note how differently the subject-matter is treated from the canonical version of the western proto-

type. Here, the seated mother is no longer cradling the body of her dead son, but she is surrounded back and front by her 'wandering' sons, at first glance almost playfully clambering and tumbling around and on her. If the canonical image represents a terrible and heart-rending bereavement, this seems to tell of the tumultuous zest of family life. Yet the story is more complex than that. The catalogue suggests that the red base recalls the executioner's block, indicating that the biblical source of the image has not been lost sight of. Even without that reference, there are many hints: the sombre tone struck by the angular abstraction of the mother figure; the hands, struggling to break free from the abstract metal in which they are encased, but not yet able to do so; the pleading posture of the armless son, looking up at her with a love that is almost desperation; the strange and disturbing compression of the two infants at her back, forced into an identity they have not perhaps desired; and not least the severed head, rolling on the ground at the mother's feet. What do all these features mean? What are they saying? How do we reconcile the feeling of 'tumultuous zest' for life with the echoes and intimations of tragedy?

I return to the sub-title and its reference to the 'prodigal' or 'wandering' sons. For what we see in this work is a dynamic inversion both of the parable of the prodigal son (who returned, we recall, to his *father*, and whose story condenses many of the potentialities for guilt and shame in the father–son relationship) and of the scene at the foot of the cross. No doubt there has been a death here, but there is also a return to life, and the bearers of that return are precisely the 'wandering' sons. The image of the 'Pietà' is an image of a death (and not just any death, but a death of God), and the artistic tradition that has bequeathed that image to us is itself a tradition that, as we have seen, has become entangled in a long-running crisis that many regard as having entered its terminal phase. In relation to that tradition, then, this work is

telling us that the inheritance of western art can only live again to the extent that its 'wandering' sons, its inheritors from beyond the confines of the West, come to it and freely make of it an expression of their own distress and need. And beyond that message there is perhaps also a deeper communication that touches on the religious meaning of the source image – or, better, images, since, as has been noted, we need to have simultaneously in mind both the Mother of God with her dead son and the parable of the prodigal son. Thinking these images together, and doing so in the light of the very particular synthesis effected in aluminium and wood by Mergenov, perhaps we can say something like the following: that faced with a religious crisis not inappropriately called 'the death of God', spiritual renewal will not come in the first instance from a Saviour figure descending from somewhere above and beyond the human condition, but from the returning 'prodigals' or 'wanderers', falling not perhaps at their father's knees (as in Rembrandt's painting, famously 'quoted' at the end of Tarkovsky's film *Solaris*) but returning to their mother's lap – not, therefore, simply 'penitent' in the manner of a penitent son kneeling before a father against whom he has sinned, but ecstatically and paradoxically full both of 'tumultuous zest for life' and of a crying need, just as one is in returning to a mother from whom one had been long since separated. And the final twist is that through her children's return she too comes back to life, and the atrophied hands reach out once more, are once more allowed to love.

11

Salvation Unseen

The Idiot-Christ

In Chapter 2, I touched several times on the striking complementarity of key images in Dostoevsky's novel *The Idiot* and Manet's 1864 paintings of 'Dead Christ with Angels' and 'Olympia'. Now I want to pick up another, related theme from this novel, a work of which one could say that it is 'an experiment in Christology', addressing, in its distinctively novelistic way, the question of the possibility of an encounter with Christ in a world marked by the death of God. It is well known that Dostoevsky set out in this novel to portray a purely good man – and his fate, were such a one to appear in contemporary Petersburg. A purely good man is, of course, not yet a Christ figure, though he may be an approximation towards one. That Prince Myshkin, the eponymous idiot, is however to be seen, at least to some extent, as a Christ figure is indicated by a number of things we are told about him. The external machinery of the plot already provides a clue: Myshkin, whose birth and origins are throughout obscure, arrives in St Petersburg from a distant, foreign land, Switzerland, to which, at the end of the novel, he returns. Then, he is described in terms that carry a distinct Christological charge, being said to have been 'a young man . . . about twenty-six or twenty-seven years old, slightly taller than the average, with very blond, thick hair, sunken cheeks, and a sparse, pointed, nearly white little beard. His eyes were big, blue,

and intent; their gaze had something heavy about it . . .' (Dosto-evsky 2001, p. 6). In other words, he bears a remarkable physical resemblance to the Christ of Russian iconography. Twenty-seven is also the age at which many believed Christ began his ministry. Like Christ, he is a Prince. His pre-name, Leo, might also be taken as allegorically signifying the Lion of Judah – although, for rea-sons that soon become clear, his family name, literally 'Mousekin', is no less significant! Like the biblical Christ, he offers uncon-ditional love to the 'fallen woman' Anastasia Phillipovna, and brings about a reconciliation between the outcast Marie and the children who had been persecuting her. He reveals the secrets of his interlocutors' hearts, reading their personalities in their faces and exposing, but not condemning, their sins. In moments of ecstasy, he seems to see into the mysteries of heaven and is given to experience a state in which time is no more. When struck, he does not strike in return.

Yet there are also significant disanalogies with the Christ of Christian faith. The heaviness of his look is said to be a symptom of 'the falling sickness' that has reduced him to 'idiocy', and, Lion that he is, he is also a 'mousekin' who, at crucial moments, seems incapable of acting. He may offer salvation to the fallen and self-condemned but, typically, they do not accept it. On the contrary, his presence seems to be a catalyst for outbursts of malevol-ence and violence: even his 'brother', Rogozhin, with whom he has exchanged icons, becomes the murderer of Anastasia. He is haunted by Holbein's depiction of the dead Christ, and concedes that, in the light of such a picture, a man might lose his faith. Of course, St John already knew that the Light that came into the world was not received, not even by his own. But can we imagine a gospel in which, as in *The Idiot*, *no one* was saved? We cannot, then, simply say that Myshkin 'is' Christ, yet his Christ-like traits are enough to warrant the suggestion that, in some measure, the novel is, as I have suggested, an experiment in Christology.

Understood in this way, the novel asks the question: what would a fully-human Christ with no memory or sign of a divine pre-history have to be like, if he were to appear among us, here in contemporary St Petersburg, in a city and a society gripped by the frenetic atmosphere of early industrial capitalism? In such a place and at such a time, could even the best of men or the most Christ-like Christ perform the miracles that were wrought in Chorazin and Bethsaida? For this, as the scriptural allusions in the novel show, is a world already standing under the sign of the destruction prophesied in the Apocalypse, a world in which there is no more time and in which the phial of God's wrath is already being poured out, as the wormwood of railways and capitalism consumes the face of the earth – too late, perhaps, for a Saviour Christ to forestall the work of the Judging Christ?

The scenario set out in *The Idiot* resonated powerfully in the art, literature and culture of the twentieth century. Here I want specifically to focus in on some particular treatments of the Idiot-Christ theme in film. While I believe that in the works I shall discuss there is either a strong analogy to or an explicit allusion to the Dostoievskian prototype, I am not suggesting that *The Idiot* is the sole source for these works. Like Dostoevsky himself, the modern film-maker is able to draw on the biblical text and such literary models as Don Quixote or Poor Tom in *King Lear*, where many of the issues that are comprised in the designation 'Idiot-Christ' can already be found. Yet Dostoevsky's novel sets out the issues with a clarity and a force that, I believe, make it the most appropriate co-ordinate from which to start mapping the theological message of these works of film art.

Naturally, the colossal scale of the violence and greed that marked the twentieth century were sufficient to invite any moralist to reflect on the fate of goodness in such a world. If that moralist was also a film-maker, there were also particular features of the Idiot-Christ theme that would be attractive. Precisely as

153

presented by Dostoevsky, the Idiot-Christ provokes reflection on seeing, perspective, point-of-view. It is the *appearance* of Myshkin, in several senses of the word, that provides a catalyst for the action of the novel. Nor is it a coincidence that this is probably one of the first novels in which a photographic image plays a crucial part, and we have already seen in Chapter 2 how the photograph of Anastasia Phillipovna offers a kind of counterpoint to Holbein's painting of the dead Christ, like two negative icons that challenge the meaning of the Christ-icon written for us in the opening description of Myshkin. Dostoevsky's question is not just the intellectual one of how we could conceive of a Christ in the concepts and categories of modernity, but whether we could even *see* such a Christ. Could a Christ for our times be seen at all?

Film, of course, like art, literature and the theatre, has always had its ways of showing goodness – in the manner of direct communication. Heroes are handsome and heroines beautiful and good triumphs or, at the very least, smiles through tears. And if what we see does not make it clear enough, the swelling chords of the score are there to remove all possible doubt. Dostoevsky's problem, however, begins precisely at the point at which such direct representation becomes dubious. It was not a new insight that all that glitters is not gold, but conceding the truth of this saying, how can the novelist or filmmaker then *show* a goodness that does not glitter? As I have just noted, there have always been and doubtless will always be novels and films in which this is simply not an issue, in which the good are also the beautiful and also prove triumphant, even when their triumph is awash with tears. Such works have their audience and their justification: but what of films that seek to go further, that seek in this so strongly visual medium to show a goodness that cannot be shown and to reveal the presence of the invisible, in, with and under the visible? Can film do this? And can it go even further than this and show, in this invisible goodness, a presence of the transcendent?

It is a formidable challenge. It is instructive that Kurosawa, while accepting part of Dostoevsky's challenge, made significant plot-changes in his adaptation of *The Idiot*, changes that contributed to naturalizing Dostoevsky's question. Set at the end of World War Two, Kurosawa's film shows the idiot as a returning soldier who has faced execution through misidentification as a war criminal, a mistake discovered only at the very last minute, when he was already tied to the stake. This trauma has occasioned his illness and 'idiocy'. The scenario of the near-execution, something that Dostoevsky himself experienced, is indeed narrated in the novel *The Idiot*, but there it is a story told by Myshkin about an acquaintance and unconnected with his illness. What Kurosawa does, therefore, is to provide a psychological rationale for events that, in the novel, have a more allusive, indirect and even enigmatic nature. This may reflect some of the issues of translating Dostoevsky's story into a non-Christian culture, but it also reflects the realist film genre's craving for narrative and psychological motivation – elements, however, that intrinsically work against the posing, on screen, of metaphysical questions.[1] Perhaps similar factors (as well, perhaps, as ideological ones) were at work in the deletion from the 1958 Soviet adaptation of those speeches in which Myshkin discusses executions and thus raises the question of the meaning of human life in the face of the grave. Within the parameters of Marxist materialism, the material fact of mortality could not be regarded as any sort of indictment against life's meaning. This leaves the film with enough material for a gripping Victorian melodrama, but it significantly weakens its potential metaphysical significance.

Although there have been several filmed adaptations of the novel (which, as well as Kurosawa's version and the Soviet 1958 adaptation, include a very successful recent Russian television version), I shall choose to focus on films from or related to the Scandinavian tradition of film-making that take up the Idiot-

Christ theme but do so in an original way. Why this tradition? Because, I think, it is clear that there is not only a tradition of Dostoevsky-interpretation at work here but there is also a dialogue taking place among the film-makers themselves. The three films I shall be examining are: *Through a Glass Darkly* (Bergman 1961), *The Sacrifice* (Tarkovsky 1986) and *Breaking the Waves* (Lars von Trier 1996), with further reference to the latter's *Idiots*, *Dancer in the Dark* and *Dogville*. Although Tarkovsky's *The Sacrifice* may seem to be an odd one out here, the director being very much a part of the Russian film tradition, this film is clearly in close dialogue with *Through a Glass Darkly*, as I shall show, and was filmed in Sweden with a Swedish cast, including well-known 'Bergman' actors, and with cinematography by Bergman's long-standing cameraman, Sven Nykvist. It can therefore be regarded as very much a part of the 'Scandinavian' film tradition, if only by adoption.

A more distant background to all these films would probably need also take into account other work, such as Robert Bresson's *Au Hasard Balthazar* (1966), an influence acknowledged by Tarkovsky (Bresson in fact visited him during the making of *The Sacrifice*) and that is also an explicit (if loose) reworking of the idiot theme. Also important, and still further back, would be the work of Theodor Dreyer, not least with regard to his 1955 film *The Word*, which portrays a Juttish farming family whose youngest son, Johannes, has been sent to Copenhagen to study theology and become a priest. However, Johannes has suffered a nervous breakdown – due, according to his brother, to reading too much Søren Kierkegaard – and, at the start of the film, we see him in the sand-dunes, berating an invisible multitude for not believing that he is the Christ and pronouncing the imminence of judgement day. At the end of the film, in an uncompromisingly hyper-stylized scene of utter melodrama, Johannes does in fact raise his sister-in-law, Inge, back to life, thanks to the faith of

Inge's little daughter – though none of the adults will believe. The pace and styling of Dreyer's film reveal his roots in the silent era, and it is hard to believe that Bergman's own breakthrough film, *The Seventh Seal*, came only two years later. Also dealing with judgement, death and resurrection (or, in this case, the absence of resurrection), *The Seventh Seal* can be seen as a direct 'answer' to *The Word*.

The issues raised in these two films (*The Seventh Seal* and *The Word*) remain very much at the heart of the three works I shall now be examining, which may therefore be seen as not only taking up the Freudian challenge posed by the paternal figure of Dreyer, but also the theological challenge of Dreyer's own Idiot-Christ.

Three Films about God and Madness

Through a Glass Darkly is set on a remote Baltic island, where a family group are holidaying in their isolated summer-house. David, the father, has returned from abroad. He is a writer who, we learn, has been neglectful of his family, and he is emotionally as well as physically distant from them. His daughter, Karin, is married to Martin. She has suffered severe mental illness, and although currently in remission, still requires medication. As the plot unfolds, we learn that her illness is likely to return, this time for good. Minus, her brother, is in the throes of late adolescence, longing for, but never getting, his father's love and respect.

As in several other Bergman films, a play-within-the-play provides a teasing programmatic clue to the film as a whole. In this play-within-the-play, Karin plays the ghost of a Castilian princess whose beauty inspires the 'artist' played by Minus. This artist says of himself, 'I am King in my own realm, which is indeed not large but really rather poor', and, he adds, he is the 'purest' artist of

all, for he is 'A poet without a poem, a painter without pictures, a musician without notes, and, withal, an actor without a role. I despise all finished artworks, the banal products of elementary efforts. My life is my work, and is dedicated to you, princess.' But when the princess summons him to join her in the tomb he is overwhelmed with doubts: 'What in the devil's name am I about to do? To sacrifice my life? For what? For eternity? For a perfected work of art? For love! Am I mad? . . . Who will see my sacrifice? Yeah, right: death. Who will know the measure of my love? Yeah, right: a ghost. Who will thank me? Yeah, right: eternity.' Stopping on the threshold, he decides instead to write a poem, in which, of course, he is forgotten and death alone loves him. A poem, a play, a film about the absoluteness of death is itself, after all, just another way of faking it: of what Kierkegaard, in his discourse 'At a Graveside' called 'mood', the antithesis of a serious confrontation with death.

Some time later, Karin tells Minus about a recurrent hallucination in which, when she is in the upstairs room, she hears voices behind the wall and, pressing herself through it, goes on to find herself in a large room, full of people coming and going. She feels secure, surrounded by light. Yet the people are all waiting for someone to come through the door, they are waiting, full of love, for God to reveal himself.

In her lucid moments Karin is also aware that by listening to these voices, she is removing herself from Martin, her husband. She is torn between two worlds. Eventually she resigns herself to returning to hospital: 'One cannot live in two worlds', as she tells her father. However, as they are preparing to leave, and the helicopter ambulance is heard approaching, she goes once more to the upstairs room. Suddenly she is gripped with hysterics, pressing herself into the corner of the room, as if protecting herself against an attacker. Calmed by Martin, who administers a sedative, she describes how, this time, the door *did open* and God

came in: but he was a spider, with a malevolent, repulsive face and cold, emotionless eyes, who tried to rape her.

In the final scene Minus and his father stand looking out over the sea, across which the helicopter has taken Karin. The setting sun is low on the horizon. Minus tells his father how, in the experiences of the last days, he seems to have entered a new world, a frightening world in which there are no rules or boundaries, a world where anything can happen. He is frightened that he cannot live in such a world. You can, his father explains, but you need something to hold on to. 'What would that be – a god?' asks Minus, adding, 'Give me a proof of God.' David offers as proof his belief that love is, despite everything, a reality in the world – 'All kinds of love ... The highest and the lowest, the poorest and the richest, the most ridiculous and the most beautiful.' 'We cannot know,' he adds, 'whether love proves the existence of God or whether love itself is God, but that doesn't matter so much.' With this thought, he says, 'The emptiness about me is suddenly turned into riches and self-absorption into life. It is like a kind of gracious reprieve, Minus. From the death sentence.' Minus suggests that this means that if they continue to love Karin, then she will be surrounded with God's love. David goes off to prepare supper and, in the closing words of the film, Minus turns to camera and whispers, 'Father spoke to me.'

This sounds, perhaps, more edifying than it is. After all, we have learned from earlier conversations in the film that David is like the artist in the play, contriving eloquent but empty words – faking it, rather than truly, existentially, confronting and transcending the meaninglessness disclosed by death. If there is edification, it is perhaps not so much in what David says, but in the fact that he says anything at all – 'Father spoke to me.'

The analogies with *The Sacrifice* are not hard to see. Here too we encounter a small family group, somewhat differently configured but equally dysfunctional, holidaying in a summer-house

on a remote stretch of Swedish coast. Both films begin and end with images of the sun playing on the glittering waters of the Baltic, to the accompaniment of music from Bach.

Alexander, the father-figure in *The Sacrifice*, is a very different personality from David in *Through A Glass Darkly*, but he too is self-absorbed in his artistic pursuits – he has been an actor (his roles have included both Prince Myshkin and Richard III), critic, and lecturer. He is skilled in expounding the mysteries of art, beauty and God, and delivers long speeches on the meaning of life, ritual and Nietzsche's theory of eternal recurrence, to the general lack of interest of his family – yet has never really come to an understanding of his own inner demons. As the film begins, he is holding forth to his son, who is about six years old and who is recovering from a throat operation and cannot speak. They are standing by a dead tree, whose branches, starkly outlined against the sparkling sea, both echo the tree beneath which the Leonardo Madonna used in the credits is sitting and also the tree of Calvary. Alexander tells his son a story of a monk who faithfully watered one such tree every day for many years until, finally, it burst into life – such, he says, is the power of ritual *if we have faith*.

Later, as family and friends gather to celebrate Alexander's birthday, a crescendo of rattling glasses anticipates the sudden, deafening noise of jets flying overhead at supersonic speed. A jug of milk spills across the dark wooden floor in a brilliantly effected image of destruction and waste. The King appears on television, calling on people to stay calm. Then the screen goes blank. We realize that the long-anticipated nuclear war between the Soviet Union and the West has happened and all is over. Alexander's wife has hysterics, and is calmed by a sedative administered by their doctor friend with whom she is having an affair. Alexander himself retreats to his room and, though not a religious man, finds himself praying the Lord's Prayer and vowing that if God undoes the catastrophe and makes it not to have happened, then

he will sacrifice everything, even his son. After a night of mysterious events, Alexander wakes up. It is a new day. He goes to the radio. Everything is as normal. The world has been saved – but now he must pay the price. Waiting until the others have gone for a walk, he stacks furniture in the dining room of his treasured home before setting fire to it. They run back, but his vow forbids him to tell them why he has done it. An ambulance arrives to take him away and, as it goes, it passes the dead tree, at the foot of which the little boy is lying. 'In the beginning was the Word. Why is that, papa?' the boy asks, now (miraculously?) able to speak. To the aria 'Erbarme dich' from the *St Matthew Passion* (the words of which explore Peter's repentance after the threefold denial), the camera moves up the dead tree, the outline of which is almost lost against the glittering luminosity of the sea beyond.

There are clear differences both in plot and ideological intention from *Through a Glass Darkly*. The hope that emerges at the end of Bergman's film is limited, tentative, restrained – almost hopeless: death and madness will sweep all away, but at least we can hold on to love. *The Sacrifice* – whose proper title, *Sacrificatio*, indicates that what is at issue is the act of sacrificing itself – suggests that through self-sacrifice redemption can indeed be won, even if the world fails to understand. If *In a Glass Darkly* only evokes *The Idiot* indirectly, the references in *The Sacrifice* to Alexander having acted the part of Prince Myshkin establish a clear link to Dostoevsky's novel (and it is no surprise to learn that at the time when Tarkovsky left the Soviet Union and began working on *The Sacrifice* he was, in fact, contracted to make a film of *The Idiot*).

Many viewers have objected that *The Sacrifice* is, in the end, too allegorical, too direct in its religious message. To the extent that the 'real event' of the world being saved from nuclear annihilation is clearly depicted and the Christological reference underlined by the use of paintings and music, this may be so. Yet

I do not think the film entirely rules out the possibility that the whole nuclear-war scenario might not have been a fantasy on the part of Alexander. We are not entirely in the realm of the realism adopted by Bergman. We are in a world where the boundaries of 'reality' are uncertain and shifting. Perhaps Alexander has not saved the world. Perhaps he is simply mad.

A similar critical response has been made to *Breaking the Waves*, especially with regard to the final moments of the film in which the incognito of realism is brushed aside for an instant of heavenly vision.

Set in a remote Scottish community of ultra-Calvinistic believers, the story centres on Bess, the daughter of a strong Kirk family. If the craggy cliffs and background hills constitute a very different landscape from that of the flat Swedish islands and coasts of Bergman's and Tarkovsky's films, there is a strong analogy in the remote northernness of the setting. Although institutions belonging to the outer world, such as the police, the health service and the oil industry all play important parts in the staging of the narrative, the central characters are very much in a world of their own. Like Myshkin and Karin, Bess has suffered severe mental illness involving hospitalization. Now, however, she is to marry Jan, an outsider, working on the oil rigs. For the golden- and simple-hearted Bess, whose intimate conversations with God are a recurrent feature of the narrative, the boundaries between sacred and secular, even sexual, love are virtually non-existent. As in David's final words in *Through a Glass Darkly*, there is only love, and it is the same love in however many guises it comes. She and Jan joke that they will hang bells in the empty bell-tower on the plain Presbyterian chapel.

Bess's conversations with God backfire when, having begged him to bring Jan back from the rig, Jan suffers an accident that leaves him permanently paralyzed. Incapable of sex, he suggests maliciously to Bess that she go out and have sex with other men

and come back and tell him about it. Repugnant as she finds it, Bess believes that in obeying Jan she will help cure him. Although there are signs that perhaps it does help, her activities lead to her expulsion from the Church. Even her own mother locks the door to her and God no longer answers when she speaks to him. Jan himself relapses and is taken to hospital in a critical condition. In a tarty red PVC miniskirt, having been stoned by a mob of children (very much like Marie in an anecdote related by Prince Myshkin), and having escaped from the police who are taking her back to the psychiatric hospital, Bess finally goes out to the factory ship anchored in the bay, where she knows she can expect only the most brutal treatment from the violent foreign crew. Yet, on the boat taking her out, God returns to her and tells her that he is with her. In making this last sacrifice, she finds assurance that she is doing his will. And it is her last sacrifice. Violently raped by the crew, she is rushed to hospital and dies shortly afterwards. In her last moments, learning that Jan's condition is no better, she doubts: 'I'm frightened. It's all wrong', are her last words. At her burial, the minister pronounces a dire commination or declaration of God's wrath.

But then comes the twist: Jan *can* walk again, and he and his friends, anticipating the gruesome burial rites of the Kirk, have stolen Bess's body, which they then bury at sea. A miracle or a coincidence? If the film had stopped there we might wonder. But back on the rig, the ship's radar suddenly shows up something inexplicable. Rushing out onto the deck the men too hear the air full of the peals of bells ringing in the sky, and in the final seconds of the film, we too see them. Indeed, it is a view from heaven, looking past the bells, and down through a break in the clouds to the rig below that provides the closing image of the film. Bess and Jan did hang their bells of joyous love on the empty bell-tower. The incognito is decisively broken. Bess has ascended into heaven. In her madness, she has re-enacted the self-sacrificial redemptive

act of Christ and been taken to the Father. Grace overwhelms judgement.

The ending verges on kitsch. But we should hesitate before taking it at face value. 'Realist' as the film largely is, using many of the techniques soon to be formalized into the anti-illusionistic 'Dogme' movement, its division into chapters, each introduced with images of Scottish landscape that could almost be drawn from a *People's Friend* calendar, give notice that we are in the domain of story-telling: this is a tale on whose 'happy ending' we are free to pass our own judgement: it is not the depiction of a real event to which we are being required to assent.

Von Trier's sense for the complex dialectics of what is and what seems is indeed demonstrated elsewhere in his work. Issues of point-of-view and the valuation of what is real are very much to the fore in, for example, *The Idiots* and *Dancer in the Dark*, the other two films of the 'golden-heart' trilogy to which *Breaking the Waves* belongs. In *The Idiots*, which depicts the adventures of a group of drop-outs who roam the streets of Copenhagen acting as if mentally subnormal (as certain conditions used to be called), we are challenged to decide as to whose reality is really 'idiotic', that of the idiot-pranksters, or that of the emotionally numb 'normal' people whom their behaviour outrages. In *Dancer in the Dark* the issue is between the harsh economic, medical and, finally, judicial realities of the world inhabited by Selma, a poor immigrant factory-worker who is going blind, and the inner reality in which she is the heroine of a stage musical. Her efforts to find the money to secure an operation that will prevent her son from developing the eye disease from which she herself is suffering lead to a fatal accident, construed as murder, for which she is eventually executed. Yet even her last walk to the execution chamber is turned, in her mind's eye (a view-point shared by us, the spectators), into a tragic-comic song-and-dance routine. Very different again, though equally powerful in highlighting the point

that we never just see but have to choose how to see, is the device of minimalist staging in *Dogville*, where chalked outlines on the studio floor represent the physical existence of the small town of Dogville – roads, walls, gooseberry beds and all. As Lauren Bacall put it when the set-up was being explained to the cast by von Trier: 'Oh, you mean we have to pretend.' Von Trier knows very well that film does not tell us what is the case: film pretends – and if it can tell us truths, those truths are mediated by pretence, illusion and the requirement that the viewer engage in the game (or work?) of interpretation.

It is precisely this capacity for playing with points-of-view and alternative visions that makes the idiot-theme so apt for treatment in film. For it is one of the hinges of Dostoevsky's novel that the book itself offers no final judgement as to whether what we are given to see of the Prince is the form of an incognito, emptied-out Christ or whether it is just a simple-hearted 'idiot'. It all depends, perhaps, on our own point-of-view. Film, we might say, has not only found a significant theme in Dostoevsky's novel: it also helps us see a dimension of that novel itself with a clarity that its literary form may arguably veil.

If the culture of modernity has made the issue of the Idiot-Christ an unavoidable co-ordinate of Christological reflection and experimentation, compelling us to ask whether any Christ could still be seen *as Christ*, in, so to speak, his Christ-ness, his divinity, and if film has provided a medium capable of making this question itself visible, we may also use the opportunity of the question to consider that, in what is most questionable in it, it is a question that pre-dates both modernity and film. It is, indeed, a question that pre-dates debates about the representability of Christ that occurred in the context of the iconoclastic controversies. For how we see the Christ depends not merely on what we are given to see, but also on how we look, and if we are really to see the truth we have to become capable of looking truthfully.

Notes

1 I have learned much about this film from Andrea Hacker's paper 'The Idiocy of Compassion: Akiro Kurosawa's Tale of Prince Myshkin'. At the time of writing this paper has not been published but is likely to appear in Joe Andrew and Robert Reid, eds, *Neo-Formalist Papers: Aspects of Dostoevsky*.

12

Cinema Paradiso

When the Cambridge Arts Cinema closed in 1999 after 52 years of showing what are now called art-house films, cinema-goers were asked to vote for the last film to be shown. They overwhelmingly chose Giuseppe Tornatore's 1990 film *Cinema Paradiso*. Part of the reason for this was, I am sure, that it is a film about film, a film that both celebrates and invites us to reflect on what cinema-going can mean in human lives. The direction in which it steers our reflections may not be entirely original (many of its insights are already anticipated in Shakespeare's reflections on drama and illusion), but it does what it does with exceptional charm, intelligence and style. It is a virtuoso piece that we can simply lean back and enjoy. But if we want it to, it can also help us identify some fundamental questions about the meaning of cinema and art and, I believe, the relationship between art and religion.[1]

This may surprise some people who know the film. Of course, being set in Sicily in the 1940s and 1950s the Church is an unavoidable presence. Many viewers might assume that its presence in the film is therefore merely part of the backdrop. This view might be further reinforced by the way in which Fr Adelfio, the parish priest, is portrayed as the stereotypical bumbling, uneducated, conservative Catholic priest found in remote Italian villages before Vatican II. Insofar as the film takes a line on religion at all, it seems that it is being portrayed precisely as that from which the joys and freedoms of cinema liberate us. If there is anything

'religious' going on in it at all, it looks more like a parody than a testimonial. And yet the film's distance from ecclesiastical Christianity does not of itself exclude a creative dialogue with some central points of Christian doctrine, and it is this dialogue that I want to illustrate here.

The film opens with a view out onto the sea from within a window, in which a net curtain is flapping in the gentle breeze. The camera slowly draws us back into the house, where an elderly lady is trying to contact her son on the phone. She is apparently having little luck. Already in these first simple images we have a kind of conjuration of the basic physical co-ordinates of cinema itself: the sea is stretched out like an empty screen, seen from within a darkened chamber, paralleling the situation of filmgoers, seated in the darkened auditorium looking up at the potentially infinite world that is about to play itself into existence on the screen – but before we have time to dwell on this analogy, the scene shifts to Rome. Here we see a middle-aged and obviously very successful man, driving home late at night at the wheel of a large Mercedes. Arriving back at his spacious apartment, his girlfriend tells him his mother has called. Someone called Alfredo has died. The funeral is tomorrow. She turns over and goes back to sleep, but Salvatore (for that is his name) is left lying awake, remembering his boyhood in the little town of Giancaldo in Sicily. From here on the film unfolds largely in the mirror of Salvatore's memories – a rather significant point in a film about film since film, perhaps more than any other art form, is itself a kind of remembrance of things past. In this respect it is strikingly different from stage drama, in which, even when the events supposedly occurred in the past, the action is happening on stage in the present, whereas what we see in film is already a record of something past, the moment in the studio or on location, a time lost to immediate perception.

Salvatore's first memory is of an early morning mass, and the

priest, who has obviously forgotten the words at the elevation of the chalice, is desperate to wake up the minute and impossibly cute altar-boy who is asleep on his knees. Finally the boy, Salvatore himself, nicknamed Toto, does wake up and belatedly rings the bell. With this aide-memoire the priest can continue: 'for this is the new covenant in my blood which is shed for you and for many for the remission of sins'. Of course, most contemporary British viewers are likely to miss this allusion and its significance, and even Catholics might have difficulty recognizing the words of the Latin mass, but it seems to me important that here, in this very first memory, we are directed to questions of sin and redemption, to the fall and its reversal, to a memory of paradise lost and a hope for paradise to be regained. And perhaps it is also significant that this theme is contextualized in the mass, the Church's pre-eminent rite of remembrance.

From the Church we move to the eponymous Cinema Paradiso, which, it turns out, is actually under the direction of Fr Adelfio, who previews all the films shown there. We see him enter, cross himself in front of the statue of the Virgin located by the entrance and take his seat. He is holding the same bell that Toto had to ring during the Eucharist. Why? We soon learn, for whenever the characters in the films get too intimate and especially when they kiss, he rings his bell so that the projectionist, Alfredo, can mark the spot and cut out the offending frames. Later we see the audience boo and groan when, once more, the film jumps inexplicably from the moment before a kiss to the moment after. Never once have they seen the consummation of a screen kiss!

Toto, we learn, is mad about the cinema and longs to spend all his spare time in the projection room with Alfredo, an avuncular figure with an astonishing repertoire of quotes from movies for every situation. Sometimes Toto steals discarded clips of gunfights from Westerns and pores over them at home. This,

however, leads to the first tragedy in the film. Toto's father is missing on the Russian Front and all Toto's mother has left to remember him by are a couple of studio photos. These are kept in the same tin as Toto's highly flammable film clippings, which the boy sometimes sets on fire, as boys do, just for fun. On one occasion this gets out of hand, and the photos of his father are also badly damaged. Meanwhile, a newsreel shown in the cinema reminds the audience of the many thousands of Italian prisoners in Russia, and that new listings of those killed are being posted. It transpires that Toto's father is among them. Yet as Toto and his mother return home from getting confirmation of the bad news, they pass a poster for *Gone with the Wind*, with Clark Gable bending passionately over Vivien Leigh. Remembering that Alfredo had told him that his father looked like Gable, Toto looks up and smiles to himself. For Toto, film is not merely entertainment, it is solace for the infinite loss of the father he never knew.

Eventually Alfredo agrees to let Toto help in the projection room. But catastrophe is just around the corner. A Harold Lloyd film is being shown, and the audience can't get enough of it. The audience, incidentally, is a key element in these early scenes. They represent all levels of society. They smoke, play practical jokes on those who fall asleep, suckle babies, boys laugh and fight and couples make love in dark corners; occasionally the better-off customers who sit in the circle spit on the plebs below – as the *News of the World* says of itself: all human life is there. Naturally, they are a noisy audience, constantly shouting at Alfredo, and when the doors are closed after the cinema has filled to capacity for the Harold Lloyd film, the crowd outside demand that he do something. Alfredo turns to Toto and quotes Spencer Tracy from *Fury*: 'The mob doesn't think; it has no mind of its own.' 'Shall we let the poor devils see the film?' he asks the boy, who asks how. Alfredo chuckles. 'If you have no faith in me, have faith in what you see', he replies, alluding to the words of Jesus responding to

the questions of John the Baptist's followers, and to Christ's words to Thomas. Are we about to see a miracle? Perhaps. There follow what, to my mind, are among the greatest ten seconds of any film art. Alfredo opens one of the lenses on the giant, old-fashioned projector: 'Watch: abracadabra', he says. 'Now we pass through walls' (a further allusion perhaps to the resurrection mystery?). Reflected off the glass plate the filmed image moves around the walls of the projection room, lighting up faded posters for Laurel and Hardy and *The Blue Angel* before passing out of the window and reforming itself on the wall of a house opposite. With a whoop of delight the crowd rush across the square and take up their seats. Not only do they get to see the film, they see it for free.

This is an absolutely crucial moment. What are we seeing here? Art's re-creation of a joyous world full of laughter and glamour seems to have escaped from the enclosed walls of the cinema and gone out into the world – but can paradise be recreated in this way? Isn't the whole point of a cinema called paradise that, in the condition of fallen humanity, paradise is available to us only in imagination, only in fiction, only in art – not in the world? The image that art offers us of a happy and joyful life can only be enjoyed under strict limitations. It distracts, it entertains – but can it become real? Can what is merely recreational do what a resurrection life can do – pass through walls and go into all the world? Can it be freely available to all?

For a moment it seems that maybe it can. But enjoying the crowd's enjoyment, Alfredo has turned his back on the projector. The highly flammable film has begun to smoke. Soon it bursts into flame. Trying to control the blaze Alfredo opens the projector door and the fire blazes out into his face. Soon the whole cinema is on fire. Everybody flees: only Toto goes back in and bravely rescues his old friend. Is this the price for transgressing the boundaries between art and reality, for imagining that art

can achieve what only a resurrection could do, were that to be possible? Tellingly, Alfredo survives – but he has been blinded, and will never see again. Hubris has been punished.

Is this the end of Cinema Paradiso? Fortunately not – Ciccio, a Neapolitan who lives in Giancaldo, has won the lottery and decides to use his money to do up the cinema and reopen it as the New Cinema Paradiso. At the grand opening the priest sprinkles holy water around the statue of the virgin in the foyer, but he no longer has the power of censor. For the very first time the audience gets to see the long-deferred kiss and bursts into spontaneous applause.

Toto is now more invaluable than ever and establishes himself as projectionist, under instruction from the blinded Alfredo. Time passes, and Toto has become a teenager, with his own 8mm camera that he takes out and about, shooting scenes and showing them to Alfredo. One day, at the station, a pretty girl wanders into view, and Salvatore's camera follows her. As he shows the film to Alfredo, Salvatore's silence is eloquent. 'A woman', Alfredo guesses. Soon, Salvatore is impossibly in love, but whenever he meets Elena he is completely tongue-tied. She smiles, but makes it clear she is not in love with him. Alfredo takes him aside and tells him a story. Once upon a time, he says, there was a King who held at feast at which all the most beautiful princesses were present. A common soldier who was on guard, saw the king's own daughter and, because she was the most beautiful of all, fell madly in love with her. One day he managed to meet her and told her that he couldn't live without her. Moved by his passion, the princess instructed him to wait a hundred days and hundred nights beneath her balcony and, if he did that, she would be his. So he waited, in all weathers, until, by the ninetieth day, he was pale, worn-out, too exhausted even to sleep. And then, on the 99th night – he picked up his chair and went away. Alfredo won't tell Salvatore what this means: it's just a story. But it inspires Sal-

vatore with a plan. He tells Elena that every night, after work, he will wait beneath her balcony for a hundred nights and, if she opens her shutters, he will know that she now loves him. So he does, through rain and storm. It is New Year's Eve, the last night. All over town people are partying, but Salvatore keeps up his lonely vigil. Midnight comes and the shutter is firmly shut. As cheers go up and glasses and bottles are thrown into the empty streets, Salvatore wanders disconsolately back to the projection room. He is in despair – but just at that moment Elena herself appears.

The months that follow are a dream of young love. In the summer Elena has to go away with her family, but she finds a way to come back and be with Salvatore. There can be no doubting her love. But she must go to university and he must do national service. Her family (who do not approve of the lower-class Salvatore) move away from Giancaldo. Soon his letters are returned 'not known at this address'. For a time, it had seemed that real life might be able to achieve what fiction could not: that the patient soldier would win his love. But it has ended in disappointment. Alfredo counsels him to leave Giancaldo forever. Never come back, he tells him, and, if you do, don't come to see me because I won't let you in. Salvatore has to go out into the world and realize the great potential that Alfredo sees in him, he has to let go of the past, resist nostalgia, and make a life for himself. So Salvatore leaves. As the train pulls out, Father Adelfio, wildly waving his broad-brimmed clerical hat, rushes out onto the platform, belatedly joining the little group of Salvatore's mother, sister, and Alfredo.

Now we are back in the film's narrative present. Of course, Salvatore will go to the funeral. We follow the plane touching down at the airport, the taxi taking him through a once familiar landscape, and arriving at his mother's house. He has been faithful to Alfredo's instructions and has not been back in thirty

173

years. Thanks to his success – he has, unsurprisingly, become a famous film director – the house has been beautifully done up. His mother has prepared a room with all the treasure of his child-hood: stills from films, his old movie camera, the restored photo-graphs of his father that he had accidentally damaged as a child.

The funeral procession winds its way through streets that are now full of cars and advertising hoardings. All the old familiar faces from Salvatore's childhood are there. Naturally the cortège pauses outside the New Cinema Paradiso. But it is all boarded up, its windows are broken and, Toto learns, it has been closed for six years. The era of video has arrived, and no one is interested in going to the cinema any more. It will be demolished the next day to make way for a car park. After the funeral, at which he helps carry Alfredo's coffin, Alfredo's widow gives him a reel of film that Alfredo had left for him.

Before the demolition, Salvatore wanders round the ruined cinema. His eye catches some tattered posters advertising the last films shown – *Passioni erotici* and *Transgressi erotici*: from being a kind of mini-paradise enjoyed by all the community, the New Cinema Paradiso had degenerated to showing porno movies. Perhaps the old priest had not been so wrong when, at the first kiss after the re-opening of the cinema, he had shaken his head and said, 'I won't watch pornographic films'!

Returning home, Salvatore watches his old 8 mm film, includ-ing the film of Elena, and has a serious talk with his mother. He apologizes for having abandoned her, but she assures him that she understands. However, she says, it makes her sad that when she rings up a different girl answers every time and in none of their voices has she heard that they really loved him. It seems he has never found the love that he once imagined he had found with Elena. Even though, at the time, that seemed real, it too is now only a memory, a 'ghost' (or 'phantasm'), as his mother says. If he wants to find happiness he must put these ghosts behind

him and live in his real world. He can't live his life longing for a lost, impossible love.

The next day a crowd of the old faithful line up to watch the demolition. As the building collapses into a cloud of dust, teen-agers drive in and out of the ruins on their motorbikes. On a nearby wall is an advertising poster with the slogan 'Paradise can wait'. The dream of paradise regained is not, it seems, to be real-ized in this world.

Salvatore has returned to Rome. He takes the reel that Alfredo left him to his private studio. The lights go down. He settles into in his chair, wondering what he is about to see. The countdown flashes up on the screen: 6–5–4–3–2–1 – and there then follows a compilation of all the kisses that Cinema Paradiso's audience never saw: Chaplin, Valentino, Errol Flynn, Visconti, and many, many more. Tears in his eyes, but smiling, Salvatore leans back, his arms behind his head, and gives himself up to these visions of love finding its fulfilment. They are, of course, only images, only film, only phantasms, only fantasies, only art – not reality. In life, the reality of love has eluded Salvatore. This is not just a matter of his failing to find the right woman. There is also the love of a father he never knew and his mother's unfulfilled love for that same father, cut down by war. Like many thousands of others, her life too was condemned to be a life lived with only a memory of love. Love lives only in memory and hope, and it is in and from memory and hope that art works its imaginary miracles. As Isaac Bashevis Singer once wrote, 'In art as in our dreams, death does not exist', and in art, as in our dreams, love can triumph on earth.

Cinema Paradiso is a film about film and, as such, a film about what art is and can be for us. It is a film about memory, the stuff of art. It is therefore constantly at risk of succumbing to the nostalgia against which Alfredo warned Salvatore, and the throb-bing sweetness of the theme music readily serves such a seduction.

Already in the nineteenth century Kierkegaard warned against mistaking the consolations offered by art for the real consolation of religion. Art, he reminded his readers, does what it does with the materials of imagination, and imagination is not reality. To lose oneself in art can, as Kierkegaard saw happening in the nineteenth-century cult of art and aestheticism, lead to a person becoming detached from life and becoming incapable of relating responsibly to real situations (see Pattison 1999). We might add that the expansion of the modern 'entertainment industry' has made it ever easier for us to opt out of citizenship in favour of entertainment, and it becomes ever harder to know just where the boundaries between art and life really lie. In this confused situation, our contemporary arts seem to oscillate between a kind of nostalgia for a perfection that can never be and an angry rejection of anything that resembles a happy ending – as in the rage of many secular critics at the ending of *Breaking the Waves*. These two tendencies are, of course, interdependent, since the discovery that perfect fulfilment in this life is, after all, an illusion, can lead those who have most hungered for it to run to the opposite extreme. Sometimes even the most violent or nihilistic kinds of contemporary art can, therefore, in their own way also witness to the same nostalgia for a more perfect being, a life more perfect than the life we know.

But are the memories and dreams of a more perfect life that art weaves for us only to be seen as a kind of narcotic, the modern world's version of opium for the people, whether it comes in the form of Harold Lloyd, art-house movies or *Transgressi erotici*? And does the final scene of *Cinema Paradiso* suggest that Salvatore is, in the end, prepared to give up on the quest for a real, if flawed happiness, in favour of losing himself in these images from a distant, impossible past? Is a retreat into imaginary happiness his (and, by implication, our) sole recourse in the face of an unyielding world? Perhaps the film itself does not tell us. But we

can also imagine another possibility: that if Salvatore is to shake himself free from the melancholy that goes all the way back to the loss of his father, then it will be precisely in the power of the hope that these film fictions inspire in him. It is a hope for and a hope in love. In a loveless world, fiction offers imagined memories that we are free to take hold of and, if we choose, transubstantiate into hope. Transubstantiate? In a non-dogmatic sense, yes, for that, after all, is the kind of remembering that we see at work in the first of Salvatore's own memories, the sacramental memory of the body and blood of Christ. And because this is a memory of a life lived in and given for love, a new covenant given for many for the remission of sins, it is a kind of remembering that is also a kind of hoping, a promise of paradise to be regained. 'Tonight you will be with me in paradise', said Christ to the man being tortured to death alongside him. From the point of view of the modern realist nothing could be a more obvious case of wish-fulfilment, a mere fantasy, invented to console us for an otherwise unendurable agony. From the point of view of faith, tonight, today, paradise waits to be regained. It does not have to wait. As Natkin reminded us, 'Remembrance is the secret of redemption; forgetfulness leads to exile'. The memories enshrined in the world of cinema can, of course, lure us towards the false paradise of pornographic 'erotic transgressions'. But they can also remind us that this is not only 'a world of pain' and, if we have forgotten how to dream of a better world, art can remind us of that too. In the complex relationships between present imperfection and imagined perfection, between life and art, we may do well to pray that we might know the difference and, more positively, remember that we are free to take the manifold crucifixions and resurrections of the image that modern art has created and let them help us be renewed in the hope that the best is yet to come.

Notes

1 It should be mentioned that this interpretation is based on the version of the film originally released in cinemas. Subsequently, a 'director's cut' has been released on DVD which involves significant plot changes that involve Elena and Alfredo and diminish the mysterious metaphysical possibilities of the earlier version.

Bibliography

Bataille, Georges, 1979, *Manet*, in *Oeuvres Complètes IX*, Paris: Gallimard.

Baudelaire, Charles, 1964a, *Baudelaire as a Literary Critic*, Pennsylvania: Pennsylvania State University Press

—— 1964b, *The Painter of Modern Life and Other Essays*, London: Phaidon.

—— 1972, *Selected Writings on Art and Artists*, Harmondsworth: Penguin.

Beckett, Wendy, 2001, *The Story of Painting*, London: Dorling Kindersley.

Begbie, Jeremy, 1991, *Voicing Creation's Praise: Towards a Theology of the Arts*, Edinburgh: T. & T. Clark.

Belting, Hans, 1981, *Das Bild und sein Publikum im Mittelalter: Form und Funktion früher Bildtafeln der Passion*, Berlin: Mann.

—— 1994, *Likeness and Presence: A History of the Image Before the Era of Art*, Chicago: Chicago University Press.

Benjamin, Walter, 1978, 'Das Kunstwerk im Zeitalter seiner technischen Reproduzierbarkeit', in Benjamin, *Gesammelte Schriften*, 1.2., Frankfurt am Main: Suhrkamp.

Berdyaev, Nicholas, 1955, trans. D. Lowrie, *The Meaning of the Creative Act*, London: Gollancz.

Biro, Matthew, 1998, *Anselm Kiefer and the Philosophy of Martin Heidegger*, Cambridge: Cambridge University Press.

Bloch, Ernst, 1986, *The Principle of Hope* (3 volumes), Oxford: Blackwell.

Brown, David and Ann Loades (eds), 1995, *The Sense of the Sacramental: Movement and Measure in Art and Music, Place and Time*, London: SPCK.

Burns, J., 1908, *Sermons in Art by the Great Masters*, London: Duckworth.

Chesterton, G. K., 1904, *G. F. Watts*, London: Duckworth.

Coleridge, Samuel Taylor, 1906, *Biographia Literaria*, 5.1.

Conrad, Peter, 2007, *Creation: Artists, Gods and Origins*, London: Thames & Hudson.

Cupitt, Don, 1990, 'The Abstract Sacred', in Judith Robinson (ed.), *The Journey: A Search for the Role of Contemporary Art in Religious and Spiritual Life*, Lincoln: The Usher Gallery, pp. 98–103.

Daab, Zan Schuweiler, 'For Heaven's Sake: Warhol's Religious Allegory', *Religion and the Arts*, Vol. 1 No. 1, Fall 1996.

Dostoevsky, F. M., 2001, trans. R. Pevear and L. Volokhonsky, *The Idiot*, London, Granta.

Eliot, T. S., 1944 (1959), *Four Quartets*, London: Faber & Faber.

Elkins, James and David Morgan, 2009, *Re-enchantment*, London: Routledge.

Forsyth, P. T., 1905, *Religion in Recent Art*, London: Hodder & Stoughton.

Fuller, Peter, 1987, 'Review: Mark Rothko, 1903–1970. London, Tate Gallery', *The Burlington Magazine*, Vol. 129, No. 1013, pp. 545–7.

—— 1988a, *Theoria: Art and the Absence of Grace*, London: Chatto & Windus.

—— 1988b, *Art and Psychoanalysis*, London: The Hogarth Press.

—— 1993, *Peter Fuller's Modern Painters*, ed. John McDonald, London: Methuen.

Gablik, Suzi, 1991, *The Re-enchantment of Art*, London: Thames & Hudson.

Gage, John, 1989, 'J. M. W. Turner and Solar Myth', in J. B. Bullen (ed.), *The Sun is God: Painting, Literature and Mythology in the Nineteenth Century*, Oxford: Clarendon Press.

Gormley, Antony, 2003, 'Still Moving', in Bill Hall and David Jasper (eds), *Art and the Spiritual*, Sunderland: University of Sunderland Press.

Graham, Gordon, 2007, *The Re-enchantment of the World*, Oxford: Oxford University Press.

Hamilton, Richard, 1969, *Manet and his Critics*, New York: Norton Library.

Hanson, A. C., 1977, *Manet and the Modern Tradition*, Newhaven and London: Yale University Press.

Hare, W. Loftus, 1910, *Watts*, London: T. C. and E. C. Jack.

Hegel, G. W. F., 1975, *Early Theological Writings*, Philadelphia: University of Pennsylvania Press.

—— 1993, *Introductory Lectures on Aesthetics*, Harmondsworth: Penguin.

Heidegger, Martin, 1983, *Denkerfahrungen*, Frankfurt am Main: Klostermann.

—— 1959, *Unterwegs zur Sprache*, Stuttgart: Neske.

—— 2002, 'On the Origin of the Work of Art', in J. Young and K. Haynes, *Off the Beaten Track*, Cambridge: Cambridge University Press, pp. 1–56.

Hjort, Øystein, 1992, 'Stilhedens Centrum', *Louisiana Revy* 32, No. 2, January.

Huyghe, René and Daisaku Ikeda, 2007, *Dawn after Dark: A Dialogue*, London: I. B. Tauris.

Jones, Jonathan, 2005, 'Almost a Saint', *Guardian Weekend*, 10 December.

Kierkegaard, Søren, 1980, *The Concept of Anxiety*, Princeton: Princeton University Press.

MacGregor, Neil, 2000, 'Introduction', in G. Finaldi, *The Image of Christ*, London: The National Gallery.

Mâle, Émile, 1984, *L'Art Religieux du XVIIe Siècle*, Paris: Colin.

Malraux, André, 1965 [1947], *Le Musée Imaginaire*, Paris: Gallimard.

Marcel, Gabriel, 1950, *The Mystery of Being*, London: Harvill Press.

Maritain, Jacques, 1933, *Art and Scholasticism*, London: Sheed & Ward.

Merleau-Ponty, Maurice, 1974, 'Eye and Mind', in J. O'Neill (ed.), *Phenom-enology, Language and Sociology: Selected Essays of Maurice Merleau-Ponty*, London: Heinemann.

Merton, Thomas, 1973, *Contemplative Prayer*, London: Darton, Longman & Todd.

Natkin, Robert, 1990, 'Robert Natkin in Conversation with Sister Wendy Beckett', *Modern Painters*, Vol. 3, No. 3.

—— 1993, *Subject Matter and Abstraction – in Exile*, St Alban's: The Claridge Press.

Owens, Lewis, 2001, 'Metacommunism: Kazantzakis, Berdyaev and "The New Middle Age"', *Slavic and East European Journal*, Vol. 45, No. 3, pp. 431–50.

Pattison, George, 1991, *Art Modernity and Faith: Towards a Theology of Art*, Basingstoke: Macmillan.

—— 1998, *Art Modernity and Faith: Restoring the Image*, London: SCM Press.

—— 1999, *Kierkegaard: The Aesthetic and the Religious*, London: SCM Press.

—— 2008, 'Is the Time Right for a Theological Aesthetics?', in Oleg V. Bychkov and James Fodor (eds), *Theological Aesthetics after von Balthasar*, Aldershot: Ashgate, pp. 107–14.

Renan, Ernest, 1935, *The Life of Jesus*, London: Watts & Company.

Saltzmann, Lisa, 1990, *Anselm Kiefer and Art after Auschwitz*, Cambridge: Cambridge University Press.

Schiller, Friedrich, 1967, *On the Aesthetic Education of Man in a Series of Letters*, Oxford: Clarendon Press.

Schleiermacher, F. D. E., 1990, *Ethik*, Hamburg: Felix Meiner.

Shiner, Larry, 2001, *The Invention of Art: Cultural History*, Chicago: University of Chicago Press.

Shrewsbury, H. W., 1918, *The Visions of an Artist: Studies in G. F. Watts: With Verse Interpretations*, London: Charles H. Kelly.

Smith, Alison, 2004, 'Watts and the National Gallery of British Art', in Colin Trodd and Stephanie Brown, *Representations of G. F. Watts: Art Making in Victorian Culture*, Aldershot: Ashgate.

Taylor, Mark C., 1992, *Disfiguring: Art, Architecture, Religion*, Chicago: University of Chicago Press.

Tillich, Paul, 1949, *The Shaking of the Foundations*, London: SCM Press.

Vad, Poul, 1992, trans. Kenneth Tindall, *Vilhelm Hammershøj and Danish Art at the Turn of the Century*, Newhaven: Yale University Press.

Watts, M. S., 1912, *George Frederic Watts: The Annals of an Artist's Life, Vol. II*, London: Macmillan.